ASIA THROUGH ART AND ANTHROPOLOGY

ASIA THROUGH ART AND ANTHROPOLOGY

Cultural Translation Across Borders

Edited by
Fuyubi Nakamura, Morgan Perkins
and Olivier Krischer

With a Foreword by Howard Morphy

B L O O M S B U R Y
LONDON • NEW DELHI • NEW YORK • SYDNEY

Bloomsbury Academic

An imprint of Bloomsbury Publishing Plc

50 Bedford Square	1385 Broadway
London	New York
WC1B 3DP	NY 10018
UK	USA

www.bloomsbury.com

First published 2013

British Library Cataloguing-in-Publication Data
A catalogue record for this book is available from the British Library.

ISBN: HB: 978-0-85785-448-3
PB: 978-0-85785-449-0

Library of Congress Cataloging-in-Publication Data
A catalog record for this book is available from the Library of Congress.

Typeset by Apex CoVantage, LLC
Printed and bound in India

CONTENTS

LIST OF IMAGES

Cover image

Phaptawan Suwannakudt, *Where there is no One… There is no Two (a)*, 2007. Acrylic, 100 × 120 cm. The Artbank Collection. Photograph: Andrew Curtis. Courtesy of the artist and Artbank.

Plates

The publication of the color plates of works by Phaptawan Suwannakudt and Savanhdary Vongpoothorn is funded by the Australian Artists' Grant, a National Association for the Visual Arts (NAVA) initiative, made possible through the generous sponsorship of Mrs. Janet Holmes à Court and the support of the Visual Arts Board, Australia Council for the Arts.

Figures

Table

CONTRIBUTORS

John Clark, CIHA, FAHA is a professor of Asian art history and ARC professorial fellow at the University of Sydney. Among his books are *Modern Asian Art* (1998), *Asian Modernities: Chinese and Thai Art of the 1980s and 1990s* (2010), *Modernities of Chinese Art* (2010), and the chapter "The Southeast Asian Modern: Three Artists" in N. A. Taylor and Boreth Ly (eds.) *Modern and Contemporary Southeast Asian Art: An Anthology* (2012).

Catherine Diamond is a professor of theater at Soochow University, Taipei. She is the director of the Kinnari Ecological Theatre Project, which stages original works by fusing well-known Southeast Asian legends with local environmental issues. She is the author of *Communities of Imagination: Contemporary Southeast Asian Theatres* (2012) and several works of fiction.

Clare Harris is a reader in visual anthropology at the University of Oxford, the curator of Asian Collections at the Pitt Rivers Museum, and a fellow of Magdalen College Oxford. She has published extensively on Tibetan visual and material culture and was instrumental in creating "The Tibet Album," a website featuring six thousand historic photographs of Tibet. Her publications include *In the Image of Tibet* (1999) and *The Museum on the Roof of the World: Art, Politics and the Representation of Tibet* (2012).

Barbara Hartley is senior lecturer and currently program director of Asian Languages and Studies at the University of Tasmania. She is joint editor of *Girl Reading Girl in Japan* (2009) and has published extensively on women's writing in Japan and on issues of gender in Asia. Her interests include representations of China and the Asian mainland in Japanese narrative. She has recently published a discussion of Takeda Taijun's 1976 narrative, *Shanghai Firefly.*

Olivier Krischer is a postdoctoral fellow with the Australian Centre on China in the World at the Australian National University. He was formerly an assistant professor in the Department of Art and Design at the University of Tsukuba, Japan, where he completed his doctoral thesis on early twentieth-century Sino-Japanese

art relations, focusing on art historian Ōmura Seigai (2010). He was the managing editor of *ArtAsiaPacific* magazine (2011-12); and in 2011 curated After Effect at the 4A Centre for Contemporary Asian Art, Sydney.

Chihiro Minato is a photographer, writer, and curator. He is a professor in the Department of Information Design at Tama Art University, Tokyo and has held visiting fellowships at Oxford, Nantes IAS, and Paris. His publications include *The Gardens of Lévi-Strauss* (in Japanese, 2008) and *Tu n'as rien vu à Hiroshima* (2009). As the Japanese commissioner for the 2007 Venice Biennale, he curated Is There a Future for Our Past?: The Dark Face of the Light, representing artist Masao Okabe.

Masafumi Monden completed his PhD in the School of Design at the University of Technology, Sydney (2011), where he regularly collaborates as an Associate. His thesis was an interdisciplinary study analyzing the relationship between cultural globalization, gender, and fictional narratives expressed via clothing. He is currently working on the role of fashion in ballet, music videos, and films.

Fuyubi Nakamura is an anthropologist and curator with a doctorate from the University of Oxford, where she completed her thesis on contemporary Japanese calligraphy. She is currently affiliated with the Institute for Art Anthropology at Tama Art University, Tokyo and has taught at the Australian National University and the University of Tokyo. Her publications include *Ephemeral but Eternal Words: Traces of Asia* (2010) and *Traces of Time, Traces of Words* (2011), the catalogs for the exhibitions she curated in Australia and Argentina, respectively.

Morgan Perkins is an associate professor of anthropology and art, and the director of the museum studies program at the State University of New York Potsdam. He is the editor (with Howard Morphy) of *The Anthropology of Art* (2006) and has curated several exhibitions of contemporary art. Much of his current research explores the relationship between contemporary art and art education with a particular focus upon Native North American and Chinese art.

Christopher Pinney is an anthropologist and art historian. He is currently a professor of anthropology and visual culture at University College London. His research interests cover the art and visual culture of South Asia, with a particular focus on the history of photography and chromolithography in India. His publications combine contemporary ethnography with the historical archaeology of particular media and include *Camera Indica* (1997) and *The Coming of Photography in India* (2008).

Phoebe Scott has recently completed her PhD at the University of Sydney. Her thesis is titled *Forming and Reforming the Artist: Modernity, Agency and the Discourse of Art in North Vietnam, 1925–1954.*

Natalie Seiz has recently completed a PhD in the Department of Art History and Film Studies at the University of Sydney, and is assistant curator of Asian art, Art Gallery of New South Wales, Sydney. She has published reviews and articles and in 2008 was guest editor, with Leong Chan, of the *TAASA Review*'s contemporary East Asian art issue. Her research deals with contemporary women artists in Taiwan, particularly of the late 1980s and 1990s.

Phaptawan Suwannakudt is an artist. She worked extensively with traditional mural paintings and public projects in Thailand during the 1980s and 1990s before moving to Australia in 1996. She now lives and works in Sydney. Phaptawan graduated from Silpakorn University, Thailand, with a degree in English and German and also completed an MVA at Sydney College of the Arts, the University of Sydney. She has held numerous exhibitions and was selected for the 2012 Biennale of Sydney.

David Teh works in the Department of English Language and Literature, National University of Singapore, researching contemporary art and visual culture in Southeast Asia. He received his PhD in critical theory from the University of Sydney before working as an independent critic and curator in Bangkok. His curatorial projects include *Unreal Asia,* a program for the 55th International Short Film Festival, Oberhausen, Germany (2009). His publications include essays in *Third Text* (2011) and *Aan Journal* (2009).

Savanhdary Vongpoothorn is an artist based in Canberra, Australia. Since her first show in Sydney in 1992, she has participated in numerous exhibitions and artist residencies across Australia and internationally. Her works are part of important private and public collections, including the Queensland Art Gallery, Brisbane, and the National Gallery of Australia, Canberra. She holds a BA from the University of Western Sydney and an MA from the University of New South Wales, College of Fine Arts, both in visual arts.

PREFACE

All but one of the following chapters derive from papers presented at the In the Image of Asia: Moving Across and Between Locations conference held in conjunction with the Ephemeral but Eternal Words: Traces of Asia exhibition. Both events, which I organized, took place at the Australian National University in Canberra in April 2010. The original idea for such a conference in fact dates back farther, when Red Chan (now at Lingnan University, Hong Kong) and I proposed a conference panel to reconsider the role of translation from a multidisciplinary perspective. It did not materialize at that time; however, the idea formed the foundation for the conference, and in turn this publication. I appreciate her guidance in the field of translation studies.

I am greatly indebted to my former boss, Howard Morphy, director of the ANU Research School of Humanities and the Arts, for supporting these events and for writing a foreword to this book. A special note of thanks goes to Ana Dragojlovic, co-convenor of the conference, who was also pivotal in the initial shortlist of papers for this volume. We made a conscious choice to include papers by doctoral candidates and early career researchers to shed light on fresh voices in the field. Thanks also to all the presenters and participants at the conference, whose papers collectively contributed to the discussions underpinning this book.

The conference was supported by the Ian Potter Foundation and the ANU Research School of Humanities and the Arts, and was hosted by the ANU Humanities Research Centre. The exhibition was sponsored by the Japan Foundation and the Australia's National Association for the Visual Arts (NAVA)'s Janet Holmes à Court Artists' Grant, and was hosted by the ANU School of Art Gallery. I am grateful to all those institutions for financial support as well as to my former colleagues at the ANU for making these events possible, especially Leena Messina of the Humanities Research Centre and James Holland of the School of Art Gallery.

I gratefully acknowledge all the artists and institutions for generously granting permission to use the images and the NAVA Australian Artists' Grant for assisting with the publication of the color plates. The inclusion of Chris Pinney's paper was made possible thanks to the generous permission to reprint it from the Canadian

Centre for Architecture. I also thank the Association of American Anthropologists permissions and publishing departments for dealing with our request to reprint Clare Harris's paper and the Charles T. Weaver Museum of Anthropology at SUNY Potsdam for funding assistance toward covering the reprint fees. Thanks also go to the two anonymous reviewers of our original proposal for their insightful comments.

The preface is usually a collective venture by all the editors, but because of the origin of the book, I took the liberty of writing this on my own. My co-editors, Morgan Perkins and Olivier Krischer, were both speakers at the conference, and I remain grateful that they agreed to join me in this project. In particular, I must acknowledge Olivier's contribution as he eventually helped with editing and translating, as well as writing the introduction with me, instead of contributing a chapter, which would surely have made this volume even richer. The editors wish to express our sincere gratitude to all the contributors and the Bloomsbury team, especially Anna Wright, Louise Butler, and Sophie Hodgson, for their unfailing support and patience in seeing this volume through to press.

<div style="text-align: right">Fuyubi Nakamura, Tokyo</div>

FOREWORD
Howard Morphy

This is a challenging and provocative book. If one adopts a view that art speaks for itself, then any writing about art can arguably engage the reader in processes of translation and interpretation. Art history and anthropology both provide contextual information about works of art, information which becomes an adjunct to interpreting and appreciating their formal and expressive properties. Texts become part of the memories the viewer brings to the work, memories which are then carried forward to other works and subsequent viewings. In moving art across borders we become involved in a dual process of translation—exegesis on the work itself and then translating that exegesis so it can be understood by people with different cultural backgrounds. This process of translation and interpretation has become one of the contested areas of cultural theory—because it references a semiotic or language-centered perspective on artworks, because it is assumed to imply rigid boundaries, because the presence of labels threatens the white cube, or because exegesis denies the autonomy of the artwork. However, while it is true that aesthetic and expressive forms can affect the viewer whatever their own cultural background, that initial experience of the work is only the beginning of appreciating its potential and of understanding its significance to the artist who produced it. Fuller appreciation requires some movement into the frame of the artists' creativity and an understanding of their agency in the work. The chapters in this book chart the exciting and challenging course between imposing frames on art through processes of translation and leaving the works open to individual interpretation and the curatorial eye.

The danger of hegemonic Western universal curatorial tropes is that their universality is illusory; they often merely facilitate the task of the global curator, giving him or her a formula that enables art from different regions to be accommodated under the same umbrella. As the editors write in their introduction, this is enlisting [the works selected] "to contribute to the narrative of an ostensibly international art space." A decentering of art history and the deployment of curatorial categories freed from a Western-centric conception of modernity are essential to accommodate the diversity and complexity of contemporary global art practice.

Asian art provides a challenge to some of the received categories and concepts that influence the discipline of art history that for too long focused on Western art. It does so in part by making people aware of long and relatively independent trajectories of Asian art practices. A number of the writers in this volume draw attention to the explicit relationship between art and language in Asian art history. Scripts can be seen to mediate between verbal language and visual expression and emphasize the naivety of either separating art from language or reducing art to language. Where script and art are entangled in history, understanding the form of either without reference to the language that at least in part provides connections would seem to be missing the point. Understanding the relationship between art and text, between writing and art-making, is equally important in the European tradition—from illustrated medieval manuscripts to contemporary art movements in which the boundaries between graphic art, design, and fine art are constantly challenged. However, the point made is even more general: art as a way of acting in the world cannot be separated from its overall cultural context and translation, inasmuch as that is a synonym for cross-cultural and cross-temporal communication and is an essential component of art history.

The chapters in this volume acknowledge the relative autonomy of different traditions that produce meaningful and aesthetically powerful forms, as well as their capacity to speak to each other without compromising their differences of expression. They also engage with a world of individual journeying and group migration. The displacement and re-emplacement of the local occurs through the globalization of contemporary artworlds (curators and biennales occupying international sites), and also through diasporic movements that have resulted in the creation of Asian communities in places far distant from their locations of origin. The process is often one of recreating difference in a new location that in turn exists in dialogue with those who remain behind in the places of origin—maintaining connections through the channels of global systems of communication, cutting across the boundaries of nation-states, and creating difference through change. The following chapters reflect the complexity of a world that is continually being recreated by the displacement of communities, by disjunction from and reconnection to the past, and by the mobility of individual artists who cross boundaries yet remain connected and attached to identities and histories whose traces they bear. The contradictions that abound therein allow individual artists who maintain a close connection to a local tradition—emplaced or displaced—to occupy the same exhibitionary space with those who disavow the local or national, identify with a global ecumene, and, in the editors' words: "view contemporary art [as] the lingua franca of our time."

This book is exemplary in bringing together the disciplinary expertise of anthropology and art history necessary to understanding images in the context of an

increasingly global world, in which locality nevertheless remains central to cultural production and identity formation. However, in addition we have the voices of a number of artists who are strongly engaged in the process of creating images across borders. They demonstrate that art is a way of learning about the world and expressing complex thoughts and emotions, and is unsurprisingly integral to the discourse about art—though too often separated from practice. The inclusion of artists in the book enables us to engage with their agency in the context of broader cultural and historical frameworks.

INTRODUCTION: IMAGES OF ASIA ACROSS BORDERS

Fuyubi Nakamura, Olivier Krischer, and Morgan Perkins

何謂文人畫？即畫中帶有文人之性質，含有文人之趣味，不在畫中考究藝術上之功夫，必須於畫外看出許多文人之感想。此之所謂文人畫。謂，以文人作畫，必與藝術上功力欠缺節外生枝，而以畫外之物為彌補掩飾之計。殊不知畫之為物，是性靈者也。非器械者也，非單純者也。否則，直如照相器，千篇一律，人云亦云，何貴乎人邪？何重乎於藝術邪？

《文人畫之價值》陳衡恪 1922年

ลอดกิ่งลอดก้าน คือก้านคือกิ่ง ป่าย่อมเป็นป่าทั้งรกทั้งสะอาด

ป่านาดอน พิบูลโขงเจียม ป่าเพ็กสันเขา หนองบัวลุ่มภู ป่าไผ่ลาด ไหล่เขา
ลำธารบ้านมอญ ต้นน้ำลำควาน้อยทองผาญมิ แดนทอง ตอง ต้นตองกุง
ตองชาด ลำน้ำสวย น้ำสวย สวยจนลายตาเหลือง ป่าดงรัก ดงรัก ดงขงอาง
พิพ เมืองขุขันธ์ ป่าเหล่านั้นล้วนป่าดิบ ดิบ ป่าดงดิบ ดิบจนหนี ไม่พ้นจาก
ป่าฝ่าพงหลงป่า ชั่วชีวิต ชั่วระยะการเดินทาง ชั่วความคิดคำนึงของ คน

"เขี้ยวหมูป่า" ไพบูลย์ สุวรรณกูฏ ๑๕๗๐

書物は建築である。わたしたちは扉を開いて本の中に入り、柱が並ぶページをめくってゆく。本には身体がある。棚に並んだ背を眺め、字面を目で追いながら、わたしたちは読んでいる。その建物のいちばん奥、たいていは最後のページにある小さな記載から、わたしたちの旅は始まる。

港千尋『文字の母たち』二〇〇七年

How do visual and creative expressions mediate our first encounters with different cultures? Regardless of how globalized our image-world might seem, languages and scripts continue to refer to particular cultural locations. If we are unable to read them, however, written words present a purely visual encounter. Yet we are often able to recognize they *are* words, and some might perhaps be able to tell, for example, that the texts on the preceding page are in different Asian scripts.[1] As artist Savanhdary Vongpoothorn discusses in this volume, language itself also "migrates and floats from place to place, from one translation to another and across cultures." We may have seen these scripts before, in a book, on a T-shirt, on the Internet, in a film, tattooed onto someone's arm, or in artworks. Nevertheless, they remain incomprehensibly "all Greek" for many, or as the French say: "du Chinois." The situation with cultural expression beyond language is similar. Hence, changes in interpretation, between different uses and users of words, images, objects, and practices, entering different social and cultural networks and flows, brings the issue of translation—literal and metaphorical—to the forefront of contemporary cultural and intellectual practice.

How has Asia been imagined, represented, and transferred both literally and visually across linguistic, geopolitical, and cultural boundaries? This volume focuses on the role of Asian cultural translators or "long-distance cultural specialists" (Harris 2006: 699)[2]—understood here to include artists, anthropologists, historians, intellectuals, writers, and other cultural producers—whose practices have the distinctive feature of traversing different worlds. While often competent in both source and target languages of translation (literal and/or cultural), their fluency is affected by movement and by tensions between local/global, individual/social, and native/cross-cultural dynamics. Taking on the role of translators of art and expressive culture, transcultural agents are also local representatives.

Reflecting the interdisciplinary and global nature of our approach, contributors are gathered from many disciplines and locations around the world. Importantly, recognizing the value of creative art as a form of research and knowledge production, we have included chapters by three artists who share personal reflections on the transcultural experiences affecting their practices, alongside ample examples of the works they discuss. Drawing variously on accounts of modern and contemporary art, film, literature, fashion, and performance, each chapter examines the shifting roles of those who produce, critique, and translate creative cultural forms and practices, for which distinctions of geography, ethnicity, tradition, and modernity have become fluid.

CULTURAL TRANSLATION: DISCOURSE, MATERIALITY, PRACTICE, AND PROCESS

> It could be argued that "translating" an alien form of life, another culture, is not always done best through the representational discourse of ethnography, that under certain conditions a dramatic performance, the execution of a dance, or the playing of a piece of music might be more apt. These would all be productions of the original and not mere interpretations: transformed instances of the original, not authoritative textual representations.
>
> (Asad 1986: 159)

The notion of cultural translation has been taken up by various disciplines (see Rubel and Rosman 2003) and has been the theme of several international conferences in recent years.[3] Nonetheless, the power of materialized or visualized language—which remains as strong as that of images (Mizumura 2003)—has largely been overlooked in scholarly texts on "cultural translation." However, it is important to note that the material and visual presence of written language has historically played an important role in many Asian cultures.[4] At times, the artwork even "appears to be asking as if language is the most fundamental marker of culture" (Harris, this volume). In her installation *Floating Words,* Savanhdary Vongpoothorn presents words that can be literally felt through the tactile materiality of Braille sheets. Vongpoothorn demonstrates how images and texts are not only for the sighted, exploring through her work experiences of knowledge and culture of which sight need not be a part. Photographer Chihiro Minato's admiration for those Orientalists at the Imprimerie Nationale in Paris who somehow formed their own understanding of Asian languages by *touching* and handling their typefaces demonstrates another kind of relationship with text and translation (Minato 2007).[5]

Rather than acknowledging the material and visual as a reaction against the dominance of linguistic approaches (see Chartier 1995; Phillips 2010),[6] it is necessary to relate all these aspects to our basic understanding and assumptions. Michael O'Hanlon has argued against the tendency to read images for their meanings in a semantic sense, proposing that "aesthetic systems may differ empirically in the degree to which they are language-like and thus in the extent to which linguistic models are helpful in understanding them" (1995: 470). Only a holistic approach might allow us to appreciate how certain cultural products or expressions can be, for example, local yet transcultural at the same time, such as the presence of visual languages as we saw at the beginning of this introduction. Just as important is that which gets lost or excluded in the process of cultural translation, as well as the knowledge that there

always remain things that cannot be translated (see Apter 2007; Benjamin 1969). In some cases, culture can intentionally resist interpretation because of secrecy or forms of restricted knowledge (see Morphy 1992). Even art produced by someone from one's own culture will always have elements—meanings, stylistic choices, and so on—that are not readily communicated to the viewer and this is only made more complex cross-culturally. Such processes describe the space in which we exist, and know only change not conclusion; as James Clifford says, "[t]here is only more translation" (1997: 13).

ART, LOCATION, AND TRAVEL

Despite the increasing movement of people and objects in the world, location remains an important factor in identifying and interpreting images. Location is not only a referential point but also the physical place where action and experience take place (see Bhaba 1994; Cherry and Cullen 2006; Harris 2006), and hence can be "an itinerary rather than a bounded site—a series of encounters and translations" (Clifford 1997: 11).

The five chapters in "Art, Location, and Travel" frame the locations and directions of movement within the context of art production and reception. The analysis of movement within and among art discourses is followed by case studies of artists from a range of Asian cultures who engage with artistic discourses and practices both at home and abroad, past and present. In so doing, their experiences reveal the contextualized nature of the various art systems and their impact on representations of Asia in local and global frameworks. These historical perspectives are necessary to reveal how contemporary artists and cultural producers position their work within ongoing traditions.

At the outset, John Clark asks what it means for Asian cultural producers—in this case artists—to move and what they move between. Clark notably includes cases of both mobility and motility, that is, not simply physical movement, but also the potential to imaginatively traverse cultural distances through artistic activity. Clare Harris explores the effects of distance from the physical locus of cultural identity through the complex case of Tibetan contemporary art and one of its major proponents—London-based émigré artist Gonkar Gyatso. Harris's study traverses issues of the location of identity in situations of migration, diaspora, and stateless nations and in the face of cultural stereotypes reinforced inside and outside the community.

Phoebe Scott's example of the discourse of cultural production in mid-twentieth-century Hanoi illustrates how a traditional past and colonial present were translated

locally to envision a nationalized future. Significantly, Scott considers the way Vietnamese artists dealt with the aesthetic regimes of both the French and Japanese colonial administrations, and the historical legacy of Sinic culture, in their endeavors to redefine a locally viable Asian aesthetic. Indeed, the return to or rediscovery of one's home culture can be just as or even more significant than the experience of distance from it. Natalie Seiz traces the contemporary experience of "re-entry" in the case of Taiwanese artist Hou Shur-tzy, after studying and practicing abroad. Seiz rejects considering Hou as "in between," arguing that the artist's hybridity is no less authentic than the well-defined cultural positions it traverses and renegotiates. On the other hand, Morgan Perkins examines the contemporary reaffirmation of traditional identifiers in the practice of Chinese ink painting through ongoing discussion with painter Lin Haizhong. Perkins examines Lin's reasons for practicing art, as well as the tensions between the artist and the changing environment in which his practice is consciously situated—engaging tradition to confront societal malaise, urban change, and the perceived hegemony of contemporary "global" aesthetics.

Since many Asian cultures possess highly developed artistic traditions of their own, such production was until recently considered a matter for art historians rather than anthropologists. However, the recognition of forms and practices as art within various Asian cultures may also be a source of misinterpretation—subtleties being invisible by virtue of apparent similarities. A number of scholarly works have questioned classifications such as fine art, folk art, primitive art, or popular art, yet they have still done so largely by adopting how these categories are understood in Euro-American discourse. At stake are measures of value, which consider art superior, as belonging to a higher level of cultural production, but this is not necessarily the case in many Asian contexts.[7]

Research into the history of art has also been slow in recognizing modern and contemporary Asian arts on their own terms rather than as poor reflections of Western art, despite groundbreaking work in English by scholars such as Michael Sullivan, Partha Mitter, and John Clark. In some respects, these scholars have reconnected to and developed earlier, overshadowed native art histories. Already in 1959, art historian and longtime editor of *Artibus Asiae* Alexander Soper noted: "One of the most remarkable achievements in the study of Chinese art lies hidden, and for most Western readers inaccessible, behind the Japanese text of Ōmura Seigai's history of Chinese sculpture" (1959: xi). In fact, Ōmura's *History of Chinese Art–Sculpture Edition* (1915) was cited by his European contemporaries such as Osvald Sirén—on the very first page of Sirén's multivolume *Chinese Sculpture from the Fifth to the Fourteenth Century* (1925).

Similarly, Sullivan's groundbreaking *Chinese Art in the Twentieth Century,* also written in 1959, referenced Chinese art histories such as Zheng Wuchang's popular

1929 work, *A Complete History of Chinese Painting Studies,* among others, establishing the field of modern Chinese art history in English, to which Sullivan has contributed for over five decades. Mitter's work on Indian art has taken a different path as his first major work dealt with European reactions to Indian art (1977), and he introduces modern and contemporary Indian art (2007) from an insider's perspective. Clark's *Modernity in Asian Art* (1993), edited exactly two decades prior to this volume, provided a comparative outline of a broader field, assembling papers by scholars from across Asia, forcefully arguing that modernity is an experience in which the past is relativized as tradition and need not be articulated in any particular aesthetic practice.[8] Similarly, Mrázek and Pitelka (2007) argue that while Asian visual and material culture must be appreciated in its context, contextualization is only one of the many factors through which it can be understood. This volume looks beyond these foundations in the anthropology and history of art to engage the reader with the complexities of current approaches to art, agency, and material culture.[9]

Artists' Voices: The Artist as Translator

"If the language I used failed to deliver, was I to appropriate another that talked to others even though it did not talk to me? How would a universal language work when the spaces in which we dwell are not synchronized?"

(Suwannakudt, this volume).

None of the research underpinning this volume would be possible without the practices of artists or cultural producers themselves, and this section acknowledges the importance of presenting their unmediated voices. Each of the contributors— Phaptawan Suwannakudt, Savanhdary Vongpoothorn, and Chihiro Minato— participated in the Ephemeral but Eternal Words: Traces of Asia exhibition in Canberra in 2010, curated by Fuyubi Nakamura. Born in Asia, these artists have all moved between or across different countries, and their work engages with issues of location, movement, and cultural identity. Their chapters discuss a particular concern with the meanings and locations of Asian languages, words, and writing. Their works also demonstrate the potential for ostensibly visual languages to simultaneously engage multiple senses, including touch, sound, and smell.

Buddhist imagery and narratives have been ongoing references in the work of Phaptawan Suwannakudt, who grew up in Buddhist temples in Thailand, where she was trained in mural painting by her late father, renowned artist Paiboon Suwannakudt. This legacy, however, had no audience when she moved to Australia in 1996. Suwannakudt reflects upon her experience of moving between different traditions

and countries and how she has struggled to deal with the issue of identity through her work. Savanhdary Vongpoothorn also migrated to Australia, though in her case as an eight-year-old child. Through her art practice, she has reconnected to the country of her birth, Laos. Vongpoothorn uses the technique of perforation to refer to the practice of weaving, and often combines words and passages from Theravada Buddhism or Lao spiritual traditions with motifs and symbols from Lao textiles. These references stem from her experience of "growing up, living and breathing in Lao cultural, familial and religious worlds, both in Laos and Australia."

Chihiro Minato's work as a photographer began while he was exploring Latin America during his undergraduate years in the early 1980s. His work has since been informed by constant travels and sojourns around the world. For him, the camera has been a tool of discovery and reflection. Drawing on his recent projects, which resulted in a book (*Mothers of Letters,* 2007) and an exhibition (*Typologic,* 2009 and 2012), Minato traces the legacy of movable Japanese types and the trajectory of "travelling typography" by examining the interaction between word-character and image in a digital era (see also Minato 2010). He argues that each era's typography, producing in turn the characters we use, is created by the interaction between the intellect and the senses, a combination of knowing and feeling.

Some might assume that anthropologists study culture while artists actively create it, yet artists and anthropologists are both creative practitioners whose work involves appropriating from and representing others (Schneider and Wright 2006). An increasing number of contemporary artists adopt ethnographic or anthropological approaches in their work, which might blur the classical division of such fields of knowledge production (Foster 1996; Schneider and Wright 2010). For example, Taiwanese artist Hou Shur-tzy, discussed by Seiz in this volume, undertook fieldwork to interview and photograph the Vietnamese brides of local men in farming villages in southern Taiwan. However, Susan Hiller—herself an anthropologist turned artist—has said the work of artists is distinct. They learn from their culture in the process of modifying it. "The artist, like everyone else, is an insider. Artists' work depicts biographically-determined social conditioning … [It] does not allow discontinuities between experience and reality, and it eliminates any gap between the investigator and the object or situation investigated' (1996: 23–24).[10]

Artists of non-Western origins in particular are often expected to represent or at least reference the cultures of their birthplace to be recognized in the global art world (Suwannakudt, Harris). In an international context—where Euro-American standards and historical experience are still commonly passed off, unremarked, as universally applicable—abstract painting by East Asian artists, for example, is often read through its assumed calligraphic traditions, when it is recognized at all. Neither are such stereotypes necessarily imposed from outside. In his discussion of intracultural

references through subtitling in recent Thai video artworks, David Teh (this volume) argues that "in art … 'the region' is a bureaucratic construct; curators and historians entertain it, but few artists have much need for it." Artists or producers who intend to introduce their cultures to an international audience assume a role similar to that of so-called native anthropologists (see Kuwayama 2003). However, their respective practices and receptions have been rather different, not only because of the different representational modes of their works, but also because anthropologists, it has been assumed, require distance from the cultures they research, even their own.

The expectation for contemporary art to be international and new has meant increasing numbers of works and artists are introduced and circulated far from their cultural origins. This process of discovery is disconcertingly similar to the work of an earlier generation of anthropologists, as well as to the identification of a readymade avant-garde by modern artists in the aesthetics of "primitive" art. In this context, curators today have become among the key translators of cultural products and those who produce them—even while they may lack an intimate knowledge of the cultures they represent through art, either through the demands of a peripatetic schedule or disinterest in the local contingency (temporal and geographic) of these potentially international works. In some respects, like enlightened cartographers, curators face the expectation of constantly adding to the known (in this case, contemporary art) world.

Moreover, while most corners of the globe have become more physically and digitally accessible, in many cases the self-appointed cultural centers still see only the otherness that is closest at hand—foreign artists studying or completing residencies in New York or London, or featured in a major biennale, for example, who will be enlisted to contribute to the narrative of an ostensibly international art space. The fact that such international spaces or cities remain overwhelmingly Anglophone should raise questions as to the real implications of non-English-speaking artists moving through them (Clark, Harris). Particularly in the realm of cultural practices, the very notion of *international* constitutes rather different things when uttered in languages other than English—sometimes it is an adjective of scale and aspiration, which says little about the event or individual's make-up.[11] On the other hand, nowadays we need to also consider the growing role of artist-curators, as well as the rise of indigenous curators, as examples of some who can have an intimate knowledge, and how their work affects our practices.

IMAGE, REPRESENTATION, AND PERFORMANCE

The relationship between visual and textual production is a notable feature of many Asian artistic traditions. "Image, Representation, and Performance" explores how

gaps, slippages, and intersections between a thing and its representation lead not only to misunderstanding but also to opportunities for cultural producers to question and renegotiate accepted meanings. Christopher Pinney's study of popular photographic practices in India reminds us of the ethical implications of viewing and imaging. Unlike the colonial image's affirmation of a single, certain truth image as assumed knowledge, Pinney notes how the postcolonial images he discusses rejoice in the same apparatus's ability to deceive or idealize, to render multiple ways of seeing the world equally viable. Turning to literary imagery, Barbara Hartley analyzes how writer Takeda Taijun elided confronting the actual experience of Japanese wartime service in China, through "translated" images of the west Hunan countryside appropriated, quoted, and translated from the evocative recollections of his Chinese contemporary, Shen Congwen. While concerned with the actual act of translation and the forging of new memories, Takeda projects himself into an other's locale, such that his attempted atonement ultimately reaffirms his fraught position.

David Teh discusses the subversive use of subtitles in recent Thai video art, which are not necessarily translations of an original text for a literate audience, but rather function as an integral part of a single work, and may evade meaning. He contends that elements of animism, feudalism, and even so-called primitive notions, foreign to Euro-American rationalism, remain embedded in social and political realities of contemporary Asia, "in ways that defy the binary logic of 'modern' and 'traditional,' and disarm the teleological assumptions of developmentalism." Meanwhile, Masafumi Monden's analysis of *Lolita* fashion, as a Japanese subculture turned globally intelligible youth style, is a fitting case of how forms and practices are translated and entangled in global flows of culture. Teh and Monden's case studies question the tropes through which cultural products, from media art practices to sartorial style, can be creatively adopted or appropriated when border crossing.

While stereotypes are assigned from outside the region to grasp Asia as other, Asian cultural producers themselves have made many attempts to self-determine a pan-Asian identity. This volume, however, consistently evades suggesting a stable regional unity, exploring instead the historical faultiness of Asia as a discourse. Aptly rounding out this section, Catherine Diamond gives a passionate account of recent intercultural collaborations in the performing arts within "the so-called region." She demonstrates the practical impossibility of the concept of *an* Asian identity (or indeed other such regional identifications), if only because of the sheer diversity of cultural and historical experiences—national, individual, communal—despite shared issues and no lack of good intentions.

Communities that form around cultural practices today are, voluntarily or not, amplified in real time through ever more pervasive modes of networked communication. While not historically unique, these processes are more actually global and

simultaneous—the effect being that we know more about each other than at any point in history. Particularly for those privileged to commute across international spaces, cultural representation may no longer be at issue, because forms such as contemporary art serve as the lingua franca of our time. Similar claims or aspirations have accompanied the development of the Internet and its related digitally networked practices (see Miller 2001). This seems to assume that simultaneity magically homogenizes experience. We must bear in mind that, historically, universal or pan-communal claims to identity have just as often stemmed from acts of colonization (cultural, territorial, economic) as from genuinely utopian endeavors. Moreover, religious and political examples of the latter just as often culminate in authoritarian if not totalitarian visions. In practice, as these chapters explore, myriad communities of identity (and the individuals within them no less) continue to proudly or playfully reserve the right to difference.

CONCLUSION: DIFFERENT VOICES AND TRANSLATIONS

How many readers will understand what is written in the texts at the beginning of this introduction? And of those, how many might be able to read a second or third? These texts are a reminder that what is available in English is only a fraction of what is written about Asia, and that only a fraction of what Asian writers produce will ever be available in English, or indeed other European languages. In other words, they reinforce the importance of acts of translation and those who undertake them. Yet, we must also be aware that what gets translated—both from and into English—is always subject to a process of selection and that such decisions are political, with a very real effect on knowledge production (see Chan 2007). The same might be said for those cultural practices that will or will not move to and from "international" sites.

Many academics and researchers now regularly travel domestically and internationally, and have lived, studying or working, in a variety of cultures; and all these movements necessarily affect our practice. In this respect, most of the authors here are also part of the subject of this volume. Hence these texts also remind us that what we—those familiar with Euro-American scholarship—assume to be scholarly writing in English might not always adequately translate, represent, or indeed *understand* the cultures, images, texts, voices, or experiences of others, who have distinguished traditions in their own languages (written or otherwise), on their own terms. Asia is home to many communities that boast exceptionally long and rich literate cultures,

compared to parts of the world where oral or visual traditions predominate. By shedding light on this aspect of Asian cultures, rather than downplaying the importance of nonliterate expressions, we seek to highlight connections between modes of cultural expression that are typically isolated, in research, from one another—such as linguistic, oral, visual, material, and performative practices.

Voicing such concerns and including various styles is meant to evoke "multiple and uneven practices of research, making visible the borders of academic work" (Clifford 1997: 12). This means being aware of the power relationships inherent within the production and dissemination of knowledge in English (see Asad 1986; Mizumura 2008). Scholarly texts in Asian languages are still often consulted as local sources of information or objects of study (textual specimens), rather than as legitimate discursive publications on an equal footing with those published in English. To counter that such texts may not function as their Anglophone theoretical counterparts do only highlights the limitations of theory itself and reinforces the need to refresh our knowledge and experience of cultural producers and their works. While this may be done as the respectful acknowledgment of equivalence and particularity, rather than the modern avant-garde's search for cultural primitives and exotic others, it still underlines a phenomenon common to all cultural productions from Asia, not simply textual. The dominance of mainstream Anglophone scholarship in fact often compels cultural producers (including the authors and artists here) working in nominally globalized spaces to write, speak, or produce expressive forms only in certain styles or discourses considered appropriate to the international community (see Teh, this volume; Mathews 2010; Schneider and Wright 2006). Choosing not to do so can leave one invisible to that system—which for some artists becomes a strategy to exploit in their turn.

The implications for creative practices generally are significant. But so is the potential of such practices to operate on levels of significance that language is always groping toward, but may never reach. While the experience of textual translation is instructive, the diversity of practices gathered here makes clear the extent to which acts of cultural translation confront distinct challenges, despite their similarities. In certain instances, art or other creative forms of expression can be a more effective cultural transmitter than scholarship. Academics can also be more open to diverse modes of representing their work and to dealing with visual or aural materials not merely as illustrations, but rather as of equal importance to written texts. Do we need translators, such as artists or cultural producers, or can creative forms of expression speak for themselves? (see Spivak 1988). The Asian texts shown earlier—each related to certain themes in this book—embody such challenge and possibility.

NOTES

1. The text in literary Chinese (top left) is the beginning of Chen Shizeng's (a.k.a Chen Hengke) essay "*Wenrenhua zhi jiazhi*" (1922), which he in fact "translated" from his 1921 vernacular, modern Chinese original. The Japanese text (top right) is from Chihiro Minato's *Moji no Hahatachi* (2007: 8). The Thai text (bottom) is from Paiboon Suwannakudt's short story "Khiew Moo Pa" in *Ganyayon Narlin* (a well-known short story series published during the 1970s in Thailand). See reference section for English titles.
2. Following the idea of "long-distance specialists" (Helms 1988 quoted in Clifford 1997: 18).
3. For instance, "Where We Meet—Cultural Translation and Art in Social Transformation" at Werkstatt der Kulturen, Germany, June 2012; "Cultural Translation and East Asia: Film, Literature and Art" at Bangor University, UK, September 2012. See Buden and Nowotny (2009), Mersmann and Schneider (2009), Naganuma (2010), and Clark's chapter in this volume for a list of publications in this field.
4. For instance, the importance of calligraphy is noted in East Asian and Islamic societies (see George 2010; Murck and Fong 1991; Yen 2005). On the works by the artists in this volume, see Nakamura (2010).
5. Schneider and Wright discuss Anselm Kiefer's bookwork *Cauterization of the District of Bunchen* (1974) made of iron oxide and linseed as an example that "invokes the tactility of vision" and involves "affective intensities" (2006: 4–5). See also Minato on Kiefer's work (2012: 193–195).
6. A report on the "Materiality and Cultural Translation: An Interdisciplinary Exploration" conference held at Harvard University, May 3–4, 2010 by Ruth Phillips and Aaron Glass: http://blogs.nyu.edu/projects/materialworld/2010/07/report_on_materiality_and_cult.html. Accessed July 3, 2012.
7. For instance, see Moeran 1997, Taylor 2009, Harris (this volume), and Pinney (this volume). Asian art history texts have generally focused on the fine art qualities of Asian visual and material culture. See, for instance, Clark 1998 and Desai 2007.
8. Clark's *Modernity in Asian Art* (1993) is also derived from the conference held in 1991, at the same venue as the one on which the current volume is based—the Australian National University's Humanities Research Centre. The geopolitical location and demographical changes of Australia itself perhaps need to be taken into account when evaluating the development of academic research on Asia, especially of modern and contemporary Asian art and visual culture.
9. For instance, see Coote and Shelton 1994, Gell 1998, Marcus and Myers 1995, Morphy and Perkins 2006, Phillips and Steiner 1999, Thomas and Pinney 2001, and Westermann 2005.
10. This paper was originally presented at the Institute of Social and Cultural Anthropology at the University of Oxford, May 6, 1977.

11. See, for example, Ito (1990) on the term *kokusaika,* a Japanese word for internationalization, which was an important catchword from the 1960s to the 1990s. Nowadays, exhibitions and conferences, for example, in Japan, China, and other Asian countries commonly have the word *international* added to their titles despite being overwhelmingly filled by local or regional participants.

REFERENCES

Apter, E. (2007), "Untranslatable? The 'Reading' versus the 'Looking,'" *Journal of Visual Culture,* 6 (1): 149–156.

Asad, T. (1986), "The Concept of Cultural Translation in British Social Anthropology," in J. Clifford and G. E. Marcus (eds.), *Writing Culture: The Poetics and Politics of Ethnography,* Berkeley: University of California Press.

Benjamin, W. (1969 [1923]), "The Task of the Translator," trans. Harry Zohn, in H. Arendt (ed.), *Illuminations,* New York: Schocken Books.

Bhaba, H. K. (1994), *The Location of Cultures,* New York: Routledge.

Buden, B. and Nowotny, S. (2009), "Cultural Translation: An Introduction to the Problem," *Translation Studies,* 2 (2): 196–219.

Chan, R. (2007), "One Nation, Two Translations: China's Censorship of Hilary's Memoir," in M. Salama-Carr, (ed.), *Translating and Interpreting Conflict.* Amsterdam and New York: Rodopi.

Chartier, R. (1995), *Forms and Meanings: Text, Performance, and Audiences from Codex to Computer,* Philadelphia: University of Pennsylvania Press.

Chen, S. (1922), "Wenrenhua zhi jiazhi (The Value of Literati Painting)," in *Zhongguo wenrenhua zhi yanjiu (Chinese Literati Painting Studies)*, Shanghai: Zhonghua Shuju.

Cherry, D. and Cullen, F. (2006), "On Location," *Art History,* 29 (4): 533–539.

Clark, J. (ed.) (1993), *Modernity in Asian Art,* Sydney: Wild Peony.

Clark, J. (1998), *Modern Asian Art,* Honolulu: University of Hawaiʻi Press.

Clifford, J. (1997), *Routes: Travel and Translation in the Late Twentieth Century.* Cambridge, MA and London: Harvard University Press.

Coote, J. and Shelton, A. (eds.). (1994), *Anthropology, Art and Aesthetics,* Oxford: Clarendon Press.

Desai, V. N. (ed.). (2007), *Asian Art History in the Twenty-First Century,* Williamstown, MA: Sterling and Francine Clark Art Institute.

Foster, H. (1996), "The Artist as Ethnographer," in *The Return of the Real.* Cambridge, MA: MIT Press.

Gell, A. (1998), *Art and Agency: An Anthropological Theory,* Oxford: Oxford University Press.

George, K. (2010), *Picturing Islam: Art and Ethics in a Muslim Lifeworld,* Oxford: Wiley-Blackwell.

Harris, C. (2006), "The Buddha Goes Global: Some Thoughts towards a Transnational Art History," *Art History,* 29 (4): 698–720.

Helms, M. (1988), *Ulysses' Sail: An Ethnographic Odyssey of Power, Knowledge, and Geographical Distance,* Princeton, NJ: Princeton University Press.

Hiller, S. (1996), "Art and Anthropology/?Anthropology and Art" (1977) in the "Inside All Activities: The Artist as Anthropologist" section in B. Einzig, (ed.), *Thinking about Art: Conversations with Susan Hiller.* Manchester and New York: Manchester University Press.

Ito, A. (1990), "Nihon ni okeru kokusaika shisō to sono keifu (The ideology and genealogy of internationalization in Japan)," in A. Sawada and A. Kadowaki (eds.) *Nihonjin no Kokusaika: "Chikyū Shimin" no Jōken o Saguru (The Internationalization of the Japanese: Exploring the Criteria of "Global Citizen"),* Tokyo: Nihon Keizai Shimbunsha.

Kuwayama, T. (2003), "'Natives' as Dialogic Partners: Some Thoughts on Native Anthropology," *Anthropology Today,* 19 (1): 8–13.

Marcus, G. and Myers, F. (eds.). (1995), *The Traffic in Culture: Refiguring Art and Anthropology,* Berkeley: University of California Press.

Mathews, G. (2010), "On the Referee System as a Barrier to Global Anthropology," *The Asia Pacific Journal of Anthropology,* 11(1): 52–63.

Mersmann, B. and Schneider, A. (eds.) (2009), *Transmission Image: Visual Translation and Cultural Agency.* Newcastle upon Tyne: Cambridge Scholars Publishing.

Miller, D. (2001), "The Fame of Trinis: Websites as Traps," in C. Pinney and N. Thomas (eds.), *Beyond Aesthetics: Art and the Technologies of Enchantment,* Oxford: Berg.

Minato, C. (2007), *Moji no hahatachi (Mothers of Letters): Le Voyage Typographique,* Tokyo: Inscript.

Minato, C. (2010), *Shomotsu no hen: Gūguruberugu no jidai (The Transformation of Books: Googleberg Age),* Tokyo: Serica Shobō.

Minato, C. (2012), *Geijutsu kaikiron: Imēji wa sekai wo tsunagu (The Return to Art: Images Connect the World),* Tokyo: Heibonsha.

Mitter, P. (1977), *Much Maligned Monsters: History of European Reactions to Indian Art.* Oxford: Clarendon Press.

Mitter, P. (2007), *The Triumph of Modernism: India's Artists and the Avant-Garde 1922–1947,* London: Reaktion Books and Chicago, IL: Chicago University Press.

Mizumura, M. (2003), *On Translation,* a revised paper of the talk presented at the International Writing Program, Iowa University. http://mizumuraminae.com/eng/talks.html. Accessed July 30, 2012.

Mizumura, M. (2008), *Nihongo ga Horobiru Toki–Eigo no Seiki no Naka de (The Fall of the Japanese Language in the Age of English),* Tokyo: Chikuma Shobo.

Moeran, B. (1997), *Folk Art Potters of Japan: Beyond an Anthropology of Aesthetics,* Surrey: Curzon.

Morphy, H. (1992), *Ancestral Connections: Art and an Aboriginal System of Knowledge,* Chicago, IL: University of Chicago Press.

Morphy, H. and Perkins, M. (eds.) (2006), *The Anthropology of Art: A Reader,* Oxford: Wiley-Blackwell.

Mrázek, J. and Pitelka, M. (eds.) (2007), *What's the Use of Art: Asian Visual and Material Culture in Context,* Honolulu: University of Hawai'i Press.

Murck, A. and Fong, W. (eds.) (1991), *Words and Images: Chinese Poetry, Calligraphy and Painting,* Princeton, NJ: Princeton University Press.

Naganuma, M. (2010), "Nihon ni okeru 'honyaku' no tanjō (The Birth of 'Translation' in the Japanese Context)," *Honyaku kenkyū eno shōtai* (*The Invitation to Translation Studies*), 4: 1–18.

Nakamura, F. (ed.) (2010), *Ephemeral but Eternal Words: Traces of Asia,* Canberra: The ANU School of Art Gallery.

O'Hanlon, M. (1995), "Modernity and the 'Graphicalization' of Meaning: New Guinea Highland Shield Design in Historical Perspective," *Journal of the Royal Anthropological Institute,* 1 (3): 469–493.

Ōmura, S. (1915), *Shina bijutsu shi chōso hen* (*History of Chinese Art—Sculpture Edition*), Tokyo: Butsuzō kankōkai zuzōbu.

Phillips, R. B. (2010), "'Dispel all Darkness': Material Translations and Cross-Cultural Communication in Seventeenth-Century North America," *Art in Translation,* 2 (2): 171–200.

Phillips, R. B. and Steiner, C. (eds.) (1999), *Unpacking Culture: Art and Commodity in Colonial and Postcolonial Worlds,* Berkeley: University of California Press.

Rubel, P. and Rosman, A. (eds.) (2003). *Translating Cultures: Perspectives on Translation and Anthropology,* Oxford and New York: Berg.

Schneider, A. and Wright, C. (eds.) (2006), *Contemporary Art and Anthropology,* Oxford: Berg.

Schneider, A. and Wright, C. (eds.) (2010), *Between Art and Anthropology: Contemporary Ethnographic Practice,* Oxford: Berg.

Sirén, O. (1925), *Chinese Sculpture from the Fifth to the Fourteenth Century,* London: Ernest Benn, Limited.

Soper, A. (1959), "Literary Evidence for Early Buddhist Art in China," *Artibus Asiae— Supplementum,* 19: xi.

Spivak, G. (1988), "Can the Subaltern Speak?" in C. Nelson and L. Grossberg (eds.), *Marxism and the Interpretation of Culture,* Urbana and Chicago: University of Illinois Press.

Sullivan, M. (1959), *Chinese Art in the Twentieth Century.* London: Faber.

Suwannakudt, P. (1970), "Khiew Moo Pa (Wild Boar Tusk)," in R. Wongsawan et al. *Ganyayon Nalin* (*Knowledge,* September Issue), Bangkok: Fuengnakorn Publishing.

Taylor, N. A. (2009), *Painters in Hanoi: An Ethnography of Vietnamese Art,* Honolulu: University of Hawai'i Press.

Thomas, N. and Pinney, C. (eds.) (2001), *Beyond Aesthetics: Art and the Technologies of Enchantment,* Oxford and New York: Berg.

Westermann, M. (ed.) (2005), *Anthropologies of Art,* New Haven, CT: Yale University Press.

Yen, Y.-P. (2005), *Calligraphy and Power in Contemporary Chinese Society,* Abington, Oxon: RoutledgeCurzon.

Zheng Wuchang (1929), *Zhongguo huaxue quanshi* (*A Complete History of Chinese Painting Studies*), Shanghai: Zhonghua Books.

PART I

ART, LOCATION, AND TRAVEL

1 ASIAN ARTISTS AS LONG-DISTANCE CULTURAL SPECIALISTS IN THE FORMATION OF MODERNITIES

John Clark

MOVEMENT AND MODERN ASIAN ARTISTS

What does it mean for modern Asian artists to move, and what do they move between? Before the institution of the modern art school in many parts of Asia in the 1850s–1880s,[1] and later in the 1920s–1940s, we may think of artistic residence or placed-ness as definable by the location of a workshop, its head, its singular patrons, and its market. By the mid- to late nineteenth century, the increasing art school certification and middle-class professionalization of artists meant they could, to some extent, move away from particular locations because their work, its reputation, and/ or its selling possibilities were now located in a far more diffuse and regulated discourse within a whole spectrum of activity and a culture or set of cultures modeled by the modern state. In this chapter, I would like to take up first the implications of movement itself by artists, works, or their viewers for definitions of modernity.[2]

There may historically have been two kinds of continuity we could call "Modern Asian" in art without postulating the kinds of historical coherence found in Europe. One is the reaction to European salon realism as a set of styles that founded the notion of art as much as a range of visual practices called "realism" seen across graphics and photography. They were accompanied by new teaching and reception institutions. This first complex arose in many Asian contexts at the same time as the domination of late Euramerican colonialism from the early nineteenth century, or in the semi-colonial context of China and the un-colonized contexts of Siam and Japan. The result was a transfer of academy styles, or in some cases the reactive

appropriation of them in part or in whole. These transfers and appropriations were in common between many Asian contexts, but only rarely causally interlinked. Their contingency was in many cases local, with the possible early exception of China-trade painting for the Euramerican market.

The second continuity that has begun to show some as yet incomplete signs of Asian interlinkage began with the transfer of conceptual and installation art concepts to local Asian contexts in the 1980s and 1990s, and was at least partially the cause of changes elsewhere in Asia. Contemporary developments in mass visual narrative forms were also causative between Asian contexts, particularly in the flow of Japanese animation to Korea and China, or Korean soap operas to Japan and widely elsewhere, in the region and the world. The extent to which these were picked up by artists such as Murakami Takashi, Nara Yoshitomo, or Tabaimo in Japan and then used as models by artists elsewhere is not very clear. But certainly examples of artists following if not fully appropriating their work can for instance be found in Malaysia, Indonesia, and the Philippines. By the 1990s there were moreover different institutional functionalities in operation throughout all Asian art worlds. Principally there was more inter-Asian circulation of artworks through biennales increasingly held for local purposes across Asia, but these were generally aimed at specialist local publics and mediated by itinerant overseas curators. The intercausality between say, some Chinese critical pop and other kinds of "pop" critique did not seem to mark any profound interrelation between parts of Asia, nor one that amounted to a marked regional and "Asian" identity for a contemporary art. However, simple and mostly unacknowledged borrowing from the mannerisms and subjects of other Asian rather than Euramerican peers also took place.

MOVEMENT BETWEEN DISCOURSES

We may also ask what it is about art discourses themselves that makes movement possible or necessary between them. The reason may be because artworks *can* be carried over long distances both between and within cultures and areas as a mode of representation or expression; they can adopt variant meanings between art discourses in a way that is not directly possible for translated texts. This meaning may be performative, which allows for multiple interpretations through the changes they operate on existing discursive systems—that is, at the level of discourses themselves. Into this kind of work fit, I think, the many Chinese performative works in the second half of the 1990s that used disgustingly material flesh, because the shock of a visual representation (e.g., photographic documentation), say, of a dead fetus being cooked and eaten—by artist Zhu Yu—occurs to the whole of the discursive system of art. It

questions the limit of what may be represented in art, not merely the moral limit for notions of humanity or of humanistic intent artworks purportedly carry.

Why should movement take place at long distances between discourses? This distance can be conceived of physically from, say, Tokyo to Paris, or discursially,[3] say, from a stylistic position like realism to an abstract redistribution of randomly redeployed images from vernacular or folk tastes. Indeed distance exists not only between the outside and inside of a discourse, but between positions within a discourse as much as across discourses. The presumption of internality or externality, what I have elsewhere seen as the exogenous and the endogenous (see Clark 2010a), is almost automatically engendered by the parallel notion of specialist and non-specialist, or professional and amateur. The former travel for study, the latter for social companionship, but frequently the roles overlap.

Thus in one sense the artist becomes a kind of technical specialist who carries knowledge of a local visual discourse into that of an "other," and then back into the new virtual, imagined space of a synthetic visual discourse outside the original one, or actually back into the original visual and more specifically art discourse from which he or she had emerged. The art discourse to which movement takes place is relativized by the movement of the incoming artist—its values now exist in relation to those of other systems. Often the fact that it is being relativized is not apparent to the culture moved to because a kind of hegemony in practices and codes of production is presumed. It is when the artist moves into an imaginary third and virtual space between visual cultures or back into the originating one that loss of hegemony (i.e., relativization) in the originating visual culture is recognized. This means the values of art discourse, and often much of the technical apparatus for visualization in artworks, are no longer sovereign, or not determinative for the production and distribution of the visual artworks. The artist moves like a kind of storyteller who learns to tell many stories in ways that the other discourses through which he or she moves can learn to decode, interpret, and understand and have their hierarchies of value changed. They also thereby create an interstitial space for hybrid visual discourses between particular cultures.

There are thus three spaces of visual relativization, not two: overseas, while abroad, and at home. If we ask what home means for an artist, we might understand this better as a site of discursial stability from which it becomes possible to vary or experiment with a discursive pattern, rather than simply a kind of conservative, relatively closed denial of variation. Indeed when we consider that many artists have moved away only to return home, and the art discourse that was instinctively and continuously referred to by them was that which they had left, not the overseas systems in which they sojourned, one may ask in what significant ways such artists actually left their home discourse at all. Those working in contemporary art often find they are talking

in Chinese or Japanese in New York or Paris, with an artist who has never *completely* mastered the local language and who in many cases has a primary market at home. So we should not presume that residence overseas is the same kind of experience for all artists and that on return they function like a bi-mensal (two-faced) cultural specialist who deploys new demonstrations of competence or brings back new practices or stylistics that reinforce his or her position in the home art world. They may be just as much split off from what they "had", what they discursively developed, overseas. What they lose when they return is the very possibility of the hybrid third space that emerged as a physical reality in the relations between art discourses on the edge of the one they found overseas. For many artists the "international", often loosely denoted as "Western" or "avant-garde", is not exactly a cultural space between nationally defined art discourses, but a kind of free, undominated space where imagination and art-discursive realization have freer play away from their home cultures. Of course the international or transnational deployment of their own interpretation of "home" values with it another set of constraints.

We tend to assume that the cross-national indicates a crossing over from one visual discourse into another and that the international indicates some kind of negotiation between two discourses. When the same hybrid position is achieved within two separate and presumably distant visual discourses, we tend to call this transnational, as if by some silent and magical force two different stones could sympathetically vibrate at the same amplitude across great differences of space and local condition. Identifying the transnational is a major ideological plank supporting new biennales, because if the artists and curators associated with them are producing new work across national—that is, culturally specific—visual discourse boundaries, then they can claim they have gone beyond the national. The fact that artists, as particular kinds of cultural specialists, *do move*—that they are mobile—is less significant than that they *can move*—they are motile, the latter being applicable to both physical and virtual travel, that is, travel in a visualized imaginary. Motility allows a different space for the imagination to operate, whereas mobility assumes the differences between cultures that produce the distances an artist could move over. Motility will be carried inside mobility as a potential, a range of creative choices, but for most artists their lives are conditioned more by the physicality of moving or not. Those who can operate the quotidian risks of mobility may also have the intentional or imaginative flexibility to deal with motility.

Seen from the side of discourse rather than of the artist mediator, a two-stage model of inter-discursial interaction would first posit transfer between discourses and then translation into a second discourse, particularly when the artist-mediator had moved between his or her practice in the two discourses and then functioned as the translator. This translation might then be called adjustment or appropriation.

But I think there is a third, endogenous in-between phase in this transfer, which, using a genetic analogy, we could call transcription. This seems to be a phase where one set of practices, styles, aesthetic ideas, and outcomes is written out into another endogenously ordered discourse. The transcription borrows those guises of the endogenous discourse that allow its acceptance but that can be adjusted almost immediately to constitute a new sub-discourse in the endogenous space. In transcription, all that is exogenous is the provision of the mapping procedure, the topology of the coding, which then becomes recoded and transformed, or conventionally speaking, is "translated", in the space of the second and endogenous discourse. How much there is a homogenous or indeed hegemonic discourse on either side of the transcription can be argued. Positions taken can extend from a pure colonialist hegemony on both sides to a relatively free exogeny and relatively constrained endogeny. The anthropological lever, in art, looks more like the latter than the former.

It seems that the artist as a traveler varies between a fully fledged, self-authorizing, exogenously endowed mediator and an endogenous trickster playing with the exogenous even as he or she endogenously appropriates it. It has too often been simplistically assumed that the pattern of responses depends on the conditions of intercultural hybridity that univalently and exogenously force a discourse or its expressions onto the endogenous. But hybridity is first of all bi-mensal between discourses, and multivalently occupies a double position at the interface of both discourses, being inside the exogenous and endogenous at the same time. The artist specialist who travels seems peculiarly able to perform in this domain of double hybridity because for many artists it is free of either the hegemonies (such as a salon system) within the exogenous, yet is undominated by the kinds of transposed essentialism characteristic of the endogenous (such as the need to demonstrate or invoke neo-traditional stylistic affiliation or subjects through the artwork itself).

Recent research in the field of cultural translation may further the investigation of these issues,[4] but reservations first need to be made for their application in the field of art. Art is not like language in that its meanings, for a given universe of discourse, cannot, without iconographical or ideological filtering, be subject to check or exercised toward semantic transparency. Part of the semiotic usefulness of art as a medium is that it can remain ambiguous; or it can have areas of ambiguity for different sets of beliefs at the same time. These allow for the generation of different sets of meanings from the same work; meaning, under conditions of translation, is transacted or negotiated. For cultural historian Peter Burke, "translation should be regarded less as a definitive solution to a problem than as a messy compromise, involving losses or renunciations and leaving the way open for renegotiation" (2007: 9).

This is particularly clear when artworks are produced in contexts where the structure of beliefs and the visual representations that correspond to them change, often

at the same time. Such an implicit negotiation about the meaning of an image happened in the late antiquity of late third-century Egypt, carefully but indicatively analyzed by Barasch, who notes that "the same image ... could serve audiences of radically different orientations and beliefs" (1996: 39). Many other examples could be considered from the spread of Christian imagery or Indic and Buddhist imagery across Asia.

Thus art, as a domain of representation through a physical work and its maker, resembled the position of the translated work and its translator, in that the artist configures the work so that it may be read ambiguously but plays or technically manipulates the way this ambiguity is made apparent. The syncretism of such a work may be displayed via the range of worked traits in an object or artwork that are identifiable by an audience as existing in parallel but appearing in a new guise, or without any move to subject them to a stylistic hegemony. This intrinsically ambiguous locution for the work gains its curiousness from the fact that it may not be interpreted in one dominant manner. Barasch discusses two types of "syncretistic" work: "In one type, the syncretistic nature of the image is manifest; you could say it is paraded. The other type ... is the tilting, or reversible, image. In that latter type, the signs and traces of different and even clashing religions, paraded in the first type, are obscured by an ambiguity in the indication of the spiritual world to which the work of art belongs and which it expresses" (1996: 52).

Syncretism is a feature of intercultural hybrids, not of secondary belief systems, which, as in monotheistic religions and secular ideologies derived from them, like Marxism, "assume the absolute untranslatability of normative self-definition" (Assmann cited in Budick 1996: 16). This position, derived by Israeli and German scholars trying to position translation in the aftermath of the Holocaust, derived a notion of absolute or secondary alterity. As Budick concludes:

> Whenever we attempt to translate we are pitched into a crisis of alterity. The experience of secondary othernesss then emerges from the encounter with untranslatability. Even if we are always defeated by translation, culture as a movement towards shared consciousness may emerge from the defeat. Thus the story of culture does not end with the experience of that which is nothing more than secondary otherness. In fact, the multiple half-lives of affiliation known as culture may begin to be experienced, as potentialities, only there. (1996: 22)

Translation theory has also exercised the minds of postcolonial scholars, concerned at the ability of dominant cultures to simply mistranslate or, more complexly, to translate in their own "image" the meaning of the other. Maier notes how Spivak has discussed "untranslatability or the withholding of translation" (1995: 27) as one response to the inequalities between the translator and the translated, but rather

concludes that "particularly for the 'First World' translator, her [Spivak's] model might better be seen as a caution than an attempt to theorize practice" (1995: 27). Sengupta notes that "by formulating an identity that is acceptable to the dominant culture, the translator selects and rewrites only those texts that conform to the target culture's 'image' of the source culture; the rewriting often involves intense manipulation and simplification for the sake of gaining recognition in and by the metropole" (1995: 160). Sengupta discusses the understanding of how to translate when the author of the original is also the translator, such as in Rabindranath Tagore's translations of his own poems from Bengali, which he had adjusted into the simpler English he was competent with and which he thought his audience might receive: "There is an advantage in having incomplete knowledge of the English language ... I discard what is beyond my powers of expression, I circumvent areas that offer resistance. I can only do this because these are my own creations" (Tagore cited in Sengupta 1995: 169).

Withholding the transfer of a visual style, a subject in art discourse, or an image type is not a position available to a visual artist except under certain conceptualist strategies. Visual artists carry styles, or their own transformations of them, as a kind of protective talisman, one which will armor them against the accusation of plagiarism, sometimes of poor plagiarism, by the originary and usually Euramerican visual culture. It acts too as a protective talisman from attack as having traduced some local, previously formed neo-traditional position or national visual style and the sentiment it is thought to embody.

One can see some kinds of visual art as operating in a space dominated by the translating or receiving culture and the one sending the translation, or vice versa. Some contemporary artists, such as Fiona Tan, recently have seen this as an issue of the projected shadow of one culture, and its construction of the "other" preventing the realization of whatever the other might be beyond this.[5] For Tan there is a gap between what she knows is in the world and what she can perceive about it only incompletely. Visual images have a peculiar power—not least because of their syncretic possibilities outlined earlier—to cross this gap or differential between perception and knowledge. Artists thus embody styles and practices in their person, and so far as this is deliberately expressed, in their persona. Many Asian art histories are almost disquisitions of the persona of a particular artist as a key for the interpretation of art practice in particular epochs, with so many examples of this allegorizing of the artistic persona, such as the portraits or self-portraits of artists such as Raden Saleh or Yorozu Tetsugorō. Like ethnographical topographies, the data of these images is inseparable from the allegorical stories the artist is telling about other cultures and their visual discourses, which James Clifford thinks "must now be seen as contingent, the problematic outcome of inter-subjective dialogue, translation and projection" (1986: 109).

But the ambiguity or range of readings does not mean the interpretation of works is subject to infinite meanings. In any given context of interpretation there will only be a certain range of ways the ambiguities may be resolved, such as the historically constrained religious switch between the ancient and monotheistic worlds in third-century Egypt. Reading is indeterminate only to the extent that history itself is open-ended. If there is a common resistance to the recognition of allegory, a fear that leads to nihilism of reading, this is not a realistic fear. And it often reflects a wish to preserve an "objective" rhetoric, refusing to locate its own mode of production within inventive culture and historical change (see Clifford 1986: 120).

In crossing the gap between perception and knowledge, the image of the artist, particularly of his or her own body, plays a prominent role as a temporally bound memory trace. This facility of memory expressed as an image of, on, or as the body seems very powerful especially where other kinds of explicit representation are disallowed for political reasons. We should therefore not think only of the artist as the transmitter and transformer of what he or she has learned discursively but also as an embodier of the experiences that otherwise escape representation. Bennet concludes: "As the source of a poetics of art ... , sense memory operates through the body to produce a kind of 'seeing truth' rather than 'thinking truth,' registering the pain of memory as it is experienced, and communicating a level of bodily affect" (2006: 29).

The question of the artist as cultural translator now appears in far greater depth. Translation theory or critiques of anthropology as a type of cultural translation provide an understanding of the limited nature of the artist as such a bearer and transformer of meaning. Sometimes all artists can do when they move between art discourses and the cultures that underpin but also constrain them is to show what they have known, or indeed to show a particular way of showing. The interpreters of this display, as Barasch noted, can simply assemble the different gods in their different guises and put them together in the same space. Or the artist can display a mannerism he or she knows will carry plural meanings, only some of which are available to viewers on either side of the cultural threshold between which they move.

TYPES OF ASIAN MODERNITIES IN ART

What kind of artists move between visual discourses, and what types of discourses need or privilege such movement? In what follows, I have periodized my set of artists into five phases, which allows for a sampling by choice of artist (Table 1.1). This periodization may appear to replicate or correspond to those applicable in the history of modern art in Euramerica. It could be seen thereby to rationalize and reinforce the existing pattern of colonial or exogenous domination in the cultural or artistic fields.

But, in my view, this correspondence is more one of surface than deep structure and conceals a very wide range of heterogeneous contingencies in the historical situation of the artists and their art discourses. There are also many analogies between these situations, and even some similarities in the way causal processes operate within them. It is this deep structure that constitutes an interdiscursive space between different discourses, some but not all of which are culturally located—that we may call "The Asian Modern".

These artists were chosen for many reasons; that they went abroad for a period or mostly stayed and worked at home was only one among many considerations. Indeed, most went abroad for further training and exhibition opportunities, but those who did in Phases I and II were not all professionals moving through a higher certification process. Some, like Goseda Yoshimatsu and Raden Saleh, studied in the studios of

Table 1.1 The Asian Modern

Phases of the Asian Modern	A: Asian artists who went abroad and returned	B: Asian artists who largely stayed at home
I 1850s–1880s **Transitions to modernity**	Goseda Yoshimatsu, Japan. (Plate 1) Raden Saleh, Indonesia.	Khrua in Khong, Siam. Simon Flores, The Philippines.
II 1880s–1910s **Academy Realism, Salon Art and the National**	Hyakutake Kaneyuki, Japan. Juan Luna, The Philippines. Tom Roberts, Australia.[6]	Ravi Varma, India.
III 1920s–1940s **Early Modernism**	Amrita Sher-Gil, India. Margaret Preston, Australia. Pan Yuliang, China & France. Victorio C. Edades and other moderns, Philippines.	Ono Tadashige, Japan. Sudjojono, Indonesia.
IV 1940s–1980s **New Narratives, Abstractionism and Conceptualism**	Abdul Latiff Mohidin, Malaysia. (Figure 1.1) Hamaya Hiroshi, Japan. Park Seo-bo, Korea.	K. C. S. Panikker, India. Nguyễn Tu Nghiem, Vietnam.
V 1980s to the present **The Contemporary**	Araya Rasdjarmrearnsook, Thailand. Gulammohammed Sheikh, India. John Young, Australia.	F. X. Harsono, Indonesia. (Plate 2) Roberto Bulutao Feleo, Philippines. Zhang Peili, China.

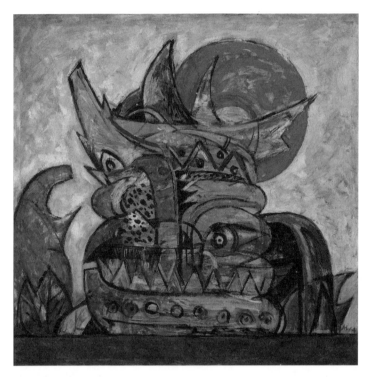

Figure 1.1 Abdul Latiff Mohidin, from *PagoPago* series, 1965. Oil on canvas. 100 cm x 100.3 cm. Collection of National Visual Arts Gallery of Malaysia. Courtesy of the artist and National Visual Arts Gallery of Malaysia.

famous masters. Others such as Juan Luna, Amrita Sher-Gil, and Pan Yuliang went to art schools or to training studios that would otherwise have provided the entrée to an art school or the salon had they not returned home. But in Phases I and II a lack of professionalization marks the careers of some artists even as they went abroad. Hyakutake Kaneyuki, in Phase II, was the social companion of a senior political family's heir and later became a civil servant. In Phase III, Victorio C. Edades studied as an architect, not a painter. Of those who went abroad in Phases IV and V, almost all went first to an overseas art school for postgraduate certification. The hegemonic and vertical model of colonial periphery and metropolitan center simply does not fit these artists because what they were approaching was a world outside that which supported their own hybridity, and lateral, horizontal relations with other artists when they went abroad. One can see that the free association of Tom Roberts with artists overseas is really like that of his contemporary Juan Luna. Further, the peripatetic association with art and artists overseas really becomes an extensive part of artistic identities and a source for their practice in the 1920s, and this can be seen in the different relations to

"Paris" as a world art metropolis, which one sees in the life and artistic trajectories of Pan Yuliang, Amrita Sher-Gil, Fujita Tsuguharu (Léonard), and Okamoto Tarō. There are reasonable grounds for arguing in the Philippines or Japan that, at least by the 1930s if not before, world art metropoles such as New York or Paris were locations for apprising the "international" in a way that was not one of dependence or hegemony but more of entry into a series of art discourses and art circles that were, within certain relative limits, free of the familiar hegemonies.

When the domestic status of the artist who moved is not sufficiently high (Goseda Yoshimatsu), or their artistic knowledge not sufficiently formulated in exhibition or institutional certification (Hyakutake Kaneyuki), they can fall out of the burgeoning discourses of modernity when they return. They find this consecrated by the class origin of famous practitioners or professionalization through domestic art school certification. Even though Pan Yuliang was able to become a respected professor on her return to China, for the period 1928–1937, her social status was low or contested enough—because she was a woman, and had once been a courtesan—that her exhibition was attacked and her work damaged or destroyed in 1936. She had to return to France in 1937, where she lived until her death in 1977.

The artists who stayed at home for the formative part or the whole of their careers in some ways constitute a more interesting group. This is because they create an endogenous discourse that embeds the exogenous as a stylistic resource, a discursial reservoir. In the way they naturalize their exogenous references, they somehow maintain creative control over them even as they integrate their use through locally ordained subject matters. This position incidentally allows us to compare artists like Khrua in Khong—a monk painter who never left Thailand, and Simon Flores—a Manila art school-trained academy painter who did not go to Madrid. Seemingly incomparable stylistically, they were in fact near contemporaries. In the 1850s, Khrua in Khong, almost certainly because of the orders of King Mongkut, Rama IV, redeployed the spatial arrangement of figures, the ways of lighting, and some of the figural representations of early nineteenth-century North American prints with the subject matter of Buddhist *jataka* stories. Simon Flores took a Spanish baroque mediation on human mortality and a *miniaturismo* preoccupation with the coruscated decoration of sacred figures to do a remarkable series of portraits of elite *illustrado*-class believers from the 1860s to the 1880s.

Comparisons between other artists who stayed at home indicate their closeness to political or national positions. These range from the allegorization of national types, found in oil paintings by Ravi Varma and the graphic reproductions he circulated based on them, to the socialist identifications of left-wing artists such as Ono Tadashige in the 1930s. Such works often inadvertently allow for their use in propagandizing the nation or a political cause. Interestingly, many of the artists who remain at home rely on allegorical devices to provide figures

or types of situation allowing muted reference to issues of the national without that being named. Sudjojono produces a kind of lyrical identification with the varieties of the recent Indonesian historical experience, as if the representation of struggle was not simply a pictorial journalism or close analog of history painting, but a representation of an historical spirit that would itself create or conjure the unity of Indonesia.

Most typically, artists who did not go abroad did not have any apparent need to because they could redeploy their stylistic references across a wide range of material, both ideal and visual, which they found working in discourses at home. There is a kind of semi-isolation that may be accompanied by a physical distance from the domestic art capital, such as Yorozu Tetsugorō's from Tokyo in 1914–1918, which enables the artist to develop, semi-autonomously a range of stylistic possibilities that may only have been hinted at or received as inarticulate suggestion from materials presented by art exhibitions or art journalism, as was the case in Japan from around 1907.

It is in such a light that we may also interpret the rise of the Seoul school in Korea and its minimalist conceptualism, which works through the qualities of *matière,* be it paint, wood, stone, or cloth. Here, in the work of exponents such as Park Seo-bo—who did go abroad to Paris, in 1959—there is a denial of allegory or semiotic recoding of the painted accumulation that we suspect has an even delirious self-reliance on what he thinks his domestic audience will receive and interpret for itself. The fact that Park works within a mannerism that can be conceived almost wholly in Korean endogenous terms, yet had direct experience overseas at a crucial point in his artistic trajectory, indicates the presence of a third type of artist. Such artists are stimulated by a sojourn overseas, or selectively position or reposition their work within an international current that authorizes it—even though their work is perfectly capable of being articulated in domestic terms alone. Similarities may be found among artists of the Chinese New Currents in Art movement of the 1980s, who worked out most of their practices in the late 1980s and early 1990s, but then reinforced certain of their own tendencies by foreign experience, such as video artist Zhang Peili, who only went to New York in 1997.

It is difficult to globally categorize the types of artist who move and those who do not. What we do see, probably most firmly from the 1880s in Asia, is the lateral constitution of period identities across cultural boundaries even as artists are going to acquire, in a series of vertical relationships, knowledge and technique at Euramerican metropoles. The causation of their work in Phases I to III depends on the vertical articulation of endogenous and exogenous discourse together; it does not involve horizontal causations between Asian countries, with the exception of one or two Japanese connections with Bengal or Siam.

By the late 1960s, however, at the culmination of Phase IV, relations between Asian artists were far more horizontally realized, although until the 1980s and early 1990s they remained dependent on the circulation of artworks, information, and

artists through Euramerican centers. Even though this dependence is still there, the circulation seems much more one of convenience than vertical causation. Sometimes the artists' identities are governed by their common experiences in the metropoles, sometimes by their common abilities to move around their own regions, a habit necessitated by distance but also learned in Europe. One sees this in the large number of conceptual sketches by Abdul Latiff Mohidin done around Southeast Asia, a practice he absorbed from his own travels around Europe while a student in Berlin. The etiological relation is then one derived much more horizontally from new practices, which become habitual to many different Asian artists in the cross-national structuring of the art world, from around the late 1950s, rather than the vertical articulation of endogenous and exogenous seen earlier.

It appears determinative of stylistic development within endogenous contexts for artists to be well informed about art practices at home and elsewhere, but also to have the psychological and financial resources to withdraw from the domestic art world for a period to develop what they have received and begun to absorb. Transnational practices have since the 1990s thus absorbed the endogenous to the extent that we may see the nesting of exogenous tendencies as much less significant than in earlier eras, and indeed already arranged. One gets hints of an attempt to absorb a new Asian practice such as the collaborations between Australian video artist Shaun Gladwell and a Japanese BMX rider. These collaborations might be seen more as a feature of the new hegemony of a now globalized arts or infotainment industry than the residues of an Asian modernity in art, which was autonomous of, or in parallel to, that of Euramerica. They indicate the disappearance of the Asian Modern, just at the point we (Asian, non-Asians, quasi-Asians) may have been able to recognize it.

NOTES

1. For a list of the institutions, see Clark (1998: 156).
2. See Clark on how Asia might be constituted as a discursive space (chapter one) and the notion of alternative or parallel modernities (1998: 272–274).
3. The "discursial" roughly corresponds to the domain where the conditions break down or become conflicted for a "strong extra—coding by which a social group explicitly and publicly establishes that a ready-made message, circumstance, or context definitely must be coded" (Eco 1979: 137). See also Clark (1998, 1999).
4. On cultural translation and cross-cultural comparison, see Asad (1986); Barasch (1996); Bennet (2006); Budick (1996); Burke (2007); Clifford (1986); Hallpike (1971); Maier (1995); Naroll (1970); Sakai (1997); and Sengupta (1995).
5. See my review of her Sydney exhibition in *Art & Australia* (Clark 2010b).
6. Australian artists are deliberately included here to show comparatively how well, or otherwise, Australian artists fit in with other structural patterns of the Asian Modern.

REFERENCES

Asad, T. (1986), "The Concept of Cultural Translation in British Social Anthropology," in J. Clifford and G. E. Marcus (eds.), *Writing Culture: The Poetics and Politics of Ethnography*, Berkeley: University of California Press.

Barasch, M. (1996), "Visual Syncretism: A Case Study," in S. Budick and I. Wolfgang (eds.), *The Translatability of Cultures: Figurations of the Space Between*, Stanford, CA: Stanford University Press.

Bennet, J. (2006), "The Aesthetics of Sense Memory: Theorising Human Trauma through the Visual Arts," in S. Radstone and C. Hodgkin (eds.), *Memory Cultures: Memory, Subjectivity, and Recognition*, New Brunswick, NJ: Transaction Publishers.

Budick, S. (1996), "Crises of Alterity: Cultural Untranslatability and the Experience of Secondary Otherness," in S. Budick and I. Wolfgang (eds.), *The Translatability of Cultures: Figurations of the Space Between*, Stanford, CA: Stanford University Press.

Burke, P. (2007), "Cultures of Translation in Early Modern Europe," in P. Burke and R. P.-C. Hsia (eds.), *Cultural Translation in Early Modern Europe*, Cambridge: Cambridge University Press.

Clark, J. (1998), *Modern Asian Art*, Honolulu: University of Hawai'i Press.

Clark, J. (1999), "Asian Modernisms," in *Humanities Research*, 2: 5–13.

Clark, J. (2010a), *Asian Modernities: Chinese and Thai Art in the 1980s and 1990s*, Sydney: Power Publications.

Clark, J. (2010b), "Fiona Tan: Coming Home," *Art & Australia*, 47 (4): 685.

Clifford, J. (1986), "On Ethnographic Allegory," in J. Clifford and G. E. Marcus (eds.), *Writing Culture: The Poetics and Politics of Ethnography*, Berkeley: University of California Press.

Eco, U. (1979), *A Theory of Semiotics*, Bloomington: Indiana University Press.

Hallpike, C. R. (1971), "Some Problems in Cross-cultural Comparison," in T. O. Beidelman (ed.), *The Translation of Culture: Essays to E. E. Evans-Pritchard*, London: Tavistock Publications.

Maier, C. (1995), "Towards a Theoretical Practice for Cross-cultural Translation," in A. Dingwaney and C. Maier (eds.), *Between Languages and Cultures: Translation and Cross-cultural Texts*, Pittsburgh: University of Pittsburgh Press.

Naroll, R. (1970), "What Have We Learned from Cross-cultural Surveys?," *American Anthropologist*, 72 (6): 1227–1288.

Sakai, N. (1997), *Translation and Subjectivity: On "Japan" and Cultural Nationalism*, Minneapolis: University of Minnesota Press.

Sengupta, M. (1995), "Translation as Manipulation: The Power of Images and Images of Power," in A. Dingwaney and C. Maier (eds.), *Between Languages and Cultures: Translation and Cross-cultural Texts*, Pittsburgh: University of Pittsburgh Press.

2 IN AND OUT OF PLACE: TIBETAN ARTISTS' TRAVELS IN THE CONTEMPORARY ART WORLD

Clare Harris

In the 1960s, when Arthur Danto (1964) and George Dickie (1969) pioneered the sociological analysis of the "art world," the institutions and individuals they had in mind were principally located in Europe and North America. But in the decades thereafter the scope of the production and consumption of art has taken a decidedly "global" turn, requiring us to rethink such a bounded, Western-oriented conception. In the field of contemporary art especially, the art world has extended its reach to all corners of the planet, so that within its current cartography a city like New Delhi has become as much of a nodal point as New York. When artists, artworks, and their audiences are increasingly busy shuttling across this greatly enlarged terrain, the traffic in culture is heavy and the movements within it are omnidirectional. This mobility is celebrated in the art world, to the extent that it has recently been imagined as a placeless utopia—rather like the mythical Shangri-La—where artists (and curators) are free to circulate and their nationality or ethnicity are of little relevance. Thus, like their artworks, artists are rarely anchored to one site or one community, which, according to Miwon Kwon, means that, at least in the art world, the "strictures of place-bound identities" have been replaced "with the fluidity of the migratory model" (2002: 165).

The contemporary art world conceives of itself as an egalitarian community in which previous power imbalances have been largely overturned. It privileges the idea that the creators of artworks are first and foremost artists and that other aspects of their identity are less significant. However, a fundamental tension underlies these universalizing ambitions. The agents of the art world are constantly in search of

new entries to the canon of the contemporary. Even as they seek to renounce the old categories of national, "primitive", "Black", or "Post-Colonial art" in preference for the stateless, the deracinated, and the global, there is still a desire to discover previously underrepresented ethnicities and undiscovered territories. The voracious appetite of the art market for difference and distinctiveness—in terms of individual or collective cultural style—has yet to be satiated, and the art world literally capitalizes on novelty. For example, if an artist were Tibetan, or hailed from a region with a troubled history (such as Tibet), this could be an asset when introducing him or her to an art world audience eager for uniqueness. Thus, even as it celebrates placelessness, the art world is still inclined to put art and artists in their place.

The art world is, therefore, no paradise; it is monitored by an international coterie of critics, dealers, curators, and collectors who, although often professing to a credo of democratization and accessibility, continue to apply strict criteria for inclusion and exclusion. The institutions of the art world also persist in framing the interpretation of the art that appears within their walls in very particular ways. By recording the experiences of a group of Tibetan artists, who initially thought the placeless art world might offer an escape from the limitations imposed by their home locations, I examine how their work has been received according to the cultural logic of the cities (Venice, New York, and Beijing) in which it has been exhibited and the agents of the art world they have encountered.

PUTTING ART IN ITS PLACE

However peripatetic its elite cosmopolitan protagonists may be, the art world still exists within a set of physical structures, dispersed across six continents, which include private galleries, public museums, and venues for fairs and festivals. Often constructed according to the same modernist principles—whether in Beijing or Boston—the buildings where contemporary art is displayed aspire to neutrality. The "White Cube" aesthetic predominates because it provides a blank container in which artworks can be pushed into high relief. These establishments must surely be added to Marc Augé's list of the "non-places of super-modernity," for, like airports, shopping malls, and hotels, their ubiquity and function as a conduit for the passage of transitory populations somehow makes them invisible to us. By examining "non-places," Augé claims, it is possible to move beyond the "whole ethnological tradition associated with the idea of culture localized in time and space" and to direct our attention toward areas where new forms of social and cultural communication take place (1995: 34). By viewing the contemporary art world as a series of sites where artists, curators, critics, and viewers interact, we can study the discursive practices that

determine who will find a place within it. In addition we can elucidate variations in the translation of artworks according to the vernaculars in operation at the local level. In order to do this the anthropologist must adhere to conventional ethnographic methods by being situated in certain places, but he or she also needs to follow the routes taken by the multi-sited artwork and the highly mobile contemporary artist. Like them, the commentator (and probably the exhibition viewer as well) must become an itinerant cultural specialist with knowledge of multiple visual histories. Only then can they track the "cumulative logic" of transcultural art practice in which an artist builds on the varied experiences and references gathered over space and time (Harris 2007: 167). For the "flows of culture" (Appadurai 2002) are not entirely liquid; they have a viscosity like volcanic lava that can pick up deposits along the way and solidify at particular points. For this chapter I have attempted to record such flows and stoppages by traveling to all the locations described within it, as well as to the homes and studios of artists in Tibet, India, the United States, and the United Kingdom. Along the way I have spoken with curators, critics, dealers, collectors, and exhibition goers and have not merely observed but also participated in art world events when both the artists and myself have been far away from home.

TIBETAN CONTEMPORARY ART ARRIVES IN THE ART WORLD

The phenomenon now known as "Tibetan Contemporary Art" is a very recent arrival in the art world, having made its first official appearance outside Tibet only in 2005. Since then it has rapidly achieved a degree of global recognition and approval, both in exhibition spaces and on the Internet. Although promoted as an utterly novel addition to the canon of contemporary art, it does in fact have a history. After centuries in which the production of scroll paintings (*thangka*), religious objects, and monastic murals had been the principal pursuit of Tibetan artists, a slight move toward modernism occurred in Tibet before the influx of Chinese troops and Chinese Communist aesthetics in the 1950s. However, only in the last decade or so have the few pioneering figures of that era—such as Gendun Chopel (1903–1951), whose radical ideas about literature, Buddhism, politics, and art have meant his name is now commemorated in the title of the most important artists' association in Tibet— been acknowledged even among Tibetans themselves. Moreover, once Tibet was fully incorporated into the People's Republic of China in 1950, its religious art traditions were abolished and Maoist socialist realism was inserted in its place, especially during the Cultural Revolution of 1966–1976. In the 1980s, Tibetan artists reacted against this colonization of their visual space and began to create a conspicuously Tibetan

form of art defined in terms of who could make it—ethnic Tibetans—and its subject matter—Tibet. Inspired to deconstruct the iconography of the Tibetan past through the lessons they had learned from Cubism, Expressionism, and Surrealism, those artists aimed for distinctiveness and to make paintings that were emphatically not Chinese (see Harris 1999). At this juncture, however, the paintings created by young Tibetan artists were highly localized in terms of consumption (they were primarily viewed in Lhasa tea houses) and the audience they sought to address (other youthful Tibetans). Not until the turn of the millennium did their works begin to move out of Tibet in significant numbers.

The primary agents who initiated this change were a collective based in Lhasa— the Gendun Chopel Guild, an artist who had left Tibet in 1992 but had since been mainly based in London—Gonkar Gyatso, and two dealerships in the West that had previously specialized in the sale of Tibetan antiques—Rossi and Rossi in London and Peaceful Wind in Santa Fe, New Mexico. From 2005 onward they joined forces to create exhibitions under the banner of Tibetan contemporary art, which in turn led to a Web presence and a Wikipedia entry. In the next few years, displays began to proliferate in Europe and America, and by 2008 more than a dozen venues— from university campuses to high-end galleries in London's Mayfair—had hosted an exhibition of Tibetan contemporary art. Since most of the shows occurred in commercial settings, a market for the artworks was swiftly generated and a number of wealthy connoisseurs switched their allegiance from ancient Tibetan art to the contemporary. Prices for a painting therefore rapidly rose: from a few hundred dollars in 2005 to over $100,000 for a piece produced by one of the stars of the "new" movement in 2008. The giddying pace of developments reached a peak in 2009 when Gonkar Gyatso became the first Tibetan to participate in the Venice Biennale. A major shift had occurred in the Tibetan art world, for rather than look- ing inward to a small group of their fellow Tibetans, the creators of contemporary Tibetan artworks were turning to the outside.

Prior to the invention of Tibetan contemporary art, artists based in Tibet had been hampered by a lack of access to national or international art circuits. They per- ceived themselves as stuck in the remote utopia that others called Shangri-La when they knew only too well that their reality emphatically contradicted that paradisal vision. Hence a primary function of Tibetan contemporary art was to represent Tibet differently, to critique the Western myth of Tibet as a spiritual haven and to simulta- neously rebuff the Chinese communist characterization of the region as a provincial outpost where only religious icons had been produced. Thus Tibetan contemporary art was a product primarily designed for export and for communication with non- Tibetan viewers; at its simplest, a vehicle that could allow Tibetan artists to affirm their existence (Plate 3).[1]

A deterritorialized art world seemed the perfect place to introduce a new form of art, particularly one created by a set of individuals who were in fact divided by geography and nationhood. For Tibetan artists it presented the possibility of escape from the strictures of their local environs: whether in the Tibet Autonomous Region of the People's Republic of China—where public culture is heavily policed and controlled—or in the Tibetan refugee community in India—where the "preservation in practice" ethos of the Tibetan exile government places limitations on the activities of artists (Harris 1999: 43). By labeling their endeavor Tibetan contemporary art—rather than contemporary art from Tibet—those who devised and promoted it enabled a transnational community of artists to be united in the international art world (see Harris 2012). It is even possible to suggest that, by including individuals based in the Tibetan-speaking areas of the People's Republic of China alongside members of the Tibetan diaspora, Tibetan contemporary art allowed a Tibetan nation to be imagined in the art world when it does not exist as a geopolitical entity.[2] The art world also proffered a social space that would allow artists from the two Tibets—the Chinese and the diasporic—to actually meet in person at exhibitions in London, New York, or Beijing. For them, Tibetan contemporary art was therefore not defined by home location or by nation but rather as a community of artists and a set of objects that (in the agentive sense Alfred Gell outlined in 1998) enabled relationships to be constructed around them. While the rhetoric of placelessness in the contemporary art world had great appeal for these artists, how would they and their works fare when relocated within its institutions and evaluative regimes of reception?

SHANGRI-LA IN VENICE?

When Swedish curator Daniel Birnbaum set about creating the global contemporary art show "Fare Mondi: Making Worlds" for display in Venice in 2009, he was attempting to circumvent the national framing of art that had determined the character of the biennale since its inception in 1893. His exhibition would be housed in the cavernous Arsenale dockyards, entirely separate from the national pavilions, to provide a "creative site" and "not simply a place where one culture is put on display for another in a way that treats each culture as something static, a fixed essence inevitably rooted in stereotypes" (2009). Citing philosopher Nelson Goodman, he declared that the artists he selected would have the opportunity to make worlds "anew" and imagine "worlds ahead," and he reiterated a view widely held among curators that the display spaces of contemporary art could provide a sanctuary from the monotony and dullness of corporate globalization afflicting the world outside. This is of course a highly romantic idea, with its roots in Kantian aesthetics and the

suggestion that the contemplation of art enables the viewer to disconnect from the tedium and defilements of the everyday. (Not to mention the fact that the art market is also a global capitalist endeavor, but one whose products are simply too expensive for ordinary people to buy!) With this scheme in mind, Birnbaum set off in search of all the latest varieties of difference he could find, choosing dozens of artists from virtually every continent. In the Making Worlds catalog, they were identified by the city in which they were born and the one in which they lived when commissioned by Birnbaum—which in most cases were not the same.[3]

In fact, only because Gonkar Gyasto had traveled from Tibet to the West had Birnbaum been made aware of his work and chosen it for the Venice Biennale. Gyatso had become the most prominent figure in the Tibetan contemporary art movement by virtue of his presence in London and the appeal of his artistic output.[4] Having become a refugee in India in the late 1980s and an asylum seeker in Britain in the early 1990s, Gyatso had led a nomadic existence for more than a decade before finally gaining a British passport in 2002. It was therefore entirely appropriate that Gyatso would be the first Tibetan to represent the non-nation of Tibet in the utopian space of Making Worlds, but many paradoxes arose as a result, not least of which was that the artist chose this occasion to make his most overt commentary on the politics of his homeland, amid the freedoms afforded by Birnbaum's exhibition space—a statement that would not have been remotely possible in China itself.

In *Reclining Buddha: Beijing-Tibet Relationship Index,* Gyatso constructed a set of ten panels narrating the course of events over the sixty years since the "Peaceful Liberation" of Tibet by China in the 1950s. A jagged black line scored across the panels like a stock market diagram indicating the fluctuations in Tibet's fortunes, with only two phases of good relations: the early 1950s, when the fourteenth Dalai Lama was involved in direct negotiations with Mao Zedong in Beijing, and the mid-1980s, when Deng Xiaoping's liberalization policies initiated improvements in Tibet following the ravages of the Cultural Revolution.[5] Otherwise, the black line only fell into deficit: from the departure of the Dalai Lama into exile in India in 1959 and the demonstrations against Chinese rule in 1988 and 1989 to the lowest point of all, the violent protests that erupted in Tibet in 2008. Behind this index, the recumbent figure of the Buddha was faintly delineated and seemed to slumber through each and every catastrophe. This "sleeping" form usually has a positive resonance for Buddhists in South and Southeast Asia, where it has represented the Buddha's death and triumphant entry into *paranirvana*—when he left the cycle of rebirth to achieve a state of bliss (*nirvana*). But among Tibetan Buddhists the demise of the Buddha is taken as a bad omen and was therefore rarely painted or sculpted in Tibet. For Tibetan viewers, Gyatso's use of this particular shape of the Buddha's body would therefore only compound his depressing image. The artist informed

me his intention had been to demonstrate his sympathy for Tibet and the suffering of Tibetans, but the work itself evidently had to be directed at the members of the art world who could (unlike most Tibetans) actually be present at the Biennale. He therefore addressed this international constituency of viewers in a ludic, multilingual mode. Above and below the reclining Buddha, Gyatso pasted dozens of humorous scenes copied from newspapers, books, and photographs. Famous figures from international politics and the art world elite were illustrated in cartoon style with speech bubbles mocking their high status. Even the Dalai Lama was featured wearing a *kippah* and asking himself: "How did Jewish people survive for so long without a country?" These scenes, captioned in English and Italian (among other languages), made Gyatso's work legible to Biennale visitors, converting Tibet's recent history into a diverting tragi-comedy for consumption in the art world.

Another work at the Biennale, Gyatso's *Shambhala in Modern Times,* was even more popular (Plate 4). Many visitors posed to have their picture taken in front of the huge image of the Buddha with its shimmering *mandorla,* the halo that emanates from the head of deities in Hinduism and Buddhism. Once again Gyatso seemed to have used the Buddha form to make his work both auratic and comprehensible to non-Tibetan audiences, when in fact he was toying with the idea of Shangri-La and the history of its formulation and circulation in the West. British author James Hilton is thought to have derived the concept of the utopia he portrayed in *Lost Horizon* (1933) from an ancient Buddhist text describing a hidden Asian kingdom called Shambhala. In the Kalachakra Tantra, Shambhala is a "Pure Land" occupied by pacifists who can achieve Buddha-hood in a single lifetime. However the tantra also predicts that in the year 2425 c.e. an apocalyptic war will occur and barbarians will threaten to invade paradise. Only when the king of Shambhala destroys the forces of greed, anger, and ignorance (the three primary Buddhist vices) will tranquility return and all living beings become immortal. *Shambhala in Modern Times* actually depicts the dystopian chaos that precedes the golden era, crafted from the detritus of popular culture, referencing pornography, addiction, and the sensory overload of consumption. In a polyglot blur of texts and imagery gleaned from the multicultural East London environment where the work was made, and with references to Tibet's exclusion from the 2008 Olympic Games because of its lack of nationhood, Gyatso raised questions about the translatability of art that is consumed in the highly transnational contemporary art world.

The fact that Tibet had reemerged on the international news agenda when rioting spread across the Tibetan-speaking regions of the People's Republic in March 2008 may explain why Gyatso's work was so positively received in Venice the following year, having provided the work with a narrative and shared context. Yet, in another capital of the international art world a year later, the art critic of the *New York Times*

announced that Gyatso's Buddhas did little to "advance the genre of Pop collage or ideas about spirituality and business," and he classified them disparagingly as merely decorative (Johnson 2010).

SHANGRI-LA IN NEW YORK?

In June 2010, the Rubin Museum of Himalayan Art in New York City launched Tradition Transformed: Tibetan Artists Respond, billed as the first exhibition of Tibetan contemporary art held in a major museum in the West. The exhibition showcased the work of nine artists of Tibetan heritage: two from the Tibet Autonomous Region of the People's Republic, one from Nepal, another from Switzerland, and the remainder from various U.S. cities. Since all the artists were born after the so-called Peaceful Liberation of Tibet and only two were from Lhasa, the show (unconsciously) mapped the global dispersal of Tibetans and Tibetan culture, prioritizing those who had lived or sought exile in the West.[6] The curatorial agenda aimed to examine the ongoing legacy of that notoriously tricky concept—tradition—and to present artworks as a series of responses to Tibetan Buddhist art of the past, of which the host institution holds a rich collection. The works by living Tibetan artists were therefore introduced to New Yorkers as an extension of the legacy of *thangka* (Buddhist scroll) painting and as modest modifications of the practices of their forefathers. But the catalog made no reference to the abolition of Tibetan Buddhism during the Cultural Revolution or to the contemporary challenges of making art either in Tibetan areas of the People's Republic or in the Tibetan Diaspora. It merely alluded vaguely to the "dizzying influences of global society." By emphasizing Tibetan artists, particularly those based in Lhasa, the exhibition could not countenance the possibility that Tibetan artists might actually be alienated from their own "tradition" or that they could set out to undermine the adoration that it inspires in the West, as Gonkar Gyatso had done in Venice.

To my mind, the result of these curatorial preoccupations was that Tradition Transformed received an extremely critical review in the *New York Times*. In his article "Heady Intersections of Ancient and Modern," Ken Johnson denounced the work as "disappointingly decorous," asking: What happens to "traditional, local cultures" when they are threatened by global corporate capitalism? "Do they become extinct? Can they be modernized without losing their souls? Can their essences be recast in non-traditional forms?" This kind of response is only too familiar for those aware of the negative reception that greeted Indian modernist artworks, for example, when they arrived in London in the 1960s.[7] It reprises the old hierarchies of value that had governed the art world: the idea that a culture has an essence, that modernity is inevitably a threat to tradition, and the assumption that artists from outside the "citadels of modernism" (Araeen 1989)

are fated to produce weak emulations of their Western counterparts. Johnson's conclusion was that the contributors to Tradition Transformed had "never been modern" (LaTour 1993) or worse: they had failed to capitalize on the freedom to become modern that the art world offered.

The only exception was Kesang Lamdark. Johnson decided he was "the one to watch." Although he had spent the first years of his life in the Tibetan refugee community in India, Lamdark grew up in Switzerland and trained at the Parsons School of Art, New York. Whether Johnson was aware of this or not, in Lamdark's work he saw the signs of a tortured psyche and the transgressive intentionality that would qualify him to be called a "contemporary artist." Lamdark's installation of disused beer cans—their bases perforated with pin-pricks to create tiny patterns of light and often illuminating sexually explicit imagery—referenced the Duchampian readymade and the modernist artist's practice of unearthing the subconscious, and meant that the two-dimensional painted works of his fellow Tibetans were inevitably construed as anachronistic by comparison. But above all the *New York Times* reviewer was disappointed that none of the artists had "expressed anything very personal about their experiences," nor dealt directly with politics. This complaint enraged one of the exhibiting artists, Tenzin Rigdol, a young Tibetan born in Nepal but whose family had been granted political asylum in the United States in 2002. Accusing Johnson of "uninformed and ignorant" views, Rigdol wrote in his blog that the critic had entirely failed to grasp the artists' "metaphorical allusions and the conceptual vocabularies" (2010). He also highlighted two exhibition pieces—Gonkar Gyatso's *My Identity* and Tsering Sherpa's *Preservation Project No. 1*—as examples of commentaries on the impact of the Chinese invasion of Tibet in the 1950s (see Harris 2007). For another exhibitor, Losang Gyatso, born in Tibet in 1953 but educated in the United Kingdom and the United States, it was the duty of a Tibetan artist to document the complexity of the Tibetan experience because the impact of "rapacious" Chinese policies was marginalizing Tibetans in the People's Republic and "smothering any initiatives by Tibetans to engage in cultural production" (2010).

However, perhaps Mr. Johnson could be partially forgiven for his blinkered interpretations and expectations. The Rubin Museum had, after all, reiterated a vision of Tibet prevalent in the West and promoted by the Tibetan government in exile in Dharamsala, India. From there, the chief ambassador of the Tibetan cause, the fourteenth Dalai Lama, sets off on his global tours to disseminate a message that defines Tibet in its religious religio-cultural distinctiveness. It is also in Dharamsala that the principle of preservation is most effectively put into practice, and where the exilic ethos demands that contemporary Tibetan culture should be entirely about the replication of traditions established in pre-1950 Tibet.[8] Dramatic deviations from this legacy are generally not encouraged because the exiles must stand in opposition to what the Dalai Lama has called the Chinese government's policy of "cultural

genocide." It is therefore no surprise that many Tibetophiles, Tibetans in exile, and a significant cohort of Tibetan artists are intent upon pursuing a subtle transformation of tradition rather than its brutal dismantlement.

SHANGRI-LA IN BEIJING?

Could there be anything more disturbing, then, for adherents of this view than the fact that there *are* Tibetan artists who have made explicit assaults on Tibetan "tradition" and who are engaged in a critical commentary on its religious foundations? And worse: that they are more likely to be found in the territory that was once called Tibet rather than in the Diaspora? When the son of a Tibetan Communist and a Han member of the People's Liberation Army (Gade) portrays the Incredible Hulk in the style of an antique Tibetan painting, he is surely proposing that the wrathful forms of Tibetan deities have been eclipsed in the minds of Tibetans by the gods of Mammon (Plate 5). Similarly, when two artists from Lhasa (Yak Tseten and TseKal) make a *stupa* out of Lhasa Beer bottles, it is hardly to confirm that the monuments commemorating the life of the Buddha still function in that way in contemporary Tibet. These are very recent examples of the groundbreaking efforts by Tibetan artists to acknowledge the post-Maoist and highly consumerist environment they occupy in "China's Tibet" (as the Chinese government likes to call it) and to move beyond what I have termed the "encrypted" visual vocabulary of their predecessors in the Tibetan contemporary art movement (Harris 1999: 187). Whereas in the 1980s and 1990s Tibetan artists presented their works in a style that was not easily decipherable by non-Tibetans and avoided the attentions of the authorities by operating at an inconspicuous level in Lhasa, the new generation of artists are more explicitly political.

For example, in 2010, Lhasa-based artist Nortse completed a major installation entitled *30 Letters* (Plate 6), comprising of the letters of the Tibetan alphabet welded in iron and laid out on panels of amber-colored earth like a field full of coffins. Each letter was accompanied by a butter lamp, of the sort used as offerings in commemoration of the dead in Tibet. This work has a connection, I believe, to Xu Bing's *Book of the Sky* (1987–1991), which features an enormous canopy of paper printed with what appear to be Chinese characters, which are actually unreadable. Nortse's use of the Tibetan script is, by contrast, entirely about legibility: not only can the shapes of the alphabet be comprehended by Tibetans, they also inscribe something fundamental about the land of Tibet as a distinctive territory where the ancestors reside and are remembered. Rather than looking to the sky, Nortse suggests that Tibetans must root themselves in the ground and the language of their forefathers. In 2010,

the Chinese government decreed that Tibetan would no longer be the medium of instruction in the Tibet Autonomous Region's schools. Nortse's artwork therefore sounds the death knoll for his mother tongue and hints that if language is the most fundamental marker of culture, then the prognosis for the future of other facets of Tibetan cultural life is not good.

If the messages of the art currently made by Tibetan artists are more overt, the works themselves are also more visible than before. But this is true everywhere other than in the Tibet Autonomous Region itself. Although several galleries run by members of the Tibetan contemporary art community exist in Lhasa, it remains difficult to exhibit their more adventurous compositions, and Tibetan visitors to these spaces are few and far between. Instead the artworks I have described were displayed at the Songzhuang Art Centre in Beijing in 2010. Curated by a team that included the Lhasa-based artist Gade and the eminent Chinese critic and curator Li Xianting, they featured in the Scorching Sun of Tibet exhibition. Li has been at the forefront of curating Chinese contemporary art since the late 1980s and coined the term "Political Pop" to characterize the production of the post-Tiananmen period. In 2007, he identified another important development in the art world of the People's Republic when he met a group of Tibetan artists at their first exhibition at the Red Gate Gallery in Beijing.[9] At that time, Li gave them his seal of approval and announced that he would invite them to show at his huge white cube-style art space on the edge of the city. When Scorching Sun opened in September 2010, Tibetan artists appeared liberated. They were seen as embracing what Mayfair Yang calls "critical aesthetic modernism" (1996: 104) and as having abandoned the traditionalism that had dogged their immediate predecessors. In his catalog essay Li celebrated those achievements and bravely declared that they arose from the "cutting pain" Tibetans were suffering as a result of the deleterious effects of Sinicization in Tibet, including the "invasion of consumerism," environmental pollution, the demise of the Tibetan language, and the erosion of religion (Li et al. 2010: 6). By engaging with these topics and expressing them in the international vocabulary of contemporary art, Tibetan artists finally found that the Beijing branch of the art world would open its doors to them. How troublesome (for everyone else) that a group of Tibetans would find their Shangri-La in Beijing, and in a white cube-style institution that, rather appropriately for China, is actually painted red.

SHANGRI-LA RELOCATED

By visiting the locations where Tibetan artists have recently exhibited, this chapter has indicated that neither the white cube aesthetic nor the rhetoric of contemporary art is as neutral as they purport to be. Though global in aspiration and reach, both

the institutions of the art world and those who engage with them are localized in specific ways. The particularities of place still determine who will succeed in entering the art world paradise and the reception they will receive within it. Gonkar Gyatso triumphed in Venice because he fulfilled the required criteria: he had lived in a troubled place (Tibet) but had since become a refugee, moving from Asia to the West. He was thus a suitably mobile citizen of the global art world. His work was also pointedly political, inscribing a recognizable narrative of place for consumption in the non-places of the art world. In New York City on the other hand, he and most of his fellow Tibetan artists were deemed to have failed because their work did not concur with the institutional parameters of the Rubin Museum or the expectations of an art world expert. It was neither sufficiently redolent of the old Tibet nor hyper-modernist enough. In Beijing, however, the pioneers of Tibetan contemporary art had gained the approval of a powerful player in China's art world. In Li Xianting's establishment their most provocative works could be readily accommodated and appropriately interpreted in the light of Chinese contemporary art criticism rather than according to the agenda of global art emanating from the West.[10] As several of the artists involved in Scorching Sun told me, it was in the capital of the Chinese art world that they felt most at home. Despite the mobility that they and their works had recently enjoyed elsewhere, it was the right place for them.

NOTES

This chapter is an abridged version of an article originally published in and reproduced by permission of the American Anthropological Association from *Visual Anthropology Review,* Volume 28, Issue 2, pages 152–163, November 2012. Not for sale or further reproduction.

1. The impetus to export Tibetan contemporary art from places like Lhasa is also driven by the fact that it is rarely purchased by Tibetans.
2. However, to date, Tibetan artists have not attempted to use the art world as a space to assert the idea of a Tibetan nation in the way First Nations artists have done (see Anthes 2009 and Mithlo 2004).
3. For a statistical analysis and important discussion about the nationality of artists and their mobility (or otherwise) within the art world, see Wu (2009).
4. Gonkar Gyatso moved to London in 1996. He established the Sweet Tea Gallery, the first gallery dedicated to the promotion of Tibetan contemporary art, in Bethnal Green in 2003.
5. The fourteenth Dalai Lama engaged in talks with Mao Zedong in Beijing following the signing of the 17 Point Agreement in 1951 that effectively ceded Tibet to China.
6. Since six of the nine exhibiting artists at the Rubin Museum were either resident in the United States or had received their art training there, perhaps Tradition Transformed

might have been better described as the first exhibition of Tibetan-American art rather than as a display of Tibetan contemporary art.

7. Another example is the reception of Aboriginal acrylic painting, Fred Myers's (1991 and 1994) discussion of which has influenced my thinking for this chapter.

8. For analysis of the cultural activities of Tibetans in exile in India, see Diehl (2002), Harris (1999), and Korom (1997).

9. The 2007 Red Gate gallery exhibition, Lhasa: New Art from Tibet, was curated by Brian Wallace, Tony Scott, and American doctoral student Leigh Miller Sangster.

10. The Songzhuang Art Centre is on the outskirts of Beijing, at some remove from the prying eyes of the authorities, and somewhat protected from interference by the status of its owner.

REFERENCES

Anthes, B. (2009), "Contemporary Native Artists and International Biennial Culture," *Visual Anthropology Review*, 25 (2): 109–127.

Appadurai, A. (2002), "Disjuncture and Difference in the Global Cultural Economy," in J. Inda and R. Rosaldo (eds.), *The Anthropology of Globalization: A Reader*, Oxford: Oxford University Press.

Araeen, R. (1989), *The Other Story: Afro-Asian Artists in Post-war Britain*, London: Hayward Gallery.

Augé, M. (1995), *Non Places: Introduction to an Anthropology of Supermodernity*, London and New York: Verso.

Birnbaum, D. (2009), *Making Worlds: Fare Mondi*, Venice: Fondazione La Biennale di Venezia.

Bloom, R. and Weingeist, R. (2010), *Tradition Transformed: Tibetan Artists Respond*, New York: Art Asia Pacific and Rubin Museum of Art.

Danto, A. (1964), "The Artworld," *Journal of Philosophy*, American Philosophical Association 61 (19): 571–584.

Dickie, G. (1969), "Defining Art," *American Philosophical Quarterly*, 6 (3): 253–256.

Diehl, K. (2002), *Echoes from Dharamsala: Music in the Life of a Tibetan Refugee Community*. Berkeley and Los Angeles: University of California Press.

Gell, A. (1998), *Art and Agency: An Anthropological Theory*. Oxford: Clarendon.

Gyatso, L. (2010), "The Implications of a New York Times Art Review for Tibetan Artists and Society," in *Gyatso: Contemporary Tibetan Artist* website http://www.gyatsostudio.com. Accessed September 16, 2010.

Harris, C. (1999), *In the Image of Tibet: Tibetan Painting after 1959*, London: Reaktion Books.

Harris, C. (2007), "The Buddha Goes Global: Some Thoughts towards a Transnational Art History," in D. Cherry and F. Cullen (eds.), *Location* Oxford: Blackwell Publishing and the Association of Art Historians.

Harris, C. (2012), *The Museum on the Roof of the World: Art, Politics and the Representation of Tibet*, Chicago, IL: University of Chicago Press.

Hilton, J. (1933), *Lost Horizon,* London: MacMilllan.

Johnson, K. (2010), "Heady Intersections of Ancient and Modern," in the *New York Times,* New York, August 19.

Korom, F. (ed.) (1997), *Constructing Tibetan Culture: Contemporary Perspectives,* St-Hyancinthe, Quebec: World Heritage Press.

Kwon, M. (2002), *One Place after Another: Site Specific Art and Locational Identity,* Cambridge, MA and London: MIT Press.

Latour, B. (1993), *We Have Never Been Modern,* trans. Catherine Porter. Harvard University Press.

Li, X., Gade, Zhang, H., and Fang, L. (2010), *Scorching Sun of Tibet,* Beijing: Songzhuang Art Center.

Mithlo, N. (2004), "'We Have All Been Colonized': Subordination and Resistance on a Global Arts Stage," *Visual Anthropology,* 17 (3–4): 229–245.

Myers, F. (1991), "Representing Culture: The Production of Discourse(s) for Aboriginal Acrylic Paintings," *Cultural Anthropology,* 6 (1): 26–62.

Myers, F. (1994), "Culture Making: Performing Aboriginality at the Asia Society Gallery," *American Ethnologist,* 21 (4): 679–699.

Rigdol, T. (2010), "Heady Intersection of an Alien and Tibetan Modern Art," in *Artists' Blogs: Tradition Transformed,* http://traditions.rma2.org/tenzing-rigdol. Accessed September 16, 2010.

Wu, C.-T. (2009), "Biennials without Borders?," *New Left Review* 57, May–June issue.

Yang, M. (1996), "Tradition, Traveling Anthropology and the Discourse of Modernity in China," in H. Moore (ed.), *The Future of Anthropological Knowledge.* New York and London: Routledge.

3 IMAGINING "ASIAN" AESTHETICS IN COLONIAL HANOI: THE ÉCOLE DES BEAUX-ARTS DE L'INDOCHINE (1925–1945)

Phoebe Scott

In 1949, while working for the Việt Minh in northern Vietnam, the painter Tô Ngọc Vân (1906–1954) wrote an essay titled "Only now do we have Vietnamese painting." Vân was writing in the midst of an anticolonial war (the First Indochina War 1946–1954), so his sense that Vietnamese art was beginning anew was tied to his aspirations for an independent Vietnam and a desire to distinguish the national future from the colonial past. In this article, Vân bitterly lamented the deluge of French influence during the colonial period, but he also remarked on the place of Chinese and Japanese art during that same period. He wrote of artists "passively following" Chinese and Japanese painting, to the extent that "when choosing a scene for a painting, Vietnamese painters would choose whatever scene was most 'Chinese.' To praise a painting we would say: Really 'Chinese'!" (Tô 1949: 61). Tô Ngọc Vân even included sarcastic formulae for paintings in the years 1929 ("Western + Chinese, Japanese") and 1931 ("Chinese, Japanese + Western") (Tô 1949: 61).

While Vân's wartime nationalism created a desire to filter foreign elements from Vietnamese art, his article nonetheless raises interesting questions about the place of East Asian influences on colonial art. Research into modern painting in Hanoi has generally concentrated on the transmission and adaptation of French painting styles and concepts of art through the activities of the École des Beaux-Arts de l'Indochine (EBAI), an art school established by the French government in 1925. The EBAI

followed a European-style academic curriculum, but also promoted localization through the development of painting on silk and in lacquer (André-Pallois 1997; de Ménonville 2003; Taylor 2004). Nora Taylor, in her seminal study of modern Vietnamese art, has described how postcolonial Vietnamese art historiography subsequently reframed silk and lacquer painting as national forms, implicitly linking them with anticolonialism to emphasize art historical continuity between the colonial and postcolonial periods (2004: 38–40).

Yet, while the definition of "Vietnamese art" was reified after independence, the quest to create a Vietnamese aesthetic in painting was a relatively open discourse during the colonial period itself. Vietnamese artists wanted to find Vietnamese characteristics in their work, but there was no clear sense about what form those characteristics should take. John Clark has identified that different articulations of aesthetic nationalism in modern Asian art correspond to different phases in the development of the nation-state (1998: 242). Following this argument, an aesthetic nationalism-in-formation can exist prior to the political nation, where aesthetic nationalism is understood as a process that "remakes the past by associating it with a people, or with the culture of a limited geographical area, and projecting its values forward as a prescription of what the future should be" (Clark 2005: 3).

I argue that the integration of aspects of Chinese and Japanese art was an important part of the development of Vietnamese characteristics in colonial period art, alongside the reception of local and French sources. This was not principally in terms of stylistic or technical exchanges, but in how Vietnamese artists imagined the "Asian character" (*tính cách Á đông*) of their own work. Writing about the formation of modern Chinese ink painting, Aida Yuen Wong has described how the style developed through transcultural contacts with Japan, in which "the foreign [became] embedded in China's identity, both literally and imaginatively" (2006: xxi). In Hanoi, a similar embedding of foreign elements into aesthetic identity was not a seamless process, but subject to contestation and reevaluation over time. Initially, a concept of "Asian" aesthetics was produced through French perceptions of Vietnamese art and the practices of the colonial education system. It was taken up in various forms by artists of the EBAI. In the early 1940s, however, a series of important touring exhibitions during the Japanese occupation period introduced Vietnamese artists to modern Japanese art. Masahiro Ushiroshoji has uncovered details of the exhibitions and introduced some aspects of the Japanese response to Vietnamese art (2005, 2009). On the other side of the encounter, the Vietnamese reception of these exhibitions shows a revision of pre-existing ideas about "Asian character" and its relevance to Vietnamese art. Through consideration of art practice and art writing in colonial Hanoi, it is possible to see how ideas of "Asian" art overlapped with and informed the development of Vietnamese aesthetic nationalism.

COLONIAL INTERVENTIONS IN THE VISUAL ARTS

In the early decades of the twentieth century, French art critics and administrators writing in the colony perceived a crisis of taste in the production of decorative arts in Vietnam.[1] This crisis was precipitated by colonial contact, resulting in the creation of hybridized products that blended local and European features. There was widespread criticism of such art forms, which were often described in terms of *décadence* and *métissage,* the latter referring literally to the physical mixing of races.[2] The disdain for hybridity stemmed from a belief that the special characteristics of a race should be manifest in an equally distinctive artistic personality. It was also thought that aesthetically "pure" products would be more successful in the international market for exotic colonial artifacts. Colonial interventions were designed around this perceived problem, including the formation of exhibiting societies and art schools oriented toward the renovation of local crafts.

But while the opening of art schools was praised for reversing the perceived degradation of local arts, it also posed a delicate pedagogical problem: How could French educators instruct indigenous students without further promoting the cultural hybridity the system was designed to correct? Various strategies were devised to attempt to preserve the "racial personality" of the Vietnamese students, including hiring indigenous professors to teach under French supervision, encouraging students to work directly from the observation of nature, and promoting the copying of model objects selected by the French professors as the best examples of the local tradition. As Muan has pointed out in her study of similar methods in Cambodia, this system arrogated responsibility for identifying, defining, and enforcing the production of "traditional" objects to French authorities, despite their preservationist rhetoric (2001: 72–183).

The EBAI, which opened in Hanoi in 1925, took a different approach to art education, largely due to the personal intervention of its first director, painter Victor Tardieu (1870–1937). The school's curriculum was adapted from French art academies and emphasized drawing as a fundamental foundation for all arts. It included training in painting and sculpture, decorative art, history of art, and anatomy and perspective (Section de l'Instruction Publique 1931). The professors were principally French. The school accepted students from all over Indochina, but the majority came from North Vietnam. Students were selected through a competitive examination in drawing and design, which were considered universal fundamentals for artistic creation.

Nonetheless, the preoccupations behind the curricula of the pre-existing art schools also left their mark on the EBAI. The Director of Public Instruction reiterated the hope that students would produce work "in harmony with their racial

genius" (Blanchard de la Brosse quoted in Merlin 1924: 2083). Tardieu, however, had a more inclusive perspective. In a letter defending the EBAI's program, he condemned the practice of copying from historical art forms as sterile, arguing that art should reflect the profound changes sweeping Indochina to avoid being "in absolute contradiction with historical truth" (1924: 19). Tardieu also disputed the idea that Eastern and Western aesthetics were fundamentally contradictory, citing a wide variety of supporting sources from Xie He (active ca. 500–535) to Arthur Waley (1889–1966) to Abanindranath Tagore (1871–1951). He quoted with approval the following passage from Ananda Coomaraswamy (1877–1947): "The chosen people of the future cannot be a nation or a race, but an aristocracy of the earth, unifying the energy of European action and the serenity of Asian thought" (Coomaraswamy as quoted in Tardieu 1924: 21). The references to Coomaraswamy and Tagore, both influential in presenting Asian art to the West, suggest Tardieu had absorbed currents of the pan-Asian aesthetic theory circulating in the period.

Thus, while the EBAI was not concerned with a narrowly construed preservationism, it was also not an intentionally Westernizing institution. Students were deliberately directed toward their "tradition" through practices like making architectural drawings of local monuments, such as the Đình Bảng communal house, so that they could be imbued with their motifs and forms. Tardieu also sought out model objects for the students to reference, including reproductions of Tang and Song dynasty Chinese silk paintings, as well as paintings from seventeenth-century Japan (Quang 1993: 25). While this could be interpreted as symptomatic of Tardieu's personal cosmopolitanism, in fact model objects from East Asia had been used before in Vietnam. For example, Hanoi's École Professionelle had hired several Japanese artisans to teach lacquerwork and bronze casting. Local critics noted a pronounced Japanese influence on local lacquerware as a result (Bernanose 1922: 124; Koch 1913: 14).

These practices reflected a widely held view that Chinese art was the original source for both Japanese and Vietnamese art, and that they shared a resulting familial connection. Even though many French scholars held a more nuanced view of Vietnamese culture, this perception was still reflected in the colonial order.[3] In the art history curriculum of the EBAI, one year was spent on "Chinese art, and art issuing from the Chinese: Japanese, Annamite and Korean art" (Gouvernement Général de l'Indochine 1937: 12). Similarly, Hanoi's museum grouped artifacts according to their perceived spheres of influence, with Vietnamese examples displayed alongside Chinese art from the Han to Ming dynasties (Wright 1995: 129). Thus through the discourse of art education, the colonial state represented to indigenous artists a perception of their own heritage, and this representation located "Annamese" art within an East Asian cultural sphere.

THE RECEPTION OF "ASIAN" ART

To consider how these ideas were taken up by Vietnamese artists, it is useful to look at some of the writing about art produced in the colonial period by Tô Ngọc Vân (quoted earlier). Vân was one of the dominant voices in the relatively small body of writing produced by the EBAI artists at the time. His views offer an alternative representation of the development of colonial-period art to that produced by the colonial state and by postcolonial scholarship. Vân was both an exemplary product of the colonial art school system and an ambivalent colonial subject. He graduated from the first intake of the EBAI in 1931, having concentrated on oil painting and the new technique of painting in gouache or colored inks on silk. He later taught drawing in schools in Hanoi and Phnom Penh, fulfilling one of the initial goals of the EBAI, namely that its graduates would become art teachers. After the revolution in 1945, he joined the Việt Minh and was the director of the first postcolonial Vietnamese art school. As a result of his death on the way home from the battle of Điện Biên Phủ in 1954, he has been remembered as a national hero within Vietnam (Taylor 2004: 42–52). Vân's posthumous reputation has, to some degree, obscured the complexity of his views, both as a colonial and revolutionary subject.

For Vân, one of the principal problems in creating a modern, national aesthetic lay in his perception that Vietnamese art had no painting tradition of its own. He began a 1942 essay with the anxious query: "Did our country have painting in the past?" (Tô 1942: 4), but concluded the few surviving examples of precolonial Vietnamese painting were slavish imitations of Chinese style. In architecture, he perceived the successful localization of Chinese influences, and lamented that if only those architects had thought to paint, then modern artists would not be facing such difficulties. Vân also rejected the idea that printed New Year pictures (*tranh Tết*) could be a useful source for modern Vietnamese painting, as he saw them as the products of artisans who were neither professionally trained nor personally inspired. Increasingly concerned with aesthetic nationalism, Vân was attempting to forge a continuity between his own painting practice and a national past. But at the same time, he saw himself as a "fine artist" within the European understanding of that term. Thus, he searched for historical precedents that corresponded to the domains of practice privileged as fine art by the EBAI. This issue was of particular significance in the Vietnamese context, as in the late 1930s the new director of the EBAI shifted the curriculum of the EBAI toward artisanal training. Several prominent Vietnamese artists recognized that this shift represented a demotion within the hierarchy of European arts discourse, and vehemently protested those changes (Taylor 2004: 33–34). This context also explains why Vân was reluctant to draw substantially from folk aesthetics.

Tardieu had perhaps also perceived a void in precolonial painting, which was why he promoted the practice of painting on silk as a return to Chinese cultural roots. However, by the 1940s some artists had become critical of such efforts. An anonymous reviewer (probably Tô Ngọc Vân) wrote: "We still remember a time when our artists imitated Chinese paintings in a not very clever manner. That work of imitation we called 'preserving the essence of Asian painting'" (Anonymous 1941b: 7). This writer described how artists would artificially age their paintings by wrinkling them or exposing them to kitchen soot to imitate the surface qualities of antique Chinese silk paintings. Vân was also quite critical of superficial hybridizations, such as efforts to "Asianize" oil painting, which he described as "weak or lacking in sincerity, with an Asian shell but not its spirit" (Tô 1941: 23). Writing in a postcolonial environment in 1949, he was even more scathing, claiming that the early EBAI practice of writing calligraphy on the painting surface and signing with a seal was "borrowing from Chinese and Japanese painting" as a trite attempt to resist dominating French influences (Tô 1949: 62).

This latter comment was perhaps an attempt to give an anticolonial gloss to earlier practices. Nonetheless, these comments suggest possibilities for understanding what engagement with Chinese art might have meant to Vietnamese artists in the colonial period. What also emerges from Vân's description is the sense of the constructed nature of the early endeavors to "Asianize" painting at the EBAI. These works were not the product of an unmediated synthesis between "tradition" and Western influence, but a deliberate set of experiments that corresponded to both colonial expectations and indigenous desires for identity. Taylor has described the practice of silk painting at the EBAI as an "invented tradition" in the sense coined by Hobsbawm and Ranger (1983), as it involved the creation of unprecedented modern forms from disparate elements of foreign and local practice (Taylor 2004: 40).[4] Tô Ngọc Vân's comments reveal a consciousness of the tensions and ambiguities within that process of invention.

Vân was not critical of all forms of painting on silk. He admired the work created by Nguyễn Phan Chánh (1882–1984) for the 1931 International Colonial Exposition in Paris. Unlike most EBAI students, Chánh had received a traditional Confucian education before coming to Hanoi and was an experienced calligrapher. In his paintings, Chánh represented scenes of precolonial Vietnamese village life, using a sober, restricted palette of blacks, browns, and yellows on a silk backing. His painted figures, although realistically treated, are abbreviated into blocks of color. The absence of defined background details focuses the attention on the intimacy of the interactions between the figures. His works were an outstanding critical success at the Colonial Exposition (Tardieu 1932) and were subsequently also well received in Vietnam. A review in the popular magazine *Phong hóa* (*Mores*) wrote that Chánh had achieved a successful integration: "Mr Chánh studied Western painting methods

[and] paints in a simple, modest manner like that of Chinese painting, but his pictures still look 'Annamese'" (Đông 1933: 9).

The technique of painting in lacquer also came about through a synthesis of existing local artisanal practices, French painting, and research into techniques and styles from elsewhere in East Asia. For Tô Ngọc Vân, Vietnamese lacquer painting transformed lacquer from a "decorative art" to a "pure art," something he believed Chinese and Japanese lacquer had never accomplished (Tô 1943). Vietnamese lacquer is a natural product of the indigenous *Rhus succedanea* tree. It was widely used in precolonial Vietnam to coat wooden furniture, architectural interiors, sculptures, and votive objects, both as a protection against the climate and to give a lustrous finish. Lacquer became incorporated into the curriculum of the EBAI from 1927, when Joseph Inguimberty (1896–1971), the professor of decorative arts, invited a master lacquer artisan, Đinh Văn Thành, to teach at the school (Quang 1993: 25).

Because of the peculiar climatic sensitivities of lacquer, as well as the allergenic properties of the raw substance, it requires careful handling and painstaking preparation. The process of transforming lacquer into a modern painting medium was hence the result of vigorous technical experimentation at the EBAI. Some of these experiments were likely informed by Japanese lacquer techniques. Trần Quang Trân (1900–1969), one of the earliest students to enroll in the lacquer studio, may even have undertaken research in Japan in the 1930s. He introduced the technique of using gold dust suspended between coats of red lacquer (Quang 2007: 269). A lacquer painting by Lê Phổ (1907–2001) sent to the 1931 Colonial Exposition, suggests that the interest in Japanese lacquer techniques may also have carried over into an interest in Japanese visual language. This painting shows a landscape rendered in geometric forms, reminiscent of the stylized treatment of natural motifs in Japanese screen painting. Another technique derived from East Asian precedents was the coromandel technique, where the lacquer surface is incised with a sharp tool and colors are painted into the depressions. Coromandel lacquer was a form of Chinese export ware, which Inguimberty introduced through a model he had studied in Paris (Anonymous 1941b: 4). This technique suited the representation of meticulous linear designs, such as in the work of Nguyễn Văn Bái, who depicted auspicious objects and symbolic motifs, as well as scenes of court and religious processions.

The most successful artist in lacquer during the colonial period, however, was Nguyễn Gia Trí (1908–1993). Trí was considered to have brought the most personally expressive vision to lacquer painting, thus moving the medium more definitively away from decoration. Tô Ngọc Vân described Trí's work in explicitly sensual terms. Trí's ca. 1936 painting *The Fairies* shows his loose and expressive handling of the

medium, which belies the painstaking nature of the technique: the slow build-up of individual layers of lacquer, and the meticulous inlay of minute fragments of eggshell (Plate 7). Nguyễn Gia Trí put lacquer painting in dialogue with French modernism: this work has a clear compositional relationship with Henri Matisse's 1905–1906 painting *The Joy of Life*. In both works, small figural groups are dispersed in a landscape, which is arranged as a flat, rhythmic plane of color. Trí substitutes the disorienting flatness and brightness of Matisse's color with the visual effects of the tension between surface and depth, figure and ground, brought about by the translucent layers of colored lacquer. While Matisse's work evokes an ahistorical pastoral arcadia, Trí's work "Vietnamizes" the scene. Whereas Matisse's image frames the landscape with trees, Trí also includes the eaves of a pagoda. Matisse's dancers are nude, while Trí's wear *áo dài,* the fashionable, modern reinterpretation of Vietnamese dress. The liberal use of gold and the stylization of the forms of the foliage suggest Trí may also have incorporated aspects of Japanese screen painting in the design.

THE ENCOUNTER WITH JAPANESE ART

Through these experiments, colonial period artists synthesized aspects of Chinese and Japanese art to develop their modern style. In the early 1940s, however, several important exhibitions of Japanese art were held in Indochina as a result of political realignments of the Second World War. In September 1940, Japan sent troops into Tonkin, and by 1941 had occupied other areas of Indochina. The Japanese occupying force did not dismantle the French (Vichy) colonial administration, but allowed it to function until the Japanese *coup de force* of March 1945. Because of this arrangement, the Japanese generally did not give much support to Vietnamese anticolonial movements (Marr 1980). They did, however, promote the idea of Vietnam's place within the "Greater East Asia Co-Prosperity Sphere" through cultural programs such as Japanese language classes, films, and performances, and the publication of books on aspects of Japanese culture (Marr 1980: 1391).

A series of art exhibitions also formed part of this cultural propaganda (Ushiroshoji 2005, 2009). Organized by the Society for International Cultural Relations (*Kokusai Bunka Shinkōkai*), these included an exhibition of Japanese oil painting and an exhibition of *nihonga* (Japanese-style) painting that toured Indochina in 1941. A reciprocal exhibition of modern Indochinese art then toured the Japanese cities in 1943. This exhibition featured works from the EBAI, as well as other art schools in Indochina (Ushiroshoji 2009: 25). Accompanying the exhibition, three Vietnamese artists toured Japan, sketching Japanese scenes and meeting local artists. An exhibition of Japanese art history was also organized in Hanoi in late 1943–1944,

where important objects and monuments were represented by detailed schematic drawings.

The 1940s was thus a time of unprecedented contact between modern Vietnamese artists and Japanese art. However, as aspects of Japanese style had already been integrated into art in the previous decade, it is difficult to distinguish an occupation period Japanism based on visual forms alone. A woodcut by Trần Văn Cẩn (1910–1994), *Washing Hair*, demonstrates the issue (Figure 3.1). The image

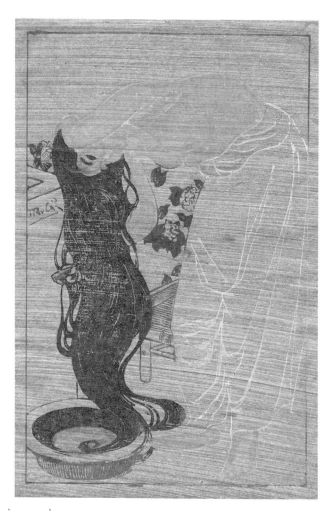

Figure 3.1 Trần Văn Cẩn, *Washing Hair*, undated hand-colored woodblock print on tinted Vietnamese paper with shell coating, from a ca. 1943 woodblock, 34 x 22 cm. Courtesy of Witness Collection, Kuala Lumpur.

represents a woman, naked to the waist, bending over a pail to comb her wet hair, which falls in stylized spirals and curves to the floor. Both in its subject matter and formal properties, the image resembles a modernized version of an *ukiyo-e* print. However, it is not certain when this woodblock was originally carved. Two surviving impressions have been variously dated to 1940 and 1943 by the Vietnam Fine Arts Museum, Hanoi and the Witness Collection, respectively. Given the ambiguity surrounding its date, then it is still possible the image was inspired through occupation period contacts, for example, through the 1941 *nihonga* exhibition, which also included examples of Japanese prints. However, *ukiyo-e* prints were also popular in France, so Trần Văn Cẩn could easily have seen them in French art magazines or via the EBAI. The image could therefore equally be a result of the "Asianizing" tendencies already in existence.

Like French colonial educators, the Japanese considered Vietnamese art part of East Asian art. This view was promoted in interviews with the Vietnamese press by Paris-trained oil painter Fujita Tsuguharu (1886–1968), who accompanied the exhibitions as a cultural attaché (Buisson and Buisson 2001: 200). The idea of a distinctive Asian art was the aesthetic dimension of pan-Asianist theory, which posited a common set of characteristics across the different countries of Asia, in opposition to the West. Within the boundaries of the censored Vietnamese press (which was still regulated by French authorities), some pan-Asianist texts were circulating at this time, including Vietnamese translations from the *Book of Tea* by Okakura Kakuzo, as well as a number of articles about the work of Rabindranath Tagore. Although pan-Asianism was also the ideological justification for Japanese imperialism, it was not a unitary system of thought (Hotta 2007: 19–52). While some strains of pan-Asianism emphasized Asia's cultural continuity, others concentrated on an ultra-nationalistic view of Japanese dominance within Asia. Vietnamese intellectuals were certainly aware of the different facets of the discourse. The previous generation of Vietnamese anticolonial intellectuals, for example, had looked to Japan as the potential source of an Asian modernity, before becoming anxious about Japan's territorial ambitions (Marr 1971). Artists were also aware of the links between pan-Asianism and Japanese control. Nguyễn Gia Trí even published a cynical political cartoon on the subject in 1938, where the "pan" in "pan-Asia" is onomatopoeic for the sound of a shooting gun.

Nonetheless, it appears that Vietnamese artists were engaged by Japanese art and aesthetics. Wong has argued that the development of Chinese national painting was mediated through the encounter with the "familiar other" of Japan (2006: 34). Vietnamese artists could also see a "familiar other" in Japanese art, not only because of a perception of shared "Asian" aesthetic values, but also because Japanese art shared a familiar problematic of modernity. Japanese modern artists had also negotiated

the complex mediation of local and Western influences, which had resulted in an institutional division of painting into separate branches for Western-style oil painting (*yōga*) and neo-traditional Japanese painting (*nihonga*). Ironically, the *nihonga* exhibition presented a more exotic image to the Vietnamese public: this was a different "Japanese art" to that previously refracted through the colonial education system. A review of the exhibition claimed that Vietnamese viewers, including artists, had trouble understanding *nihonga* painting (Anonymous 1941c: 3). This sparked a discussion of the different concepts of art in Western and Eastern painting, with the writer cautioning viewers not to seek photographic truth in Japanese painting, but to respond to the subjective impressions of the images (Anonymous 1941c: 3). Further articles took up this theme, emphasizing the division between Western realism, which aimed to capture the external features of objects in form, color, and light, and Eastern painting, which focused on line and evocative treatments of the object.

The *yōga* exhibition contained work that was more familiar. Tô Ngọc Vân described the *yōga* works as "old friends," through their echoes of Bonnard, Matisse, and Utrillo (Tô 1941: 22). However, seeing oil paint used by Japanese modern artists seems to have led Vân to question the idea that it was an innately Western medium. He commented that artists should not try to use oil paint in an "Asian manner," but if an artist was sincere, then the work would inevitably still have "Asian character" (Tô 1941: 23). A similar review suggested that oil painting had affinity with Asian people (Anonymous 1942: 3). Vân returned to this theme in 1945, referring to the case of an unnamed artist, who had many times "shown us the flavor of ancient Vietnam" (Tô 1945: 130). This anonymous artist (possibly the aforementioned Nguyễn Phan Chánh) claimed that in his early paintings he worked like an archaeologist, attempting to reconstruct the daily life of precolonial Vietnam. The artist confided:

> If you see me as a pure Vietnamese artist, you are completely wrong. I have to confess: I played a role well…When the work was finished, I looked for myself in it. Nothing at all of myself could be seen! Can you see that Western painting has some evolving magic that can express the complications of our hearts?…I find it so convenient to express my soul, the nervous wonderings dominating my mind.
>
> In oil paint, I don't lie to others, I don't lie to myself anymore. I feel relaxed and comfortable, under no pressure, as if in my own domain. (anonymous artist quoted in Tô 1945: 130–131)

This confession resonates with Homi Bhabha's discussion of colonial mimicry, where the adoption of forms of the colonizing culture is not a veneer masking an indigenous essence, but an indication of the hybridity of the colonized subject

(1994: 88). In this case, the sense of alienation did not come from the adoption of Western painting, but the performance of a "pure Vietnamese artist." Part of the issue was temporal: the artist was projecting a past Asia rather than the complicated feelings and "nervous wonderings" of modernity. Vân acknowledged this temporal problem too, commenting that works in oil would not have the "Asian" characteristics of the Han and Tang dynasties, but would reflect "the Westernized Asia of the twentieth century" (Tô 1941: 23).

These discussions shed light on how Tô Ngọc Vân might have considered his own practice. His 1940s oil paintings drew on Post-Impressionism, using flattened space and abbreviated patches of color, but with a harmonious color palette, as in *Two Young Girls and a Baby*.[5] His sense that oil painting could still be "Asian" if produced by a sincere artist was a way of asserting the legitimacy of his work. Vân had also begun to consider that some Western modernist styles had an "Eastern spirit" because of their embrace of subjective expression over Realist observation. That Wong has noted similar comparisons made in China and Japan between literati painting and Post-Impressionism suggests that Van's view may have been a result of contact with pan-Asian aesthetic theory (Wong 2006: 65). For Vân, the implication was that when Vietnamese artists took up modern painting styles, it was as if the work "had already been Vietnamized" (Tô 1945: 135). Though Vân still thought the project of "Vietnamization" was unfinished, ideas like these were dissolving the sense of concrete divisions between Eastern and Western art and creating a sense of ownership over a medium and style of exogenous origin. Ironically, by the early 1940s, it was not the deliberately "Asian" practice of painting on silk, but the imported medium of oil painting that Vân considered the more successful form of aesthetic nationalism.

CONCLUSION

The development of aesthetic nationalism in Hanoi in the colonial period was significantly influenced by the character of the EBAI as an institution. The EBAI transferred a European academic discourse that privileged certain forms of activity as art. On the other hand, anxiety about the preservation of the local "racial genius" resulted in "Asianizing" initiatives in the curriculum. But these interventions were not received uncritically by Vietnamese artists. As the writings of Tô Ngọc Vân demonstrate, Vietnamese artists began to question the relevance of some of these practices to their modern experiences. At the same time, the encounter with modern Japanese art also caused artists to reassess their position. Pan-Asianist theories may have provided a way to reframe oil painting practice in terms of "Asian" subjectivism, while seeing that modern Japanese painters were also inspired by French oil painting

perhaps likewise allowed Vietnamese artists to distance that medium from its colonial associations. However, these ideas were relatively short-lived. As a result of the revolution of 1945 and the subsequent war with France (1946–1954), the idea of "Asian" characteristics lost much of its relevance. Aesthetic nationalism became more specifically directed toward the priorities of the state, and informed by Marxism-Leninism (Taylor 2004). As silk and lacquer came to be understood as "national mediums," the subtleties and ambiguities of colonial period aesthetics were obscured.

NOTES

1. In the French colonial period, Vietnam did not exist as a country but was divided into three separate regions (Tonkin, Annam, Cochinchine), which were among the five "countries" of the Indochinese Union. French writers in the colonial period used the term "Annam" to also refer to Vietnam generally. Vietnamese writers used "Annam," or in later years "Vietnam." I use the term "Vietnam" rather than "Annam."
2. Comments on the problem of *décadence* were very common: examples can be found in art historical surveys (Bernanose 1922: 10–11; de Pouvoirville 1894: 277–282; Gourdon 1933: 64), art criticism (Koch 1924: 353), and documents on colonial education policy (Section de l'Instruction Publique 1931). Similar terms were used in the Cambodian context (Muan 2001: 10–24).
3. Several studies have demonstrated that French colonial scholars, particularly of the École Française d'Extrême-Orient, did not hold a simplistic view of Vietnamese culture. Nonetheless, there was a perception that Vietnamese art had developed its own characteristics from a Chinese basis (Clémentin-Ojha and Manguin 2001; Taylor 2000).
4. Evidence of precolonial silk painting is limited, although Taylor does identify possible precedents for the EBAI technique in ceremonial temple scrolls and the art of the Yao ethnic minority (2004: 35).
5. There are several versions of this painting, including nearly identical works held by the Vietnam Fine Arts Museum, Hanoi and Fukuoka Asian Art Museum. It has been suggested that Tô Ngọc Vân painted multiple versions of the image in 1943–1944, in the aftermath of wartime damage to the EBAI (Rawanchaikul 2005: 181).

REFERENCES

André-Pallois, N. (1997), *Indochine: un lieu d'échange culturel?; les peintres français et indochinois (fin XIXe-XXe siècle)*, Paris: Presses de l'École française d'Extrême Orient.
Anonymous, (1941a), "Les Maître-lacqueurs de Hanoi" ("The Lacquer Masters of Hanoi"), *Indochine*, 22–23.
Anonymous, signed "*nghệ sĩ* (artist)." (1941b), "Hội họa và Sơn ở Phòng Triển lãm Năm nay" ("Painting and Lacquer at this Year's Exhibition"), *Thanh Nghị*, June: 7.

Anonymous, signed *"nghệ sĩ* (artist)." (1941c), "Tranh Nhật với Công chúng An Nam" ("Japanese Paintings and the Public of Annam"), *Thanh Nghị,* November: 3.

Anonymous, signed *"nghệ sĩ* (artist)." (1942), "Tranh dầu Nhật-Bản" ("Japanese Oil Painting"), *Thanh Nghị,* 8: 3.

Bernanose, M. (1922), *Les Arts décoratifs au Tonkin,* Paris: Henri Laurens.

Bhabha, H. (1994), *The Location of Culture,* London and New York: Routledge.

Buisson, S. and Buisson, D. (2001), *Léonard-Tsuguharu Foujita,* Courbevoie: ACR.

Clark, J. (1998), *Modern Asian Art,* Sydney: Craftsman House.

Clark, J. (2005), "Okakura Tenshin and Aesthetic Nationalism," *East Asian History,* 29: 1–38.

Clémentin-Ojha, C. and Manguin, P. (2001), *Un Siècle pour l'Asie: l'École française d'Extrême-Orient, 1898–2000,* Paris: Editions du Pacifique, École française d'Extrême-Orient.

de Ménonville, C. (2003), *Vietnamese Painting from Tradition to Modernity,* Paris: Les Editions d'Art et d'Histoire.

de Pouvourville, A. (1894), *L'Art Indo-Chinois,* Paris: Ancienne Maison Quantin, Librairies-Imprimeries Réunies.

Đông, S. (1933), "Mỹ thuật: Nguyễn Phan Chánh" ("Art: Nguyễn Phan Chánh"), *Phong hóa,* 34: 9.

Gourdon, H. (1933), *L'Art de l'Annam,* Paris: E. de Boccard.

Gouvernement Général de l'Indochine. (1937), *Les Écoles d'art de l'Indochine,* Hanoi: Imprimerie d'Extrême-Orient.

Hobsbawm, E. and Ranger, T. (1983), *The Invention of Tradition,* Cambridge, New York: Cambridge University Press.

Hotta, E. (2007), *Pan-Asianism and Japan's War,* New York: Palgrave Macmillan.

Koch, M. (1913), "Amicale Artistique: Hanoi 8 December 1912—3rd Exhibition," *Les Pages Indochinoises,* 1: 14–15.

Koch, M. (1924), "Chronique artistique: le bourgeois français et l'artiste annamite," *Les Pages Indochinoises,* 9: 353–354.

Marr, D. (1971), *Vietnamese Anticolonialism 1885–1925,* Berkeley, Los Angeles, and London: University of California Press.

Marr, D. (1980), "World War II and the Vietnamese Revolution," in A. McCoy (ed.), *Southeast Asia under Japanese Occupation,* New Haven, CT: Yale University Southeast Asia Studies.

Merlin, M. (1924), "Arrêté 29 October 1924," *Journal officiel de l'Indochine française,* 2083–2085.

Muan, I. (2001), *Citing Angkor: The "Cambodian Arts" in the Age of Restoration,* New York: Columbia University, PhD thesis.

Quang, P. (1993), *Painters of the Fine Arts College of Indochina,* Hanoi: Fine Arts Publishing House.

Quang, V. (2007), *Từ điển Họa sĩ Việt Nam* (*Encyclopedia of Vietnamese Painters*), Hanoi: Fine Arts Publishing House.

Rawanchaikul, T. (2005), "The Painting in Multiples," in M. Ushiroshoji (ed.), *50 Years of Modern Vietnamese Paintings: 1925–75,* Tokyo: The Sankei Shimbun.

Section de l'Instruction Publique, Exposition Coloniale Internationale, Paris, 1931, Indochine Française. (1931), *Trois écoles d'art de l'Indochine: Hanoi, Phnom-Penh, Bien-Hoa,* Hanoi: Imprimerie d'Extrême-Orient.

Taylor, N. (2000), "Whose Art Are We Studying? Writing Vietnamese Art History from Colonialism to the Present," in N. Taylor (ed.), *Studies in Southeast Asian Art: Essays in Honour of Stanley J. O'Connor,* Ithaca, NY: Southeast Asia Program Publications, Cornell University.

Taylor, N. (2004), *Painters in Hanoi: An Ethnography of Vietnamese Art,* Honolulu: University of Hawai'i Press.

Tardieu, J. (1932), "L'Art annamite moderne," *L'Illustration,* 4683 (unpaginated).

Tardieu, V. (1924), Letter to the Governor-General of Indochina on the subject of a letter by M. Silice. GG51038. Aix en Provence: Centre des archives d'outre mer.

Tô, V. (1941), "Phê bình Nghệ thuật vẽ Sơn của Họa sĩ Nhật" ("Art Criticism of Japanese Painting"), *Trung Bắc Chủ Nhật,* 90: 22–23.

Tô, V. (1942), "Tranh Cổ Việt Nam, Tranh Tết" ("Antique Vietnamese Pictures, Tet Pictures"), *Thanh Nghị,* 9: 4–5.

Tô, V. (1943), "Sơn ta: Mỹ thuật Thuần túy hay Mỹ thuật Trang sức?" ("Lacquer: A Pure Art or a Decorative Art?"), *Thanh Nghị,* 45: 2–3.

Tô, V. (1945), "Mỹ thuật Việt Nam Hiện đại và Tương lai Hội họa" ("Modern Vietnamese Art and the Future of Painting"), *Thanh Nghị,* February: 130–131, 135.

Tô, V. (1949), "Bây giờ mới có Hội họa Việt Nam" ("Only now do we have Vietnamese Painting") *Văn Nghệ,* Spring issue: 55–58, in volume 2 of N. Hữu (ed.) (1999), *Sưu Tập Văn Nghệ 1948–1954 (Collected Văn Nghệ 1948–1954)*: 61–64, Hanoi: NXB Hội Nhà Văn.

Ushiroshoji, M. (2005), "The 'Modern Age' of Vietnamese Fine Art—From the Perspective of Southeast Asia," in M. Ushiroshoji (ed.), *50 Years of Modern Vietnamese Paintings: 1925–75,* Tokyo: The Sankei Shimbun.

Ushiroshoji, M. (2009), "'The Great East Asia War' and Art Exchange between Japan and Vietnam: The Vietnamese artists' 1943 Journey to Japan," in S. Lee and N. H. Nguyen (eds.), *Essays in Modern and Contemporary Vietnamese Art,* Singapore: Singapore Art Museum.

Wong, A. (2006), *Parting the Mists: Discovering Japan and the Rise of National-style Painting in Modern China,* Honolulu: Association for Asian Studies and University of Hawai'i Press.

Wright, G. (1995), "National Culture under Colonial Auspices: The École Française d'Extrême-Orient," in G. Wright (ed.), *The Formation of National Collections of Art and Archaeology,* Hanover and London: University Press of New England.

4 COMING HOME: HOW "RE-ENTRY" SHAPED THE WORK OF A CONTEMPORARY WOMAN ARTIST IN TAIWAN

Natalie Seiz

INTRODUCTION

During the 1980s and 1990s, a number of Taiwanese artists left the country to pursue more advanced art training abroad because of the lack of postgraduate art training at home (see Wang and Kuo 2010).[1] Taiwan's economic and political development and the lifting of martial law in 1987 helped generate more overseas opportunities.[2] This chapter considers the situation of Taiwanese women artists returning to their "homeland" after a period of study overseas, and the influence this had on the work they produced and in turn how they stimulated ideas in Taiwan. Because of their efforts, the complexity of contemporary art production in Taiwan has become multilayered and feeds into larger questions dealing with ideas of globalization and transculturalism. Specifically, women re-entering during the period of the 1980s and 1990s, whether or not they were ideologically aligned with a burgeoning feminism, became inadvertently marginalized on various levels in a male-dominated Taiwanese art world. I particularly examine how artist Hou Shur-tzy has confronted "re-entry" and its cumulative concepts.

THE NOTION OF "RE-ENTRY"

Education abroad became a rite of passage for Taiwanese artists during the 1980s and 1990s, yet between the recognition of legitimacy they receive at the site of return—or "re-entry"—and their interconnectedness with the space and time of the site itself

is a tension that is sometimes overlooked. Re-entry can have a dual meaning—first a return to the usual place one inhabits; and second the act of coming back to a place, which makes it a new entry.[3] I primarily use the second sense of the term here. I also use re-entry as a lateral concept that can refer to different re-entry sites based on class or on diversity within culture and race.[4] This examination of movements allows an exploration of what effect alternative circuits of transnationality had on women's art in Taiwan (Lionnet and Shih 2005: 13). Re-entry was not only a return home, it opened up artistic links between the place of origin and where one studied or lived abroad. Further, it was a way by which different overseas art movements and styles entered Taiwan's art history.

The route to re-entry is not static, and it does not function only one way. As Peggy Levitt and Nina Glick Schiller have noted in regard to the notion of simultaneity, people have lived experiences both in the "country of destination" and transnationally:

> Movement and attachment is not linear or sequential but capable of rotating back and forth and changing direction over time. The median point on this gauge is not full incorporation but rather simultaneity of connection. Persons change and swing one way or the other depending on the context, thus moving our expectation away from either full assimilation or transitional connection but some combination of both. (2004: 1011)

Re-entry for the artist can consist of multiple "intervals" that are neither located in place of origin nor in place returned from, and therefore creates a dilemma in pursuing a singular identity. This was the experience of a number of Japanese women artists in the late 1950s and early 1960s, for example, who lived and worked in New York. They were marginalized in both Japanese and Western societies and hence pigeonholed into a "this" or "that" position (Yoshimoto 2005: 44), as opposed to what Samir Dayal has referred to as a "neither just this/nor just that" view (1996: 47).[5] Their reception was also often put down to Western influences from other artists and not judged in the context of their own production.

I hesitate to refer to artists in such a position as inhabiting "in-between" spaces, as this implies that being is drawn from simple pre-existing binaries, and hence circumscribes a location placed against notions of "purity." Instead, I suggest an examination of the different circuits of movement artists make. Homi Bhaba comments that "'in-between' spaces provide the terrain for elaborating strategies of selfhood—singular or communal—that imitate new signs of identity, and innovative sites of collaboration, and contestation, in the act of defining the idea of society itself" (1994: 1). As such, he defines these spaces as legitimate for the pursuit of identity in a society. But by nature of this categorization they are then relegated to

just another marginal space among multiple hybrids. Whose identity would one presume to find here? A hybrid among many hybrids—all of which cannot attain a genuine position on the extant binary scale? Or can the "in-between" be regarded as legitimate, as the limits of the binary in which it is confined? As Clark notes in regards to the work of artists:

> Due to globalisation, hybridity may no longer be a condition that artists of "Asian" origin choose in undertaking their work. Hybridity has become a much more generalised feature of cultural and hermeneutic identification, and may have become one of the conditions of both. It now appears to be a notion that encompasses the amalgamation, or mixing, of differently constituted or differently originating cultural elements as a condition for modernity in art. (2008: 4)

Can hybridity then be attributed to the conditions of globalization, or is it a condition of itself? If globalization could be perceived as an assault from the West to the detriment of the localized culture, the point of re-entry for the artist would represent a complexity that a single identity would not suffice to explain.[6] Therefore, aspects of the artist themselves and their work could be perceived as a rebuke on local ideologies, or as Clark states, "When artists cross boundaries there are basic discrepancies between their position with regard to the local art world and their motivation in what they seek to obtain from it" (1998: 264).

Reasons for re-entry are numerous, including the conclusion of a period of study, duty to family needs, relationships, work opportunities, finances, homesickness, health, and so on. But re-entry could also be seen in the context of a sojourn in one's country of origin when one is already living and working abroad. For example, performance artist Hsieh Teh-ching (Sam Hsieh), after going to the United States and being an illegal immigrant for some time, at one point did not go back to Taiwan at all for fourteen years (Heathfield and Hsieh 2009). He admits his family was extremely conservative and always asked him to return, yet they also supported him financially whenever he asked. At the same time he also was upset that the type of art he was doing in the United States was severely criticized in Taiwan (Bajo and Carey 2003). Cho Yeou-jui, a woman artist who left Taiwan to study abroad in the 1970s, went to New York and never returned to settle in Taiwan, as the freedom she had in New York kept her there, along with her then-husband, who was also an artist.[7]

Once "home," the inability to reassimilate or even accept the society from which one originates can cause other tensions.[8] Additionally, the risk of no longer being considered "Taiwanese" in the nationalist sense by those in Taiwan, but rather a member of the diaspora, created further incentive for some to try to maintain links to place of origin.[9] Identification with a diaspora has presented another discourse

with which many of these artists could also engage. While there was a need to fit in abroad, on returning home they were considered diasporic, and hence were in the same situation twice.

In Taiwan, such a point of re-entry was a crucial space for a number of women artists and their recently engaged notions of feminism. Whether or not there was a political affiliation with feminist practice, these artists came back to a changing society that was attempting to come to terms with the more significant presence of women in visual culture. These women, in return, were more heavily scrutinized, especially as they were openly enunciating their opinions and their status. Tradition-alist attitudes toward "Chinese" or Confucian ideologies related to filial piety (*xiaos-hun*), and the duty to get married (*nüsheng waixiang*) for women in particular—values that may have been put aside once the opportunity of overseas education was determined—often conceal other reasons why artists left and re-entered the "home-land", and indicate the manifold issues surrounding re-entry into such a context.

THE WOMEN'S ART ASSOCIATION

One of the effects of the re-entry process for women artists was the emergence of the Taiwan Women's Art Association (WAA) (*Taiwan nüxing yishu xiehui*),[10] a non-profit organization formally established on January 23, 2000, generally because of the hostile reception a number of women encountered upon return, and the fact that opportunities for women artists were limited in a male-dominated art world. The WAA is not a generic arts association, as its focus is mostly on the visual arts, with members primarily involved in contemporary, critical visual art practice and discourse. Members include artists, curators, administrators, and art historians, as well as others involved in the visual arts industry.

In an art historical context, the WAA in Taiwan is more than a group of women who came together purely based on their gender. The aim of the association, in the Euro-American feminist art movement mold of the 1960s and 1970s, was, at a more grassroots and ideological level, to seek and provide opportunities for women to exhibit in what was seen as a frustratingly patriarchal art industry. It legitimized women's art and, as an association, could apply for government funding to realize ex-hibitions. Its influence generally was to increase research and awareness of feminism in the country's art scene.

However, not all women artists saw the WAA as an answer. For example, abstract artist and previous director of the Taiwan Museum of Art in Taichung, Ava Hsueh (Hsueh Pao-hsia), did not join the organization after returning from study in New York during the 1990s. It can be construed that she actively did not want to be

compartmentalized as a woman artist. Another woman artist who worked with geometric abstraction, sculpture, and performance did not know much about the organization upon her return from the United Kingdom in the 2000s and had no need or desire to join such an organization, as she felt its philosophies had nothing to do with her purpose as an artist and her formalist art practice.[11] As such, the ambiguity of the term *nüxing* in the association's name, meaning female and woman, seldom identified a woman's political position.

HOU SHUR-TZY

By the 1980s and 1990s, a number of women artists, such as Wu Mali, Lai Chunchun, Chen Hsing-wan, Yan Ming-huy, Lin Peychwen, and Shieh Jun among others, had returned from study or sojourns abroad. Curators and writers such as Chang Yuan-chien (Rita Chang) and Lu Yung-Chih (Victoria Lu) were also returning from abroad. Significantly, this period of increased women's participation in the Taiwan art world also represents a generational shift in how contemporary art in general was practiced on the island. The artist I concentrate on here is Hou Shur-tzy (also known as Lulu Hou), who returned from the United States at the end of 1994.

Hou Shur-tzy was born in 1962 in southern Taiwan's Chiayi county, into a middle-class, rather well-off, conservative family. From the age of five or six she was interested in drawing and sketching.[12] In the first year of high school, she started to take external drawing classes at the National Taiwan Normal University every week.[13] In Taiwan in the early 1980s, only two universities had art departments: Taiwan National Normal University, which was a teacher training university, and the Chinese Cultural University. There was also one dedicated art school, the National Taiwan College of the Arts, which became the National Taiwan University of the Arts in 2001. Hou had decided to take art as part of her high school curriculum, with the rigorous examination process requiring passes in four areas: calligraphy, Chinese painting, sketching, and watercolor. To her disappointment, she did not gain entry into art school and studied philosophy instead at National Taiwan University (NTU), the most prestigious university in Taiwan. However, Hou dismisses getting into philosophy as insignificant, especially in light of family expectations that she would enter a more professional degree, as most of her siblings did (also at NTU).

Hou was given a Nikon FM2 35mm single-lens reflex camera as a congratulatory gift from her mother for getting into NTU, a significant, costly gift in early 1980s Taiwan. Hou pursued art studies on her own and joined a student activity group in which she started to learn photography, including how to develop film, mix chemicals, and make prints. At first, she followed the study of photography in the

same way that she followed painting, seeing the new medium as a convenient way to express what she thought and saw. Yet eventually she decided photography better suited what she wished to convey.

STUDY OVERSEAS

After graduating in 1985, Hou worked for some years and then, in 1989, produced a photobook titled *Reflection in the Lake of Life* (*Shengming de dao ying*) as her portfolio. With this she entered the Rochester Institute of Technology in upstate New York, one of the leading US institutions for the study of photography, where in 1992 she attained a Masters of Fine Art in Imaging Art. While in Rochester, Hou also went to study sculpture at the School of Art and Design at Alfred University in upstate New York and learned to work with ceramics. There she developed sculptural works that were later incorporated into a number of her performance and photographic pieces, including *The Labyrinth Path* 1992 (*Mi gong zhi jing*) for her MFA exhibition, which was the first time she exhibited her work. To enhance her study of photography, Hou then completed a certificate in photographic preservation at the International Museum of Photography (Eastman House), Rochester in 1994.

Hou acknowledges that although she had mixed feelings about her time in Rochester, it was where she was able to cement her practical knowledge of photography and art in general.[14] Her early works were very dark and reflected her mood at the time. For Hou, the transition from Taiwan to the United States was a rapid one that presented the hurdle not only of a new country but also an entirely new ideological and emotional environment. Rochester itself was typical of U.S. cities at the time, experiencing negative growth and population shrinkage, with a number of major companies such as Kodak and Xerox pulling out their operations.[15] Hou spent six years in the United States in total, including a residency in New York City, to which I return later.

FIRST RE-ENTRY

After graduating with her MFA degree, Hou re-entered Taiwan and showed works she had produced in the United States. Not Only for Women (*Buzhi shi wei le nüren*) was an exhibition first shown at the student gallery of Alfred University in 1993, where Hou was studying ceramics, and later held at IT Park Gallery, Taipei, in 1995, as her first exhibition after returning. This was also the first time she had exhibited in Taiwan. At that time, Hou was considered a type of avant-garde artist by Taiwan standards, most likely because of her return from abroad after so many years and

also because of the controversial subject matter of the works she displayed—of a kind rarely if ever exhibited in Taiwan previously. She re-entered Taiwan because she had graduated and finished her studies in the United States and it was time to work and exhibit in Taiwan. This was another reason that brought many artists back to Taiwan, as their purpose of study abroad was fulfilled at that point and they had never held long-term plans to reside overseas. Hou herself had changed and matured, and because of the controversy surrounding her work, re-entry was not at all a return to the comfort of home.

In Not Only for Women, Hou interviewed her American subjects with a tape recorder, playing their recorded voices in the exhibition. The transcripts for these were displayed (in Chinese and English for the Taiwan exhibition) next to photographs of the subjects. The male and female subjects were each given a cross or could choose from a number of crosses with a ceramic form attached, similar to a breast. For Hou the breast was a symbol of women's victimization by society, and the cross symbolized the repression of women within Christianity.[16]

The subjects were asked to speak about, perform, or express what the cross they had chosen symbolically meant to them and what feminism meant to them, and Hou photographed their expressions. Their reactions were diverse, from ideas dealing with acts of martyrdom to the number of women raped in the United States each day. For Hou, photography could not be a substitute for words, and so she started to use both. More broadly, words and text have had a defining influence on Hou, perhaps stemming from her time as the editor of a new Chinese dictionary in the late 1980s.[17]

In her artist statement Hou said she had never thought of herself as a feminist, nor participated in feminist organizations, although she did believe in gender equality. She felt that few women in Taiwan had claimed themselves to be feminist.[18] Western feminist theory had just started to enter the vernacular of women who had studied abroad, and it was seen as a negative influence that went against Confucian ideals regarding the role of women (Lu 2004: 224). Hou acknowledged that her move into a different cultural context had influenced her, along with seeing the role of the women's movement in the United States. However, an audience unprepared for her work, and subsequent harsh criticism of the exhibition—including a male Taiwanese artist who allegedly said if he had been given the cross in such a context he would have urinated on it—provoked her to return to the United States.[19]

Regardless of the petty infighting encountered in the art world and the attempt to gatekeep the type of work exhibited,[20] in her case the attack became personal, rather than being directed toward the work, because of the fact that she was raising gender issues that usually remained hidden or unspoken. Although this type of attack had started to occur when Cho Yeou-jui painted a series of photo-realistic bananas in the

1970s, this time there was a stronger sense of the local, male-dominated art world's insecurity. Other artists had from the 1990s alluded to feminist issues, such as Yan Ming-huy in her paintings of fruit and male genitalia, which were also criticized; yet, in Hou's case, it seems her use of photography as art and the appearance of "foreigners" in those images, as well as the work's conceptual, performance element, were more confrontational.

RETURN TO THE UNITED STATES

Hou was accepted into an artist's residency in 1995 called "Earth" in Brooklyn, New York, established by performance artist Hsieh Teh-ching. Hsieh had bought a building and set up studio space and a residency program for artists the previous year.[21] He was quite particular in whom he chose for the residency; the candidates needed to have a philosophy background and performance elements in their work, for which Hou qualified. Hsieh acted as an important mentor for Hou,[22] with reactions in Taiwan toward their art somewhat similar and unkind.

This was the first time Hou lived in New York City, and here she had to confront another unfamiliar cultural element—the practicalities of how the art world ran. She had never had to think about how artists made a living and garnered exhibitions, something she could not study at art school, and perhaps the financial support from her family had previously kept that consideration from being a necessity. Reminiscing about the period, Hou acknowledged the great influence Hsieh had on her work. He was interested in the performance aspect of Not Only for Women and encouraged Hou to begin doing performance art herself, however it was a considerable challenge to use her own body in her work.

SECOND RE-ENTRY

Hou's first exhibition in New York City, at the Synchronicity Space in 1996, was called Take a Picture It Lasts Longer. Hou wrote a prelude for this exhibition explaining the title:

> In America, when women feel someone is looking at them profanely, they will say to the person: "Take a picture, it lasts longer." It is meant to embarrass the viewer, also to snap the activity of visual violation.[23]

It seems Hou did start to refer to herself as a feminist at this point, and in her artist statement for the New York show she stated:

> As an artist, woman and Taiwanese, I am in a complex situation of considerable discomfort. I find myself in constant conflict with social conditioning of

one source or another. My work is expressive of the labor to push back these discomforting limits.[24]

She explained her interest in feminism by addressing the male gaze through the use of her own body:

> The ways in which men look at and depict women are examples of such limits. In the work shown here, I have used my own body as a subject, inviting visual curiosity with male-established patterns, in order to deliver unexpected and unwanted visual rewards, expressive of my own feminist thinking.[25]

In 1997 this exhibition was showcased at the Dimension Endowment of Art gallery space in Taipei. This was the second time Hou re-entered Taiwan, and the second time she exhibited work there produced in the United States. The exhibition contained her controversial work *Peek a boo (Kui)* from 1996, a series of eight photographs of Hou doing a performance with various props such as bananas, masks, pompoms, and her own body (Figure 4.1). When shown in the United States, the works received some criticism; not over the subject matter, but over the fact that an "Asian" woman was doing such work (Pai 1998: 50). This criticism came from a Eurocentric center that had the tendency to stereotype Asian women because of race. The criticism she received in Taiwan was because, as a woman, she was expected to live under Confucian values related to her position within a family. Hou's first re-entry was after having been a student in the United States, but this time she

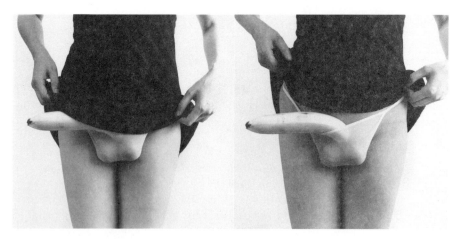

Figure 4.1 Hou Shur-tzy, *Peek a boo series–Bananas*, 1996 (one in series of five), gelatin silver print, 16 in. x 16 in. Courtesy of the artist.

re-entered having been a practicing artist there. As such, her reaction to both periods was quite different.

Peek a boo: Body Bounding (1996)[26] comprises four photographs of a lone performance (Figure 4.2). The work shows Hou herself, who can only be partially identified in one of the photographs, and is otherwise faceless, underneath a gauzy sheath, the middle of her body bound with a thick black band, her arms locked beneath the binding effacing her female form and allowing her no possible movement except parts of her lower body, which are not visible. These bindings, frustrating and restricting the body, could be an analogy for the position of women in patriarchal societies. Further references to S&M (sadomasochism) bondage and the possibility of confronting the male gaze were lost on many viewers who unknowingly overlooked the fact that the work referenced not only the bound female body but, subversively, the phallus itself.[27]

At that time however, the work was controversial and uncomfortable, again because nothing of this nature had been shown before in Taiwan, especially a work in which the woman artist's own body was so exposed. As a result of this

Figure 4.2 Hou Shur-tzy, *Peek a boo series–Body Bounding,* 1996 (one in a series of four), gelatin silver print, 16 in. x 16 in. Courtesy of the artist.

type of work, a number of articles about Hou tend to make reference to her physical appearance. For example, Maggie Pai refers to Hou as: "The tall, slim artist" (1998: 49), and Blake Carter, many years later, refers to her "sassy, irreverent style," her "dishevelled hair," and her "propensity for giggling" (2009: 15). Yet the amount of media coverage this work received was enormous and broad, including coverage in magazines such as *Art and Collection* magazine (*Diancang*), through to *Playboy* and *Elle*.[28]

Further, the idea of binding, restricted movement, powerlessness, and silence Hou conjures in the work could also have complex associations to the Taiwanese political context of the period. Hou was personally attacked for not even being sexy enough to attract the male gaze, so how did she expect to return it? For example, artist Lien Teh-cheng asked her why she did not perform fully nude as Carolee Schneemann had in the 1960s (1998: 50), or why she did not expose her face. Further comparisons were made with Western feminism, which some viewers at the time knew about while others did not. Another issue belying much of the petty criticism was that many overlooked the deeper implications, reading the work as a self-portrait. This may have reflected the fact that the politics of feminism had not yet infiltrated the local mainstream audience. In retrospect, Hou did break certain barriers to further the exposure of feminist ideology, and the body in art, in Taiwan.

As she stayed longer, Hou started to do more work specifically associated with social issues in Taiwan. I feel this was the beginning of her lateral shift of re-entry, the use of the local to address larger theoretical concerns of artists returning. In Hou's case, it was applying the grassroots ideals of feminism in the Taiwan context. For example, in 1997 she worked with a number of women factory workers in the town of Hsinchuang to create *Labors and Labels (IV)* 1997 (*Qingchun bianzhi qu*), as part of a joint community project along with other artists, which culminated in the exhibition Lord of the Rim: In herself/for herself (*Penbian zhuren: zizai ziwei*). In 1998, she further worked with local people in *Guess who you are (Caicai ni shi shei?)*, a work obviously influenced by Barbara Kruger, in which she graphically added two lines of text onto the photographs—one line of her own words, the other the words of the subjects. These works were very specific to a local context, reflecting internal political issues during that period in Taiwan.

In 2000, during a residency in Japan, Hou looked at issues regarding S&M in the series "*Japan–Eye–Love–You*" *–Mr. Suzuki's Medical Intervention* (2000), referencing the depiction of women in Japanese popular culture and pornography. Hou felt the reaction in Taiwan to this work would automatically be critical, and decided people would simply fail to understand it. So this piece too was produced abroad and has never been shown in its entirety in Taiwan. When she exhibited this work in Japan at the Yokohama Museum of Art in 1996, her exhibition Take a Picture was shown

concurrently at Yokohama Portside Gallery, and ironically it immediately achieved popular acceptance without the kind of furor surrounding its showing in Taiwan.

In the two series of works, *Border-Crossing/Diaspora—Song of Asian Brides in Taiwan (I) (2005)* *(Yuejie yu liu yi-Yazhou xinniang zhe ge)* and *Border-Crossing/Cultural Identities–Song of Asian Brides (II)* (2008) *(Yujie yu rentong-Yazhou xinniang zhe ge)*, once again Hou moved laterally in Taiwan, re-entering a part of the culture that was absolutely foreign to her. It is also interesting that her work has taken a more grassroots path, as opposed to her previously highly ideological approach to feminism and the male gaze. The *Song of Asian Brides* project started when Hou moved to Kaohsiung in southern Taiwan to teach in 2004. In a sense, Hou was re-entering Taiwan society, but at the local level, and as such came to certain realizations that differed from those formed when re-entry was from abroad. In this case, she was exploring a level of her culture of origin that she had never needed to encounter, undertaking fieldwork projects with working-class people in farming villages and with Vietnamese brides.[29]

The works consist of images of the wives and children Hou had been introduced to in southern Taiwan (Plate 8). For Hou, each image is first a document that is a hint or mark of what is to follow. According to Hou, talking to these women was like looking into a mirror at herself and what it meant to be Taiwanese. She recognizes that she has benefited and grown from this experience, realizing how privileged her life has been.[30] The brides' comments, which are over-printed on each image in Chinese characters, reflect not only differences but similarities—for example, "yes they love their children like all women do." While the women's motivation to go to Taiwan is financial, there is a price to pay that can be more costly than the money involved. Hou is ashamed at times of the stories about what some Taiwanese men or their families have done to these Vietnamese women; however some have happy lives.

In the succeeding series from 2008, Hou went to Vietnam to photograph the women's families and to continue documenting their stories, some of which placed a heavy mental and physical strain on the artist. Unlike her strong reaction to people criticizing her early works ten years prior, she listens to criticism of her current work in silence. This is no longer her story. And quite telling in her comments regarding these works is how we come to realize that the *Peek a boo* series in some way was Hou's personal story as a woman coming to terms with feminism. Here, however, she has separated her work from herself and is trying to give voice to other, less fortunate women.

CONCLUSION

In most instances, the reason women artists have returned to Taiwan has been a sense of duty to family, which may have deterred some artists from pursuing careers abroad in the first place. During the 1990s, however, there was more incentive for those

who had gone to return as they were now almost certainly guaranteed an academic position at one of the many art institutions being established—opportunities not previously available.

There are numerous ways to re-enter one's place of birth, but mitigating factors such as being a woman, society, and politics all have a strong influence on one's acceptance, especially when new ideas are introduced into an art world with anachronistic tendencies, as the example of Hou Shur-tzy illustrates. For Hou, re-entry, both from overseas and into different levels of her culture of origin, introduced new artistic practices, theories, and discussions, deepening not only Hou's practice, but that of the many artists she has encountered and influenced along the way.

NOTES

1. See Clark (2010) for a study on Taiwan's art education in the 1950s through the 1980s, and comparing patronage for contemporary artists returning from overseas, often Europe and the United States, with that of an older generation of Japan-trained artists such as Chen Jin, who traveled to Japan during the Japanese occupation period (1895–1945) (see Lai 2007).
2. According to statistics published by the Taiwan Ministry of Education, 1994 saw the greatest number of Taiwan students studying in the United States, at 37,580, http://english.moe.gov.tw/public/Data/7281050371.gif. Students to Japan were at their highest level in 1990, with 9,073, http://english.moe.gov.tw/public/Data/72817241471.jpg, and students to Europe were at their highest level in 2000, with 11,424. http://english.moe.gov.tw/public/Data/72810463571.gif. All accessed September 1, 2011.
3. From the *Oxford English Dictionary* online, http://dictionary.oed.com. Accessed April 4, 2009.
4. In Taiwan the Chinese phrase *xue cheng guiguo* or *xue cheng fanguo* refers to students who have successfully returned from study abroad. In China it is *haigui pai*. I am grateful to Chia-Chi Jason Wang for pointing this out.
5. Samir Dayal makes reference to this notion in regards to the diaspora context, but it can also be used here as the notion of "double consciousness," conceptualizing it as "less a 'both/and.'"
6. Ling feels that there is an alternative globalization consisting of a mix of hybridity, simulacra, and the global/local (1999: 277).
7. Interview with Cho Yeou-jui, Hong Kong, October 17, 2005. Her ex-husband was artist Szeto Keung (1948–2011), originally from Hong Kong.
8. Yoko Ono, who on returning to Japan experienced ridicule of her art as well as the tension of the US military occupation, felt she was "a stranger in her home country" and returned to New York (Yoshimoto 2005: 102–103).
9. When I mentioned Cho as a Taiwanese artist, a number of people took issue with this identification. When I told Cho this, she was surprised at their reaction. Interview, October 17, 2005.

10. Its abbreviation is *nüxing hui*. The Taiwan Women's Art Association website used to be at http://waa.deoa.org.tw/. Accessed January 30, 2007. Now it is a blog at http://waahouse. blogspot.com. Accessed September 19, 2011.
11. Discussion with a Taiwanese woman artist in her studio, Taipei, December 18, 2009.
12. Hou, interview, Huashan, Taipei, December 13, 2009.
13. Ibid.
14. Ibid.
15. The Rochester population was approximately 231,636 in 1990, but dropped to 206,000 by 2008. See U.S. Census Bureau at http://factfinder.census.gov. Accessed March 13, 2010.
16. Hou Shur-tzy, artist statement for Not Only for Women, undated. Provided by the artist.
17. According to Hou, in Kaohsiung people apparently think she is a Chinese teacher as she speaks in a refined way (*wenya*). Hou, interview, December 7, 2009.
18. This is reflected in a number of interviews I completed with Taiwanese women artists in the early to mid-1990s, who were reluctant to distinguish themselves as women artists, simply wishing to be considered artists.
19. Hou, informal conversation, November 18, 2007.
20. Gatekeeping is a way to control flows of content or images based on the personal interests of the gatekeepers. See Clark (1998: 294). Interview with Hsieh in Bajo and Carey (2003).
21. Interview with Hsieh in Bajo and Carey (2003).
22. Hou, interview, December 7, 2009.
23. Lulu Shur-tzy Hou, "Take a picture it lasts longer," IT Park website, at http://www. itpark.com.tw/artist/essays_data/310/441/204/en. Accessed March 23, 2010.
24. From the press release for Hou's exhibition at Synchronicity Space, 1996.
25. Ibid.
26. I felt this work was reminiscent of Ana Mendieta's 1975 performance piece *Untitled* at Cuilapan Church in Oaxaca, Mexico. However, when asked Hou was not aware of it.
27. Hou has said she had to point out this phallic symbolism to a number of people, some of whom were shocked. Informal conversation, November 18, 2007, Taipei.
28. The Taiwan *Playboy* article was titled "36.24.35?" May 1997.
29. The Coalition to Abolish Modern-day Slavery in Asia (CAMSA) has estimated that in 2007 there were approximately one hundred thousand brides in Taiwan from Vietnam alone, http://www.camsa-coalition.org/en/index.php/resource-center/statistics. Accessed September 21, 2011.
30. Hou, interview, December 13, 2009.

REFERENCES

Bajo, D. and Carey, B. (2003), "In Conversation: Tehching Hsieh," in *The Brooklyn Rail*, Aug/Sept, http://brooklynrail.org/2003/08/art/tehching-hsieh. Accessed March 20, 2009.
Bhaba, H. K. (1994), *The Location of Culture*, London: Routledge.

Carter, B. (2009), "Sociopolitical Art: A Happy Marriage?," *Taipei Times,* August 19, p. 15.

Clark, J. (1998), *Modern Asian Art,* Honolulu: University of Hawai'i Press.

Clark, J. (2008), "What Does Hybridity Mean for Asian Art Today?," *TAASA Review,* 17 (1): 4–6.

Clark, J. (2010), *Modernities of Chinese Art,* Leiden: Brill.

Dayal, S. (1996), "Diaspora and Double Consciousness," *The Journal of the Midwest Modern Language Association,* 29 (1): 46–62.

Gargano, T. (2009), "(Re)conceptualising International Student Mobility: The Potential of Transnational Social Fields," *Journal of Studies in International Education,* 13 (3): 331–346.

Heathfield, A. and Hsieh, T. (2009), *Out of Now: The Lifeworks of Tehching Hsieh,* Cambridge, MA: MIT Press.

Lai, M.-C. (2007), "Modernity, Power, and Gender. Images of Women by Taiwanese Female Artists under Japanese Rule," in Y. Kikuchi (ed.), *Refracted Modernity: Visual Culture and Identity in Colonial Taiwan,* Honolulu: University of Hawai'i Press.

Levitt, P. and Glick Schiller, N. (2004), "Conceptualising Simultaneity: A Transnational Social Field Perspective on Society," *International Migration Review,* 38 (145): 1002–1039.

Ling, L.H.M. (1999), "Sex Machine: Global Hypermasculinity and Images of the Asian Woman in Modernity," *Positions: East Asian Cultures Critiques,* 7 (2): 277–306.

Lionnet, F. and Shih, S. M. (2005), "Introduction: Thinking through the Minor, Transnationally," in F. Lionnet and S. M. Shih (eds.), *Minor Transnationalism,* Durham, NC and London: Duke University Press.

Lu, H. S. (2004), "Transcribing Feminism: Taiwanese Women's Experiences," in C. Farris, A. Lee, and M. Rubinstein (eds.), *Women in the New Taiwan: Gender Roles and Gender Consciousness in a Changing Society,* New York: M.E Sharpe.

Pai, M. (1998), "A Picture Lasts Longer: Photographer Lulu Shur-tzy Hou Fights Prejudice through Her Daring Images," *Asian Art News,* 8 (1–2): 49–51.

Wang, L.-Y. and Kuo, A. (2010), "Glocalisation: Art Education in Taiwan," *The International Journal of Arts Education,* National Taiwan Arts Education Centre, 8 (1).

Yoshimoto, M. (2005), *Into Performance: Japanese Women Artists in New York,* New Brunswick, NJ: Rutgers University Press.

5 PAINTING ON LOCATION: LIN HAIZHONG AND CONTEMPORARY CHINESE INK PAINTING

Morgan Perkins

Consider the environment—natural and manufactured, personal and cultural—in this view of the Hangzhou studio of ink painter Lin Haizhong (Figure 5.1). In the foreground lies an array of objects associated with contemporary Chinese ink painting. Materials with quite ancient origins such as ink, brushes, and rice paper are interspersed with the latest technologies in the form of digital cameras and high-quality reproductions of paintings in books. On the walls, a series of scrolls form one immense landscape painting. Through the open doors, a balcony furnished for social gatherings around a table laden with a tea set looks out over gardens that line the shore of West Lake, in the center of Hangzhou. It is an intimate space at the heart of a busy city, for students, friends, and colleagues to gather (Plate 9).

Lin Haizhong and his acquaintances have aspired to create social spaces for artistic creation and personal growth, particularly through gatherings inspired by the culture of the literati (*wenren,* literally "cultured or literate person"), an elite group that flourished in China primarily between the eleventh and seventeenth centuries. Their intellectual and aesthetic philosophies were most often expressed through the interconnected arts of painting, poetry, and calligraphy, ideally pursued as scholar-amateurs.

> In ancient times, people gathered together, some playing music, some painting and some composing poems … I personally still prefer this kind of lifestyle; I have some friends who prefer it too. We think this is how life should be. The civilization of today, with its skyscrapers—all of us think that is meaningless. (Lin Haizhong, May 26, 2008)[1]

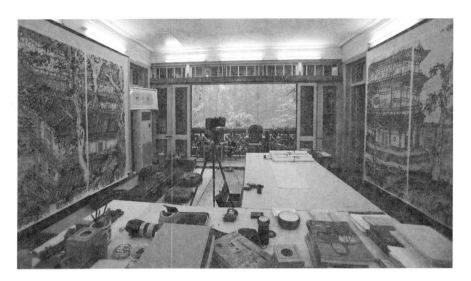

Figure 5.1 Lin Haizhong's Qingbo Bridge studio in Hangzhou, 2006. Photograph by Lin Haizhong.

Such gatherings have the potential to encourage mutual artistic inspiration, and they offer companionship for those who share similar interests. But how does ink painting in a contemporary context relate to personal and social experiences on a daily level?

What follows is an ethnographic account of contemporary ink painting that has developed through conversations with one painter over the course of several years.[2] When I first met Lin Haizhong in Hangzhou in 1991, he was a graduate student in the Chinese Painting Department (*guohuaxi*) at the Zhejiang Academy of Fine Arts (now the China Academy of Art (CAA)), where he is now a professor. He specializes in a style of Chinese ink painting known as *shanshuihua* (literally "mountain water painting"), which is often translated as "landscape painting," although the idyllic scenes typically reflect the painter's inspiration rather than accurately depicting specific places. While Lin's dissatisfaction with urban development in contemporary China fuels his interest in traditional culture as both a refuge and a solution, he is also resigned to the fact that modern industrial society is a force in his life. Indeed, he adapts new technology to his needs, most notably to document and communicate his artistic and cultural endeavors.

The classical style of Lin's art paired with the contemporary social settings in which it is produced brings our subject into the center of discourse in the anthropology of contemporary art (Morphy and Perkins 2006; Perkins 2010; Schneider and Wright 2006). Two central and interconnected questions form the basis for this analysis. First, is this art and social practice the most recent incarnation of a long, cohesive tradition

or an entirely new form derived from a conscious effort to revive or even invent a tradition (see Hobsbawm and Ranger 1984)? Second, how are these forms and social conventions learned, and what place do they have in contemporary Chinese culture?

LITERATI CONNECTIONS

Certainly, the gatherings described by Lin must be interpreted in part as efforts to emulate some social conventions in literati painting (*wenrenhua*). His painting style is classical, and indeed Lin refers to his work as contemporary literati painting. For an exhibition of his artwork that I curated with an anthropological emphasis on cultural context, he suggested we recreate a "contemporary literati studio" (*dangdai wenren shuzhai* or *gongzuoshi*) to help the audience appreciate the nuances of his painting process (Figure 5.2).[3]

QUESTIONS OF CONTINUITY, RELEVANCE, AND AUTHENTICITY

Consider a provocative question asked by an audience member when some of the ideas in this chapter were presented at the symposium from which this volume emerged.[4] I paraphrase it as: "Do you think a Song Dynasty painter would recognize the efforts of Lin Haizhong and his colleagues as authentic literati art?" I have often been asked variations of this question when I display or discuss Lin's art. While an account of contemporary ink painting benefits from an understanding of its place in and engagement with the art historical record, as a current phenomenon it warrants attention regardless of perceptions of continuity.[5] Here I am more concerned with how ink painting is currently manifested socially rather than whether such emulation is accurate. At issue is not the art-critical or art-historical reception of contemporary ink painting, but rather the social fact that the desire to paint and live in this manner exists and why that is so.

Much attention has been paid to the perceived continuity of such painting between dynastic and contemporary China, and the discourse has often focused on the importance of the interconnected elements of medium, style, subject, and social practice. Susan Bush has focused on the writings of the literati themselves to reveal the range in diversity and cohesiveness surrounding the conception of literati painting. She begins her assessment with the writings of Su Shi (1037–1101), who first used the term *shiren hua* (scholar's painting), and concludes with Dong Qichang's (1555–1636) discussions of *wenren zhi hua* (literati painting) (1971: 1–29), even though elements of artistic practice that have been considered characteristically literati precede and extend beyond this timeframe.

To describe the range of approaches that have referenced literati themes and styles over the last two hundred years, Robert Thorp and Richard Vinograd suggest that

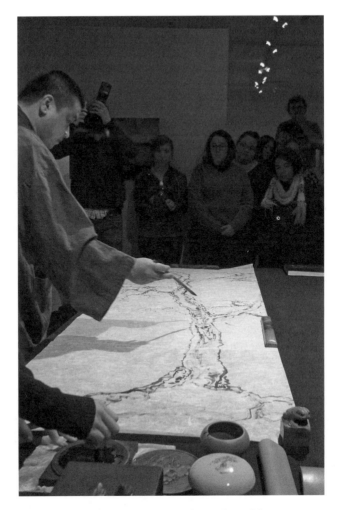

Figure 5.2 Painting demonstration during the exhibition
Chinese Painting on Location: The Art of Lin Haizhong, SUNY
Potsdam, 2012. Photograph by Morgan Perkins.

"the term 'post-literati' is useful to reflect the dramatically changed social and cul-
tural circumstances in which artists operated, in comparison to the literati of late
Ming and earlier times" (2001: 379). Within this broader category, we might also
consider the term *guohua* (national painting), under which most ink painting has
been practiced in twentieth-century China, albeit in specific academic and politi-
cal frameworks (Andrews 1990). More recently, the work of a number of artists has
been collectively referred to as *New Literati Painting* (*xin wenrenhua*). As Francesca

Dal Lago (1998) has pointed out, however, this term is only marginally appropriate when applied to artists whose paintings share a common media yet vary widely in their depictions of modern life and adherence to traditional styles.

The idealized separation between the elite literati amateurs and their professional peers, on which most of the traditional literature is based, has been partially demystified by James Cahill (1994) and others. The application of anthropological theories of social exchange in China in the study of Wen Zhengming (1470–1559) by Craig Clunas (2004), for example, reveals the nuanced exchange system within which the Chinese literati were active. If only on the most superficial level, a basic disconnect between contemporary ink painting and the historical literati must be acknowledged on the basis of its practice and appreciation by a broader, more diverse range of social classes, amid different political, economic, and social relationships. Although ink painting thrives on an amateur (non-specialist) level—not to be confused with, but perhaps warranting comparison with, the literati ideal of the amateur—professionalism is widespread among current painters. Painters remain deeply embedded within Chinese social networks of obligation and exchange—*guanxi* (personal relationship) and *renqing* (human obligation)—that make it difficult to assess where professionalism applies.[6]

Nevertheless, contemporary ink painters are frequently compared to the masters of the past, and learning their techniques and styles remains a central component of current educational methods. In the course of this research, I have heard many opinions regarding the last "real" masters of ink painting. Indeed, Lin once remarked: "Look at the paintings of Pan Tianshou (1897–1971), they are full of a bold and generous feeling. I don't see this in any others after him" (June 17, 2008). The disruption of ink painting in China under Mao Zedong, particularly during the Cultural Revolution (1966–1976), broke an essential artistic lineage. This may have hindered the ability of the post-Mao generation to reach the standards of its predecessors, and suppressed the expression of some of the cultural memory associated with the social practices of ink painting. Yet this left painters with a remarkably clean slate to develop their own visions of the medium. This may ironically be the best position from which to examine what Lin Haizhong is doing.

To fully appreciate the process through which he connects his art and life to that of his literati predecessors, I argue we must first detach ourselves from any discourse regarding the authenticity of contemporary ink painting and its position in a perceived literati continuum.[7] Only then can we begin to recognize the many points of comparison and why these matter to Lin and other members of the art world in which he circulates. In the next section, I briefly consider some of the core characteristics of literati painting and why Lin is drawn to them.

CHARACTER AND ELEGANT GATHERINGS

The idea of painting and calligraphy as windows into the character of the artist lies at the core of the earliest conceptions of literati art.[8] Lin describes his relationship with painting and tradition as both reciprocal and personally revealing.

> I am a *shanshui* painter; this is how I am known. I came to know traditional art many years ago through study, and now my own lifestyle has become more and more traditional. Now, when I paint, it's not about the concept of art. It's something about the man, the painter, like me. I am a man with a lot of problems. For example, I've been busy lately and am very fickle right now; you can tell that from my painting. If I feel very comfortable, you can tell that too ... It's not only about adjusting your artwork; it's about adjusting yourself through cultivation and study. (June 17, 2008)

He has learned about traditional techniques and philosophical approaches to painting through his studies and makes frequent reference to them in conversation. This intimate confession makes it clear that he has made these approaches personal as a reflection of his character and as a means to improve it.

Lin's concern with the spiritual aspects of his life and art has evolved in recent years through his growing interest in Buddhism—although he does not consider himself Buddhist—that has developed in part through his friendships and artistic associations with Buddhist monks in Hangzhou. There was a historical relationship between literati painters and religious communities that again connects Lin's relationships to those of the past, but his motives and approach must be considered in a contemporary context.

> Traditional concepts [in Confucianism, Buddhism, and Daoism in China] focus on the improvement of one's self ... Confucianism focuses on the concept of righteous men and petty men (*junzi xiaoren*). We all want to become righteous men, because a righteous man has good character and morals, and his paintings will show them to you. For example, this is why the paintings of Wu Daozi (active ca. 710–760), Lu Tanwei (active ca. 450–490), Gu Kaizhi (ca. 345–406) and the calligraphy of Wang Xizhi (303–361) became people's models. (June 17, 2008)

Lin's references to common values and timeless qualities in spiritual and artistic practice highlight one of the central themes that, for me, begins to dismantle concerns about authenticity and continuity in his work. That is, the emphasis on those qualities of life, of character, and of nature that do not change. These are ideal values in literati painting that Lin wants to make relevant for the present, and his friendships with those who share his ideals are the basis for their contemporary gatherings.

Communication between artists across space and time is also made possible in part through the agency of the artwork (Gell 1998), which is often clearly documented through inscriptions and seals marked on ink paintings and scroll mounts by artists, viewers, and collectors.

> The scroll-complex passed from hand to hand, painter to dedicatee, owner to guest, viewer to viewer, acquiring traces of its passage in the form of inscriptions and seals. The painting was thus visibly altered by the act of viewing, becoming a vehicle for cultural bonding, and it claimed communion that could extend across centuries. This was commonly referred to as *shen-hui,* or "spirit-communion," which on a refined level implies a kind of meeting of congenial minds; a more prosaic and somewhat anthropological perspective would note that it also involved handling the same tangible object in a kind of ritual coparticipation across time. (Vinograd 1991: 184)

The variety of inscriptions and the occasions for viewing paintings in the past, which allow artists in the present to respond with a semblance of the same ritual knowledge, reinforce Lin's connections to his predecessors by creating a model for contemporary social gatherings—even if this is a case of what Helen Siu (1989) has called "recycled rituals." By using the traditional term *yaji* (elegant gathering) to describe a range of interactions with his friends and colleagues, he is consciously drawing connections to this fundamental social foundation for literati art.

> *Yaji* is a gathering about discussing truth through painting and calligraphy ... This is the background of our lifestyle. We spend time with people who share the same concept. They may not only be painters, some of them are writers, some are musicians, some are businessmen, some are architects, and some are dramatists. (June 17, 2008)

These friendships and associations connect and reinforce the participants' interests in those traditional elements of Chinese culture that relate to their varied fields and the connections between them.

> I have a friend who plays a traditional Chinese flute. When we can find time to spend with a few friends, we may paint or compose music ... Sometimes he plays his flute while I do my painting, and we don't know what's happening with each other's work. Sometimes it's just good company. (June 17, 2008)

Although these social gatherings are often spontaneous, more formal occasions have been filmed during which Lin paints while his friend Du Rusong plays the traditional *dizi* flute, and Zhi Guang, the assistant head monk from Lingyin Temple in Hangzhou, marks the meditative qualities of their practice through notes on

traditional *pengling* bells (Plate 9). On the occasion illustrated here, Wang Shu, the recipient of the 2012 Pritzker Architecture Prize, joined the gathering with his architecture students to examine potential intersections between traditional painting and contemporary architectural forms. Lin is interested in expanding such gatherings to communicate his ideas cross-culturally. He asked me to announce the opening of his exhibition in New York as an "elegant gathering," during which Du provided music while Lin performed a tea ceremony. Lin brings elements of the historical literati world into current intellectual and artistic discourse, creating new configurations with significant differences yet enticing similarities that make current manifestations both anthropologically and artistically rich.

CONTEMPORARY ART AND EDUCATION

> Your current state of mind can be seen through your painting and calligraphy. This is not a concept of art at all. If we follow the art concept now, painting is meaningless. This is what I have discovered in the past few years. Our teacher's teacher may know this, our teacher's generation does not know it, and it is very rare for teachers who are teaching now to know anything of this. However, this is most important. It's the ultimate philosophy of life. (June 17, 2008)

By addressing the role of education Lin raises a crucial component in the interpretation of contemporary Chinese art practice. Any anthropological effort to understand art in its sociocultural context requires an appreciation of art education as a foundation from which artists can begin to learn about that context. Whether it occurs in an institution or another setting, art education involves the transmission of knowledge about the social components of artistic practice as well as their techniques and styles. Yet art education is also a process that occurs over the course of a lifetime. As a student of Chinese art history, for example, Lin's ongoing studies inform both his painting techniques and the manner in which he uses his painting to educate a range of viewers about his ideas—both in China and abroad.

The modern Chinese art academies were developed on a European model during the twentieth century to create an institutional system that could revitalize Chinese art, in part through a synthesis of Western and traditional Chinese forms and techniques.[9] Although supportive of ink painting and various efforts to make it more modern, the institutional setting further disrupted the remnants of the social system in which ink painting was taught and practiced. Paired with hostility toward traditional ink painting under Mao, these changes fundamentally altered the educational lineage and continuity of ink painting practice. Yet within the limitations imposed by the institutional format, the Chinese Painting Department at the CAA

has succeeded in retaining (or reviving) many fundamental aspects of traditional ink painting education. "*Shanshui* painting already has a quite complete educational system. Anyone who comes to major in this at the academy basically comes to study the traditional painting style. This has not really changed during these past years. What has changed are the students" (May 26, 2008).

While many students learn from the examples produced by their teachers, practicing the styles of the masterpieces of Chinese painting is still a fundamental exercise, now made easier through access to high-quality digital reproductions. In comparison to traditional practice, however, the length of study has been radically shortened, even when one considers that most students have had many years of training prior to their admission to the academy. Students are expected to produce original works by the time they graduate. Such an early effort would have been rare in the past, but the current emphasis on creativity is, in part, the result of a foreign academic ideology influencing indigenous practice.

> Now students can easily see some works that were difficult to see years ago and their comprehension is better too … Some people will start to create their own style after they know a little bit about antique ideas (*guyi*). This will be meaningless. You can only be successful if you come back and stay firm in the study of antique ideas until you really know them. While you study, you can make friends and become more and more principled. (June 17, 2008)

The approach to education Lin advocates includes a process of acculturation that occurs both within the curriculum and through experiences students have outside their formal education. "I not only teach my students painting, I teach them everything—including how to drink tea, how to live. Only then is it meaningful" (May 26, 2008). Here art education acts as a form of socialization by orienting artists toward the conventions and social practices associated with the many subcultures of the Chinese art world. The complex Chinese system of social exchanges involves every aspect of an artist's life, not just those involving their artistic activities. While Chinese artists oriented toward the international contemporary art world are integrated into Chinese social networks as individuals, until relatively recently their artwork has not been widely exhibited in China and its local audience still remains restricted despite its vast international appeal. In contrast, Lin has very different exhibition networks and markets, relationships often documented in the inscriptions on paintings created or exchanged on social occasions.

> According to the traditional concept, it is not me who is pursuing art. I am not an artist. An artist is someone who keeps producing a lot of new concepts. People like this are the so-called modern artists, just like those in our art academy … Traditional concepts focus on accomplishment of one's self. (June 17, 2008)

In the conclusion I take up the provocative statement that Lin is "not an artist." The connection he makes here between education and the diverse directions contemporary art has taken in China are reflected and even driven by the art world microcosm of the CAA. The academy provides a social foundation for disparate yet intersecting art communities, as each generation of students emerges into the maelstrom that is the contemporary Chinese art world. In contrast to what he perceives as the drive for innovation among "the so-called modern artists"—the CAA having played a prominent role in the Chinese avant-garde art movement—the emphasis Lin places on the education of young ink painters seeks to re-establish traditional connections between painting and personal cultivation.

PHYSICAL AND CULTURAL ENVIRONMENTS

Many viewers may not necessarily understand how a traditional style of painting is relevant to contemporary life. One of the most controversial assessments of ink painting in the post-Mao period began with the first of a series of articles by Li Xiaoshan (1985), in which he suggested that the tradition had essentially reached a dead end. Li ridiculed the work of contemporary ink painters because he considered the styles and subjects of the past irrelevant to social life in contemporary China. Aware of this criticism, Lin recently asked Li to revisit his opinion. In an essay for a publication about Lin, Li expressed praise for Lin's efforts amidst continued skepticism about much ink painting practice in China (2010: 13).

During one of my conversations with Lin, a Chinese woman who was also visiting his studio asked why his paintings generally depict traditional architecture and people wearing classical forms of clothing. When she suggested that including aspects of modern life—as many other ink painters do—might promote audience understanding, he offered this heated response:

> What does this mean, to not paint modern things? This is an attitude for life. I have chosen something natural and internal. Not something fashionable that will soon be replaced ... Since we are already in the city, then why would we need to paint the city again? I have no interest in this. The life I want to have is the life in the mountains ... Our ancestors thought like this too, they also had life in the city as well as life in the mountains, exactly as modern people do; on this point we have no difference. (May 26, 2008)

Of course there are still monks and temples in China, and although threatened on an unprecedented level, there remain fundamental elements of nature. Even if we accept that Lin's choice of classical motifs is subjective or strategic, I believe we are still

missing the point. His paintings' basic relevance to modern life is due simply to the social fact that Lin wants to paint in this way, and his friends interact socially based upon principles associated with this art form.

Then again, Lin's paintings can advocate for contemporary cultural change directly. Concern over the consequences of rapid commercial development and its impact on the environment has become a common theme for many contemporary Chinese artists. As a *shanshui* painter, it is perhaps natural that Lin uses his art to question the path of development China has taken. The circumstances surrounding the painting *Qiantang Daguan*[10] (*Grandview of Qiantang*)—displayed on the walls in Figure 5.1 and Plate 9—further illuminate the creative and collaborative nature of *yaji* occasions while illustrating his concerns about the physical and cultural environment. In the calligraphic inscription for the painting, Lin describes the circumstances of its creation.

> Du Rusong is a flutist. One day he visited me and shared this traditional poem he composed:
>
>> Life in Qiantang, leisurely and carefree, content to be near nature;
>> looking at the mountains, listening to the sound of a spring or ocean waves.
>> With nothing else to do, I play my flute all day long;
>> Till the moon appears, parting the clouds, making me chuckle.
>
> I said to him, "This is an elegant poem! Just to add to the fun of your music, I want to make a painting describing the leisurely and carefree life in Qiantang." (*The Preface of the Grandview of Qiantang*, 2007)

While the inscription, poetic inspiration, and much of the brushwork are typical of the literati tradition Lin emulates, the painting's scale (ten scrolls combined to comprise a 250 x 120 cm image) is entirely modern. When Du plays music to accompany Lin as he paints, the collaborative nature of the artistic experience has roots in literati practice, yet it also serves a contemporary social agenda.

> The painting *Qiantang Daguan* includes Hangzhou, the Qiantang River and the area around it, but it is not a place in reality now. There are no specific places in Hangzhou that appear in the painting, but you can feel them because it combines the style of many Hangzhou sites, especially those related to Buddhism. (May 26, 2008)

Thus far Lin's social agenda has been encoded within references to literati practices and his interests in their relevance to contemporary art in China. Yet, as some of his comments have indicated, Lin's contemporary motives go far beyond these goals.

> One reason for creating *Qiantang Daguan* is that Hangzhou has now changed so much, and I believe that we can see the world from a different evolutionary

> perspective. I want to lead Hangzhou society toward the world in my painting . . .
> The evolutionary direction of a society can be chosen, and my painting is also
> a choice; it expresses a kind of beauty . . . Now we still have places like those in
> my paintings, but in the future we will have none, and people will not come
> to China, and this place will become a pile of trash, architectural trash! (May
> 26, 2008)

Those concerned with preservation and new developments are collaborating to
find modern solutions based upon reference to traditional forms, including paint-
ings that depict the social uses of particular spaces. Even though Lin is critical of
the rate of development in Hangzhou, the city's historical importance and its role as
a major tourist destination have guaranteed efforts to preserve important sites and
develop others in a manner that replicates or incorporates traditional forms and
techniques—as in the buildings designed by Wang Shu on CAA's satellite campus.

> This idea has gradually started to affect society, but may not be perfected imme-
> diately. Since it has already been started, it needs to be completed by generations
> and generations. We now have a direction to walk towards, and we have already
> started this walk. Like my painting, it is a direction, a modern (*xiandai*) direc-
> tion. (May 26, 2008)

This ambitious agenda is not merely an artistic vision. Although Lin is critical of
efforts to create environments in traditional styles to cater to tourism, through his
collaborations with architects and developers, he aspires to use *Qiantang Daguan*
and his other paintings as guides for renovations and new developments in Hang-
zhou. Lin may emulate his literati predecessors in his propensity to retreat into the
landscapes of the imagination when disillusioned by the historical moment, yet his
sense of social responsibility is also manifested through his teaching and his efforts to
influence the direction of China's urban development.

CONCLUSION

If, as Lin Haizhong claims, he is "not an artist," what then is he? He provides the
easy answer himself: "I am a *shanshui* painter." Yet his statement is both provocative
and illuminating, for it sheds a critical light on the cross-cultural use of terms such as
art. In Chinese, *meishu* generally refers to fine arts, while *yishu* is a broader category
incorporating crafts, dance, music, and other arts. His rejection of the term *artist*
(*yishujia*) highlights the importance of recognizing that these terms are negotiations
of European terminology.[11] Even though indigenous terms provide the most accurate
interpretations of culturally specific practices, I also use the term *contemporary art*

quite intentionally when referring to the work of Lin Haizhong. The term *art* in various translations has become part of the international parlance Lin and I both use. As with many traditional art forms throughout the world that continue to be practiced and developed, Lin's artistic and lifestyle choices engage with many aspects of contemporary society. The matter of choice is crucial. Lin could have followed a different artistic direction—indeed he could have chosen an entirely different career—yet he chose to paint and to emulate styles and practices associated with literati aspects of the ink painting tradition.

Particularly in the past three decades or so, Chinese artists have been experimenting with traditional art forms through installation, performance, and other styles of contemporary international art, just as their predecessors experimented with Western art genres such as realism in painting.[12] Lin's work has more in common with contemporary international art than he may recognize himself. Many of the collaborative events that have emerged from Lin's *yaji* occasions could be considered forms of performance or installation art. Certainly, Lin is well aware of performance art as practiced by many artists at the CAA, yet I believe his intention is to present spaces for the sincere creation of contemporary traditional art rather than to critique those traditions.[13]

Lin is not retreating into the past and rejecting innovation; he is instead offering an alternative vision of contemporary art. While opposing the emphasis on innovation associated with the avant-garde in current art, he actually seems to be embracing a basic goal of historical Euro-American avant-garde art—the effort to embed art within daily life (Bürger 1984). The intimate role of art in Lin's daily life is guided by his engagement with historical literati theories to address current personal and social concerns. Through his own studies and by teaching future generations, Lin Haizhong is translating past practices and forms across many intellectual discourses manifest in contemporary China. Beyond the level of emulation, he has formulated a set of principles that explain why his paintings feature classical figures and architectural forms. While his goals are personal, the use of Hangzhou as a specific location to express his strong opinions about the environment and the contemporary art world resonates beyond China's borders as a response to artistic and cultural globalization.

NOTES

Lin Haizhong has my gratitude for his patience and enthusiasm as he taught me about his approach to painting. I extend my thanks to Lee Hui-shu, Eileen Hsiang-ling Hsu, and my coeditors for their comments on drafts of this chapter.

1. The quotes from Lin Haizhong are based on our conversations and they have been translated into English with the assistance of Zheng Cong.
2. See the biography of Li Huasheng (Silbergeld and Gong 1993) for a relevant study of contemporary ink painting based on the experiences of one artist.
3. Chinese Painting on Location: The Art of Lin Haizhong, College Art Museum, State University of New York at Potsdam, March 1–31, 2012.
4. In the Image of Asia: Moving across and between Locations. Australian National University, April 13–15, 2010.
5. See Phillips (2005) for an assessment of the disciplinary relationship between art history and anthropology.
6. *Guanxi* involves the cultivation of relationships for mutual interest and benefit. The closely related term *renqing* refers to human feeling and the individual's social obligation to consider such issues in relationships. For one anthropological study of these exchange systems, see Yan (1996).
7. See Alfred Gell's (1992) conception of "methodological philistinism" for a relevant anthropological approach to cross-cultural art practices.
8. For anthropological examinations of the connection between personal character and calligraphy in China and Japan respectively, see Yen (2005) and Nakamura (2007).
9. Julia Andrews (1994) outlines much of the historical and political framework of Chinese art education in the twentieth century.
10. *Qiantang* has historically referred to the region around the Qiantang River adjacent to Hangzhou.
11. See Liu (1995) for the historical context of such translations. For a relevant cross-cultural study of indigenous translation and use of the word *art,* see Perkins (2005).
12. Many works by Gu Wenda, Qiu Zhijie, Xu Bing, or Zhang Hongtu, for example, illustrate the varied interpretations of classical forms and practices over the last thirty years. On the complexities of the international display of experimental *shanshui* paintings by Zhang Hongtu, see Perkins (in press).
13. For a relevant discussion of techniques to adapt contemporary gallery spaces to the specific needs of Chinese ink painting, see Tsong-zung Johnson Chang (2005).

REFERENCES

Andrews, J. (1990), "Traditional Painting in New China: *Guohua* and the Anti-Rightist Campaign," *Journal of Asian Studies,* 49: 555–575.
Andrews, J. (1994), *Painters and Politics in the People's Republic of China.* Berkeley: University of California Press.
Bürger, P. (1984), *Theory of the Avant-Garde,* trans. Michael Shaw, Minneapolis: University of Minnesota Press.
Bush, S. *(1971), The Chinese Literati on Painting: Su Shih (1037–1101) to Tung Ch'i-ch'ang (1555–1636),* Harvard-Yenching Institute Studies 27. Cambridge: Harvard University Press.

Cahill, J. (1994), *The Painter's Practice: How Artists Lived and Worked in Traditional China,* New York: Columbia University Press.

Chang, T. (2005), "The Yellow Box: Thoughts on Art before the Age of Exhibitions," *Yishu,* 4 (1): 42–53.

Clunas, C. (2004), *Elegant Debts: The Social Art of Wen Zhengming,* Honolulu: University of Hawai'i Press.

Dal Lago, F. (1998), "'New Literati Painting' at the China Art Gallery, Beijing," *ART Asia-Pacific,* 19: 32–34.

Gell, A. (1992), "The Technology of Enchantment and the Enchantment of Technology," in J. Coote and A. Shelton (eds.), *Anthropology, Art and Aesthetics,* Oxford: Clarendon Press.

Gell, A. (1998), *Art and Agency: An Anthropological Theory,* Oxford: Clarendon Press.

Hobsbawm, E. and Ranger, T. (eds.), (1984), *The Invention of Tradition,* Cambridge: Cambridge University Press.

Li, X. (1985), "Dangdai Zhongguohua zhi wo jian" ("My Views on Contemporary Chinese Painting"), *Jiangsu Huakan* 7.

Li, X. (2010), "Lonely Sail, Distant Shadow," In *Lin Haizhong: Yearbook of Chinese Artists* (*Zhongguo Yishu Jianian Jian*), Beijing: Art and Culture Publishing House.

Liu, L. (1995) *Translingual Practice: Literature, National Culture, and Translated Modernity—China, 1900–1937,* Stanford, CA: Stanford University Press.

Morphy, H. and Perkins, M. (2006), "The Anthropology of Art: A Reflection on its History and Contemporary Practice," in H. Morphy and M. Perkins (eds.), *The Anthropology of Art,* Oxford: Blackwell Publishers.

Nakamura, F. (2007), "Creating or Performing Words? Observations on Contemporary Japanese Calligraphy," in E. Hallam and T. Ingold (eds.), *Creativity and Cultural Improvisation,* Oxford: Berg.

Perkins, M. (2001), *Reviewing Traditions: An Anthropological Examination of Contemporary Chinese Art Worlds,* Doctoral Dissertation, University of Oxford.

Perkins, M. (2005), "'Do We Still Have No Word for Art?' A Contemporary Mohawk Question," in E. Venbrux et al. (eds.), *Exploring World Art,* Long Grove, IL: Waveland Press.

Perkins, M. (2010), "Cultural Knowledge on Display: Chinese and Haudenosaunee Fieldnotes," in A. Schneider and C. Wright (eds.), *Between Art and Anthropology,* Oxford: Berg.

Perkins, M. (Forthcoming), "Exhibition Cultures: Zhang Hongtu and Cultural Practices of Display," in F. Dal Lago (ed.), *China on Display,* Leiden: Brill.

Phillips, R. (2005), "The Value of Disciplinary Difference: Reflections on Art History and Anthropology at the Beginning of the Twenty-First Century," in M. Westermann (ed.), *Anthropologies of Art,* Williamstown, MA: Sterling and Francine Clark Art Institute.

Schneider, A. and Wright, C. (eds.), (2006), *Contemporary Art and Anthropology,* Oxford: Berg.

Silbergeld, J. and Gong, J. (1993), *Contradictions: Artistic Life, the Socialist State, and the Chinese Painter Li Huasheng,* Seattle and London: University of Washington Press.

Siu, H. (1989), "Recycling Rituals: Politics and Popular Culture in Contemporary Rural China," in E. P. Link, R. Madsen, and P. Pickowicz (eds.) *Unofficial China: Popular Culture and Thought in the People's Republic,* Boulder, CO: Westview Press.

Thorp, R. and Vinograd, R. (2001), *Chinese Art and Culture,* New York: Harry N. Abrams.

Vinograd, R. (1991), "Private Art and Public Knowledge in Later Chinese Painting," in S. Küchler and W. Melion (eds.), *Images of Memory: On Remembering and Representation,* Washington, DC and London: Smithsonian Institution Press.

Yan, Y. (1996), *The Flow of Gifts: Reciprocity and Social Networks in a Chinese Village,* Stanford, CA: Stanford University Press.

Yen, Y. (2005), *Calligraphy and Power in Contemporary Chinese Society,* London: Routledge.

PART II

ARTISTS' VOICES

6 CATCHING THE MOMENT, ONE STEP AT A TIME

Phaptawan Suwannakudt

My participation in the Womanifesto International Residency in 2008 was the first time I created studio work in Thailand during the fourteen years since I had left the country. It was an intense six-week exchange program with Thai and international women artists that included workshops with local artisans, craftspersons, and school students. Some of the work produced there was included in the 2010 Ephemeral but Eternal Words: Traces of Asia exhibition, to which I return later.

Womanifesto started in 1995 with the Tradissextion exhibition, which brought five Thai women artists and writers together as a group to exhibit their work at Concrete House Art Centre, a nongovernmental organization (NGO) activist group working with prostitutes and AIDS victims in suburban North Bangkok. Later that year, it was left to me and two other participants in the group, Nitaya Ua-areeworakul and Mink Nopparat, to decide whether to continue. Varsha Nair—an Indian artist who lives in Thailand but originally trained at the Maharaja Sayajirao University of Baroda—joined us later, and together we created Womanifesto, aiming to make an art exhibition by women artists in Thailand for the following year. However, through the efforts of Nitaya and Varsha, this went on to become a series of biannual activities under the name of Womanifesto in which international women artists were invited to participate. The activities varied over the years, from exhibitions, performances, workshops, book projects, Internet-related activities, and more recently an artist-in-residence program. Womanifesto does not have a permanent office, nor is it a formal organization, but it has provided mental space for many of the women artists involved, particularly for me.

I do not easily feel at home in places: Womanifesto provided a space in Thailand for me to temporarily hold on to. From the age of eight I was placed to live in a temple within the Sangha community of monks, together with my two brothers, and among an all-male painting team. My father led the team for his mural projects and lived there as well. As a girl, I was not allowed to address monks directly. Women are not allowed to offer or take things directly from the hands of monks. Instead women offer alms indirectly by handing out and taking things to monks through the monks' handkerchiefs or some such piece of cloth, while objects, when given by monks, are released from above to land on women's hands. Monks take considered care with their hands so as not to touch objects at the same time as a woman's hands touch them. This is to avoid all direct contact with women. Without any other women in the temple, it was almost as if I had been singled out to be treated differently, while everyone else on the mural team moved and worked freely. Nevertheless, I found a space of my own in a sandpit inside the temple, which was surrounded by trees and canals within a short distance from nearby villages. Although I grew up with plenty of unanswered questions, I was without contempt for this situation. I had my own world in which I gave names to things, objects, trees, snails, insects, squirrels, birds, dogs, and cats. In this space I moved and thought freely.

Outside the temple, apart from my family, I learned that in the real world there were two different sets of rules to negotiate in Thai. The rules of conformity I was to follow at schools, at workplaces, and in society stressed that to say "no" in answer to your superiors was forbidden. However, and often in contradiction, you must also say "no" out of courtesy when you are offered something, no matter if you need or desire it or not. Your superiors in Thai society are all those who were born before you, regardless of whether they are wiser. There is an exception: if you are a man and have been ordained, you can become superior to those who have not. Women cannot be ordained for one simple reason: that there are no *bhikkunis*, or female monks, to perform an ordination for a woman. As a teenager I used to wish to be a monk but could not, as I was to find out, for this particular reason. Thai terms of superiority, however, are compromised when you have rank or money. I could not see a space for me in the real world in which I lived. Silence was what I was used to, not having to say no and lie at the same time.

My father was a nonconformist and he too could not work sincerely within the Thai system, although life forced him to compromise with it for the sake of his children. He was kicked out of the conformism of Silpakorn University in Bangkok, where he had studied painting. He was ordained as a monk, twice. He took me to Buddhist Vipasana meditation sessions with a monk twice a week. He taught me how to swim, dance, cook, sweep the floor, do haircuts, and write poems—as well as building skills, how to use carpentry tools, how to make and level a cement floor,

and how to plaster a wall. But he never taught me to draw or paint. I learned a lot, however, from role models and learned to draw by copying, sitting alongside the craftsmen. My father also wisely advised me not to go to art school, a view I later appreciated. The reason he gave was in the single phrase "You are a woman," and nothing else. He also had faith that I would make a great writer, after I showed him a thirteen-page short story I had translated from an English children's story when I was eleven years old. In his last year, when he was very ill, he asked Chang Sae Tang, a Thai-Chinese poet and artist, to mentor me in writing. I went to see Chang Sae Tang every day for one year to talk, to listen to him read his poems, and to see the collection of artworks he had worked on all his life but had never shown to anyone. Art critics, scholars, writers, and art journalists asked in vain to see his work but he seldom let anyone see them, only a select few. His neighbors and friends called him a "mad Chinese." He earned his living by pushing an ambulant stall with his wife, selling herbal tea at markets, while never stopping his production of artworks and poems. People stared at me each day on the way into his house or after stepping out of it, as if to ask whether I was the same as him. He died a few years after my father, and I became one of the first, if not the only, female artist in Thailand at the time to work on and lead a mural project. I was twenty-two years of age, a single woman, and the youngest member, and had never been to art school—yet I led the team.

My work during the next fifteen years included more than ten murals covering thousands of square meters of walls and ceilings. Men and women traveled either to learn themselves or to bring their children to learn from me. Then one day, at one of the temple murals I conducted, a passer-by came in and made a remark. It was meditative to have watched me working, he said—but how did I feel while working with my back to the world? In front of this very temple, where I had painted the life of the Lord Buddha and his previous reincarnation in Jataka stories, a girl I knew of, I later learned, had been sold by her parents to a brothel agency. She was twelve years old. It was at that moment I realized that when my silence had become empty, it was time for me to leave.

I had been selling my paintings at exhibitions to raise funds for a women's shelter in Thailand for many years by then, but the Tradissexion exhibition at Concrete House, in early 1995, was the first time I showed work dealing with the issue of women. The work was *Akojorn,* meaning "no-go zone." I hung pieces of used sa-rong fabric on a washing line, forcing the audience to walk underneath it. Because women's clothes are considered polluted, it was a social taboo for women to do this in a public space. Men, knowing this, tried to walk around to the back door of the gallery without crossing under the line. Some women artist colleagues contested that feminism was a problematic issue in Thailand, and besides—they had never been af-fected or treated badly as women in Thai society, they maintained. One of the artists

referred to Simone de Beauvoir, since she had studied at the École des Beaux Arts in France; another came from a wealthy family with live-in maids and servants. I concluded there was a big gap in the art context between Thailand's capital city and its provincial areas. The next year, I completed the *Nariphon* series, which portrayed the girl sold in front of the temple (Plate 10). I sent the painting from Australia to participate at the first Womanifesto exhibition, held in 1996 at the Baan Chao Praya building in Bangkok. There was one review by a male art journalist commenting on the overall exhibition, which reported the work was from a bunch of women. It was referred to as merely an exercise in rhetoric. Nothing was said about my work. I realized I had yet to be established on the Thai contemporary art scene; to the audience I was just a Thai temple mural painter who had married a foreigner and left the country.

I first went overseas much earlier, in 1987, when I brought the work of the group I led on mural projects to show at a gallery on the French island territory of Réunion in the Indian Ocean. This later led me to take an exhibition to Paris in 1989. During the exhibition in Paris, I also looked for possibilities to work with galleries overseas. Art dealers and gallerists sent me on to other dealers who traded crafts and antiques, then to people who dealt with Oriental art—and those only dealt with Chinese and Indian art. These people kicked me out—back to the art gallery that had sent me there in the first place. It must have been one of my unlucky days when, on the way back to where I was staying, a man stood next to me in the Metro, placed his hand on my head, and started stroking my long black hair, down my spine. Shocked and upset, I could not do anything at that moment, not until he went away. I went back to the friend's house where I was staying, an old classmate who studied at Paris's Sorbonne University. I told him what had happened and asked him to teach me how to swear in French. "*Salot, laisse-moi tranquille*," he answered. I repeated the words a couple of times to memorize them, when he said: "Why didn't you just scream at him in Thai?" that left me struggling to find words. I had never sworn in Thai. What language should I speak to deliver the message?

Somehow it reminded me of the route from a jetty I had frequently traveled during a mural project at a temple on Koh Samui island. I would put my cap and sunglasses on, with my earphones plugged into an empty walkman. I was one of a few, if not the only Thai passenger on that jetty, from which ferries carried foreign tourists to the island. I dreaded having to answer questions about why I was there, for what purpose. Sometimes I got questions like "How much?" Under sunglasses and earplugs I was connected to a tune outside of what was happening around me.

In 2003, I participated in the Abstractions exhibition, at the Drill Hall Gallery in Canberra, with the series *The Elephant and the Bush* (Plate 11), alongside my earlier work on the life of the Buddha. A viewer approached me and said, "Your paintings

are exquisite; they are all beautiful, but you have to tell me the story—without one, I don't know what you are talking about." The question left me stumbling for an answer. If the language I used failed to deliver, was I to appropriate another that talked to others even though it did not talk to me? How would a universal language work when the spaces in which we dwell are not synchronized? *The Elephant and the Bush* series referred to my being an alien when I first arrived in Australia; the elephant is not native here and has never existed on this continent. Apparently this message has not gone across to my audience . . . yet.

My relocation from Thailand to Australia meant breaking free from the nuanced but split ends of Thai contemporary art at the time; the notion of "Here and There," "East and West," "Now and Then." But rather than feeling liberated, I found making art in this new location suffocating. During my first weeks in Australia, I struggled to remember people's names let alone the streets and localities I was new to. The year was 1996; politics had just turned around with the new prime minister, John Howard. A rising-star party called One Nation was led by Pauline Hanson, the MP from Queensland, which I briefly visited as a new permanent resident. Curiously, I felt somehow relaxed to have found that one of the national icons here was named Pharlap, even though very few Australians knew that it was a Thai name and it carries a meaning (lightning). My husband even told the director of the Melbourne Museum this once, but he was not interested. Back home in Sydney, entrapped by my condition in a narrow studio, I went out and started writing Thai names for flowers found in the townscape where I lived. I carried that sense of being lost and unable to subjectify my work into my production of art. The Thai alphabet first appeared in my work with *Consecration II* in 2002, where I wrote my own version of Buddhism, as I understood it, alongside and behind rows of Buddha statues. These referred to a consecration ceremony that had taken place in the temple I attended as a child.

An Elephant Journey (2005) (Plate 12), shown in the Open Letter exhibition at Gallery 4A in Sydney, contained Thai names of flowers listed in my sketchbook, dating from 1996. These Thai names were written randomly and subtly throughout the work, the direct view of which was carefully obscured by panels of ink drawing on Perspex sheets hung in front. I used the language as a vehicle to which I was emotionally connected to make sense of the place I lived in and to build up a space for me to fit in. Ironically it also obscured the view, keeping people from being able to see me.

Unfortunately, this identity baggage with which I travel does not shed itself even if you want it to. No matter how much you want to be included in society, individual identity shows up and answers how others want to see you, or in my case demands I be seen differently. That is, I struggle as I walk between two parallel lines that will never meet, one of which is that demanded by the audience to be connected to me,

which I cannot offer. The other line is the language of my studio practice, which I hold onto, no matter how thin and fragile it is, and without which I cannot possibly maintain my existence. As an artist I can only reflect on what I have experienced, but I feel that this question is phenomenal. That is, humans are subjected to alienation in this fast-track world, with its massive relocations and dislocations. Furthermore, the world nowadays has produced a sense of dislocation or of having been misplaced within one's own society. Do we or don't we leave enough room for our own necessary mental space?

The exchange program I participated in at Sisaket, in northeast Thailand, in 2008 had two components. The first was a workshop, for which I sent out a message before I arrived, asking the students who would be participating to read a story my father had written that was set in the same area forty years prior. Each participant was asked to come with their own "objects of memory" and not to reveal them to others. At the workshop, the students placed their chosen objects in jars found in local shops, meant for preserving pickled fish, a local specialty (Plate 13). There were ten altogether. I left nine at the site of the exchange program and took one jar to keep. One of the Thai participating artists commented in Thai that my project was too conceptual, too complicated to follow, and besides, it only served my own work's purpose and did not teach anything to the students. As I liaised between the three Thai participants and three international artists at that time, I encouraged the Thais to speak English as much as they could in their presentation and throughout the program. But the atmosphere became intense. I was thought imposing, too pushy for the Thais, and too accommodating to the international artists. Things were resolved by one of the organizers, who persuaded the Thais to tolerate my manner out of the fact that I had become too much of a *farang* (foreigner) since I had lived outside Thailand for such a long time. The international participants, one Swiss, one Argentinean, and one Indian, reminded all participants that no one in this workshop was a native English speaker. I apologized for my own culture shock, and thereafter kept my head down, focusing on my studio work.

I worked on weaving a piece of fabric with the assistance of Mae Pan, an elder craftsperson who mentored me to achieve the skill of weaving on her handloom (Plate 14). Together we wove the unbleached yarn found at a local market into a mesh cloth resembling a cast-off reptile skin (Plate 15). In fact, I had found a shed reptile skin on top of the mosquito net at the farm where we were staying. The skin was a welcome surprise as it had answered to the project I proposed to achieve during the residency. That was to set up an installation work near the creek on the farm to pay tribute to Naga, the serpent deity. I gave up the plan but instead went on weaving the fabric. There is no direct English translation for a Naga, but it is a type

of mythological figure appearing in the shape of a great serpent, which is sometimes half-human and half-animal. Nagas are commonly depicted in Thai mural painting as important figures of Thai Buddhist narrative. I had depicted Naga in some of my works over the years as an allegorical subject in reference to Thai women, because both the Naga and Thai women belong to those disqualified from Buddhist ordination. There is one requirement the candidates for ordination must be able to answer in the affirmative: that they are human. The Nagas are not qualified because they are animals. I used this theme to question the condition of women in Thai beliefs—that women are equivalent to the non-human. It also symbolically paid tribute to my mother, who at that stage suffered from early dementia. My earlier 1998 work, *My Mother was a Nun* (Plate 16), is a portrait of my mother when she became a nun, while I was still a child. In a later work, picturing her attending my brother's ordination, her figure transformed into that of a Naga.

I went to Thailand to care for my mother in hospital halfway through working on the ten-panel series *Three Worlds* (Plate 17). In some of the work shown in the Ephemeral but Eternal Words exhibition, I wrote a Thai text copied from the book *Traibhumi-Praruang* (*The Three Planes of the World*), written by King Lithai (King Ruang) of Thailand in the fourteenth century. This literature is supposed to be read to Buddhist believers in a Thai cultural context. The text was written interwoven with images I had depicted of figures, houses, and trees using both Australian and Thai icons. I came across the description of the realm of Naga when I included the figures of Naga in the series. I was still working on the series when I had a break to attend the residency. So instead of the installation work I had intended, I wove fabric that referred to a snake shedding its skin for rebirth, and the ink was the stained evidence of the moment I touched my paintbrush on the cloth. I then used this piece of woven mesh to create a fabric sculpture. I wrote this with Thai text to testify to how viewers see my work. The piece can be seen from a distance with Thai lettering written over the outer shell, which remains visible that way. But this mesh can be removed to unveil its content only when viewers come closer to the object and look through the mesh at the drawing inside.

I would like to finish with an excerpt from a short story by Brazilian writer Clarice Lispector, titled "The Crime of the Mathematics Professor." A clue to its deeper meaning is found in a review in the magazine *Belles Lettres,* as follows: "Reading Clarice Lispector's novel is like listening to a stranger unravel her thoughts and then walk out of the door, leaving behind a strong sense of character but few facts about daily life. You wonder after meeting such a person whether she was real or imagined—and then decide it does not matter" (quoted on the book cover of *Family Ties,* 2008 [1972]).

"The Crime of the Mathematics Professor" begins with the professor digging a grave to bury an unknown dead dog to punish himself for his earlier crime of having once abandoned his own dog. While he dug:

> He then began to think with difficulty about the *real* dog as if he were trying to think with difficulty about his *real* life. The fact that the dog was far away in another city made his task difficult, although his yearning drew him close to the memory.
>
> "While I made you in my image, you made me in yours," he thought, then, aided by his yearning, "I called you Joe in order to give you a name that might serve you as a soul at the same time. And *you?* How shall I ever know the name *you* gave me, and how much more you loved me than I loved you," he reflected with curiosity.
>
> "We understood each other too well, you with the human name I gave you, I with the name you gave me, and which you never pronounced except with your insistent gaze," the man thought, smiling with affection, now free to re-member at will. (Lispector 2008 [1972]: 143; my emphasis)

REFERENCE

Lispector, C. (2008 [1972]), "The Crime of the Mathematics Professor," in *Family Ties,* trans. Giovannai Pontiero. Austin: University of Texas Press.

7 LIFTING WORDS, FLOATING WORDS

Savanhdary Vongpoothorn

My work has always had Lao cultural references interwoven with Australian and other cultural influences. Besides using motifs and symbols from Lao textiles, for example, I have applied a technique of perforation to some works as a direct reference to the act of weaving (Plate 18). Spiritual references have also been important, especially the use of Lao words, texts, and concepts from Theravada Buddhism, including *khaathaa* (Lao-Pali) and *paritta* (Pali) protective incantations or spells. For me, such cultural references do not constitute a fixed tradition or an objectified sense of "culture." Rather, they stem from my experience of growing up, living, and breathing in Lao cultural, familial, and religious worlds, both in Laos and Australia.

Toward the end of 2005, I went back to Laos with my parents. While in Laos we spent two weeks in my mother's village, Muang Khang, in Champassak, where there is no running water and electricity is very unreliable. My main purpose in going back was to find inspiration for my work; and although I had no preconceived ideas as to what form this inspiration would take, the two weeks I spent in the village made an everlasting impression on me as an artist.

We arrived at the village by boat, passing other villages on our way down the Mekong River. After a day or two of settling in, it was time to go and take food to the local temple as an offering for the monks. Going to the temple was highly anticipated as this was the landmark we saw when we first approached the village. We admired the grounds and the temple complex's architecture, which consists of three buildings. One is a large wooden stilt house, where the monks' education takes place. The second building is made of concrete in the vernacular style. This building

is called *Buddhasimma* and is where special religious ceremonies take place such as monks' ordination and meditation (Plate 19). The third building is the *sala;* here is where everyday lay people offer food to the monks, and this is also made from concrete. Entering the *sala* via long staircases on either side of the building, you come into an open space with a beautiful wooden floor, in which there is an altar on a long wooden platform that faces the river. Monks sit on the platform in front of the altar.

When I saw the altar, my heart sank. This was unlike any altar I had seen at temples in Australia, which were lavish and ornate with flowers, candles, and incense, and with gold Buddha statues—some even with emeralds. But this Buddha, the only one I had seen in my mother's village temple, was made out of concrete and was so lackluster and unattractive! The only thing it had going for it was its size. It was huge, but it had no flowers and maybe only one or two candles on its lap. My parents were unfazed and far removed from what I was thinking and feeling. I could see they were totally absorbed and did not share my views or expectations. I was sad and disappointed when I later realized that I had been looking at the culture of Lao Buddhism through Western eyes. These feelings were silently transposed onto my extended family and friends in the village. I could not understand why they did not help with the upkeep of the temple. Is it because they are poor, I wondered? Or have they lost their devotion? Are there any teachings anymore, or only rituals? All these questions played in my mind throughout my stay. More and more, I longed to go back home to Australia.

Finally that day came. After saying goodbye to family and friends, and before boarding the little boat that was to take us away, we went to say farewell to the head monk and to ask for his blessings. But before the final goodbye, my mother asked the head monk if we could pray to Phra Hin Sila. I did not understand what was going on, but I followed them into the temple's second building. It had been shut up and was so dim inside when we entered. We followed the staircase to the top floor, which had galleries all around the room, like corridors. Then we came upon a double door, chained and bolted. A novice soon appeared from somewhere with a key, unlocking the door. As the windows were opened to let in natural light, the light revealed a room filled with hundreds of palm- and mulberry-leaf manuscripts kept in four or five wood and glass cabinets and in two large boxes the size of coffins, painted gold. When we entered this room, my first impression was "Wow!" But before I could form any thoughts in my mind I heard a small devotional cry from my parents. I turned around and saw them kneeling in prayer in front of an altar full of the most beautiful Buddha statues I have ever seen. About thirty statues stood on the altar, all various sizes, the biggest no larger than the length of my arm. Some were made out of wood, some out of stone then painted in gold color or maybe gold leaf; but the most revered was the Phra Hin Sila, made out of a sacred stone and said to have

belonged to the village for hundreds of years. Now named Champassak, the area was once the old capital city, named Muang Khang (meaning "middle city").

As soon as I saw my parents praying, I immediately knelt and prayed with them. The sudden surprise of seeing these beautiful hidden Buddha statues was more than I could take; this experience was such a contrast to my initial feelings about the temple that I could not stop the flow of tears as we went down to the river. In retrospect, I wish I'd had the presence of mind to ask the head monk about the manuscript leaves. How old are they? Are they secular, vernacular texts or religious Pali manuscripts? Who inscribed them? Are they being used? And why were the Buddha statues (which appeared to be of museum quality) hidden away?

Later, I told this story to my anthropologist friend, Phillip Taylor, over many conversations. He then asked me if I knew Justin Thomas McDaniel's book, *Gathering Leaves and Lifting Words: Histories of Buddhist Monastic Education in Laos and Thailand* (2008). I was immediately intrigued by the title alone, and even more so from my discussions with Phillip, so I went to the library to get it. Reading McDaniel's book has shed some light on my inquiries about the palm leaf manuscripts and enriched my art practice. It has also inspired the titles of two recent paintings, shown in my 2011 exhibition, Stone Down the Well, at Niagara Galleries in Melbourne. Here I discuss these two paintings, *Lifting Words* (2011) (Plate 20) and *Gathering Leaves* (2011) (Plate 21), as well as the work on paper *Floating Words* (2005–2006) (Plates 22–24), commissioned for the 2006 Biennale of Sydney. By writing about my inspirational experiences and the creative process in making these works I hope to create a dialogue between form and meaning.

LIFTING WORDS

It was also in 2005 that I started to use Lao-Pali texts in my paintings. My father transcribed these *khaataa* and *parrita* texts for me from Thai-Pali into Lao-Pali. The texts come from a book that was printed in Thailand but given to my father by the abbot of the Wat Buddharangsee temple in Sydney, where my father was ordained as a monk. The book was printed for free distribution among Buddhist teachers and lay practitioners, and is a compilation of different *khaataa* written by many famous abbots. While the book notes the authorship of various contributors, it is understood that these Thai *khaataa* are reinterpretations of original Pali sources, using a process known in Lao as *yok sab,* or "lifting words." Thus these authors are also scribes, in the sense that McDaniel describes for the role of the scribe in the premodern era:

> Scribes often mentioned their names but not the name of the author of the text they copied…Ownership of ideas was simply not as strong a concept before

> print culture (and if one reads the published religious works in Thailand or Laos today, it quickly becomes evident that citations are few and far between, that often authors completely copy or plagiarize previous writers' work, and that many other texts are written by a group or dedicated to an abbot who may have had little to do with the actual writing). (2008: 180).

My father is also a *mo pone* in the Lao community in Australia, perhaps best described as a lay priest. He is often invited to perform ritual blessings, called *su kuon,* for weddings, birthdays, and births, and even for those who are ill. He begins and ends a blessing ceremony with a *khaataa,* which he chooses and memorizes from the book mentioned earlier. The narrative incorporated into his chanting is based on his experience with and knowledge of the person he is performing the ritual for, often raising a laugh from the crowd or, sometimes, tears from me. To the community, the *mo pone*'s ability to translate the Pali syllabus into the ritual is considered a gift:

> The practice of translation, or better—languaging (the "shaping of old texts in new contexts")—was the "poetics" of religious literature in the region. Vernacular narrative collections, *nissaya, vohara,* and *namasadda,* as well as *anisamsa* (blessings), *paritta* (protective mantras), and *xalong* (guides to ceremony) all draw from the Pali canon. Even if the source text was originally composed in the vernacular, an ideal Pali source was "invoked." (McDaniel 2008: 187)

To the Lao community, when the ideal Pali sources are invoked the resulting prayers are considered sacred sounds.

The Lao term *yok sab* describes the role my father plays in the community, as well as the work of Pali scribes.

> This process of languaging is very specific, but not systematic. The word *yok* is used for the activity of "lifting" Pali words and passages from a text and incorporating or commenting on them in another text. These lifted words, removed from their original source context, take on the adapted meanings assigned to them by the original "lifters" and subsequent "citers." These lifted words, if repeated enough and incorporated into vernacular syntax, slowly become part of the vernacular vocabulary and cease to be seen as loan words…Originality and individual creativity are obviously prevalent; here it is creativity in Goethe's or Walter Benjamin's sense of the term—a creative reformulation or recombination of words spoken by the Buddha and his disciples. No one says anything new; they just say it in a new way. When they do say something new, they rarely admit it. (McDaniel 2008: 188)

For this reason, I situate my father in the same tradition as these scribes of palm leaf manuscripts. Moreover, I see myself as a painter working within the same tradition.

I paint by lifting words; I am not saying anything new, yet, through painting, I say it in a new way.

In some of the incantations my father transcribed for me I noticed the characters for the three words of the Triple Gem—Buddha, Dharma, and Sangha—repeatedly appeared. In previous works, especially those created for my solo exhibition at Martin Browne Contemporary art gallery in 2005, I used the full *khaataa* text, however in *Lifting Words* (2011) and *Gathering Leaves* (2011) I focused on repeatedly painting the Triple Gem's calligraphic characters across the gridded canvas as I gradually learned and internalized their meaning.

FLOATING WORDS

This process of lifting words has extended into my series of works on paper titled *Floating Words* (2005–2006) (Plate 22). When my husband, Ashley, an anthropologist, came back from a research trip to Vietnam in 2005, he brought back local magazines printed in Braille, thinking I might like them. I more than liked them—I loved them! They were the best thing he had ever brought back for me. Feeling their little bumps with my fingertips, I thought about how much we take sight for granted, and how seeing is not just about vision. At first, with this in mind and excited by the aesthetics of the Braille, I began to tear off the pages and pin them onto the wall in a grid. Their tactile quality resonated strongly with perforated works I had previously made on paper and canvas. But, conceptually, I felt I couldn't use just any Braille; it was important the Braille was Vietnamese. Hence where the pages came from and how they were obtained became particularly significant.

Initially, Ashley got some magazines from Saigon and Danang, but only after long meetings with people working and hanging out at associations for the blind, because of the scarcity of Braille publications there. The fact that the Braille came from Danang was especially interesting for me because Danang is on the central coast of Vietnam, a region now a key migration point for those coming from Vietnam into Laos. By contrast, the Braille magazines were plentiful in Hanoi, and could be had for the asking. I later found that this was because the magazines are printed and distributed from Hanoi: the farther away you get, the scarcer they become. I like to think that these Braille magazines were migrating and floating, the way language migrates and floats from place to place, from one translation to another, and across cultures.

It was not enough to just ponder the abstract nature of Braille. I was curious to know exactly what it was people were reading through these bumps. I later asked my husband to translate the contents of the magazine for me, which he was able to do by getting hold of a sighted copy of one. That particular magazine opened up with a quote by Ho Chi Minh: "To emulate is to love your country, if you love your

country you must emulate, and those who emulate are those who love their country the most." More than a little propagandistic, the contents of these publications are generally in an ideological time warp, having been left way behind by sighted print media culture in Vietnam. However, they also contain useful information, such as poetry and inspirational stories of blind people who have succeeded.

One of the conceptual possibilities that emerged for me was to think of Braille as a metaphor for being blind, blinded by propaganda. At the same time, however, I sympathized with the blind for having such limited reading material; there seemed to be something very poignant about this group of people reading the leftover ideological dross of the past. Eventually, I wanted to make a Lao connection to this Vietnamese Braille story. Historically, Laos and Vietnam have been close since the French colonial period, when Vietnamese administrators were employed in Laos by the French (i.e., Indochinese) colonial authorities, while Vietnamese merchants and traders were encouraged to migrate there as well. All modern Lao cities were actually Vietnamese at first. Following the war with America this colonial relationship persisted in the form of a special friendship treaty that essentially made Laos a client state of Vietnam. And strong Vietnamese political influence persists in contemporary Lao affairs.

However, in Indochina and indeed across large parts of mainland Southeast Asia, cross-border migration has been tied to political and military power in a way difficult for most in Australia to understand, since there is nothing quite like this in our own migration experiences. There is one social reality in Laos in which Lao and Vietnamese people live happily alongside each other, building hybrid cultural worlds. But there is another social reality in which ongoing informal migration from Vietnam reflects weak Lao sovereignty and raw Vietnamese power. Many recent Vietnamese migrants are coming into direct competition with ethnic Lao and upland peoples over scarce resources, in environments already under significant pressure. I wanted to find texts in Lao that reflected this shared national history while also speaking to the contemporary situation, so as to "lift" them onto the Braille sheets.

In Laos with my parents, in 2005, we also spent three days in Vientiane. During one of my many trips to the morning market I went to a bookstall and picked up a Lao language primer for Vietnamese speakers. Amazingly, this primer had also been printed in Danang, in 1997, and made its way across to Laos. Flicking through the pages, I was even more astonished to find quotes from the two revolutionary leaders, Ho Chi Minh and Kaysone Phomvihane, dating back to 1966–1967. Each quote is written in two languages and three different scripts: Uncle Ho's poem is written in Vietnamese, accompanied by a translation into Lao Sanskrit, and a Vietnamese phonetic transcription of the Lao translation. The speech by Uncle Kaysone also features a Vietnamese phonetic transcription and a Vietnamese translation. While I couldn't believe how lucky I was to find such perfect material, I also wondered if

people still believe these words, or whether the words are just floating like ideological driftwood in a country fast becoming a capitalist society. It was also then that I learned the terms for Braille in both Lao and Vietnamese can be loosely translated as "floating words."

I began to transcribe these quotes, as they appear in the primer, onto the sheets of Braille from the magazines. For example, Uncle Ho's poem uses the metaphor of shared geography to express the closeness of the nations:

Lao-Vietnamese Friendship

> Loving each other, we have scaled mountains,
> Forded rivers, crossed passes;
> Vietnam-Laos, our two nations.
> Our affection is deeper than the red river, than the Mekong.

<div align="right">Ho Chi Minh</div>

Heart-Line, Laos-Vietnam

> We wish to nourish the special, immense friendship between Laos and Vietnam, to make it ever fresher and firmer, to educate our children ever after, to respect and protect the beautiful and elevated feelings of friendship of the Lao and Vietnamese peoples, eternally brilliant and loyal, before and after, as one.

<div align="right">Kaysone Phomvihane</div>

At first I used paint and a brush to "lift" these words onto the Braille. My aim was to achieve a calligraphic quality, so the words would "float" on top of the Braille; but this failed because the text became unintelligible and, aesthetically, it counteracted the Braille's fragility. It didn't float enough; it looked big and heavy, as though it was weighing the Braille down. I was also excited to find that each Braille magazine had a different color and quality of paper. Some had thicker paper, in a darker and warmer color, while others had finer paper and were cooler in color (Plate 23). Initially I used a system for arranging the magazines according to color and tone, from dark to light, and I was careful to keep the pages in order. But the more I worked on it the more this system broke down, and eventually all the pages became mixed up. In the end, I decided to transcribe the quotes using sharp colored pencils: close up, the text appears to float on the surface, but from a few steps back it has a lost and found quality, which works with the fragility of the Braille (Plate 24).

In *Lifting words* (2011) and *Gathering Leaves* (2011) the text was painted on the canvas surface repetitively and calligraphically. Similarly, the political speech in

Floating Words is used a bit like a religious mantra. This was applied repetitively, but it was important that it be legible. This exercise showed (alarmingly) how easily two very different languages and cultures could be translated, each into the other, because of their shared recent history and common language of Marxist-Leninist propaganda.

On reflection, this work is both political and aesthetic for me. On the one hand, I approached it as a painter, trying to add to what was already a beautiful and mysterious object (the Braille) without diminishing its integrity. On the other, for conceptual reasons, I was trying to work with texts that were not at all mysterious, nor very attractive; trying to use them as part of an integrated aesthetic. I found that sometimes I had to let go of ideas and concepts to find the ideal aesthetic. Among the many layers of significance in this work is the fact that Braille is exotic to us, the sighted, but to the visually impaired it is not. Creating these pieces has made me keenly aware that the way we understand life and the world is not just visual, verbal, or aural. It is also a world of touch, which is visceral.

Whether painting in solitude in the studio or participating in a religious ceremony, what is prevalent in both these rituals is the desire to create a dialogue between form and meaning. This requires knowledge of the meaning of rituals, and a sense of how the performance aspects of ritual can affect participants in certain ways. Like all rituals, painting comes from a tradition. Despite our preconceptions, tradition is not static, but changes. The dialectic between form and meaning is, I believe, key to this transformative aspect of tradition (Plate 25).

This is beautifully summed up in Lao Tzu's metaphor of the vacuum: Lao Tzu "claimed that only in vacuum lay the truly essential... The usefulness of a water pitcher dwelt in the emptiness where water might be put, not in the form of the pitcher or the material of which it was made. Vacuum is all-potent because all-containing. In vacuum alone motion becomes possible..." (cited in Okakura 1964 [1906]: 24). For me it is this "absence" in the center of the ritual that I am trying to capture in my work. This is a means of inviting the viewer in, to participate and in a sense complete the ritual of painting. As Okakura puts it so well: "In leaving something unsaid the beholder is given a chance to complete the idea... A vacuum is there for you to enter and fill up to the full measure of your aesthetic emotion" (Okakura 1964 [1906]: 25).

REFERENCES

McDaniel, J. T. (2008), *Gathering Leaves and Lifting Words: Histories of Buddhist Monastic Education in Laos and Thailand*, Seattle: University of Washington Press.
Okakura, K. (1964 [1906]), *The Book of Tea*, New York: Dover Publications, Inc.

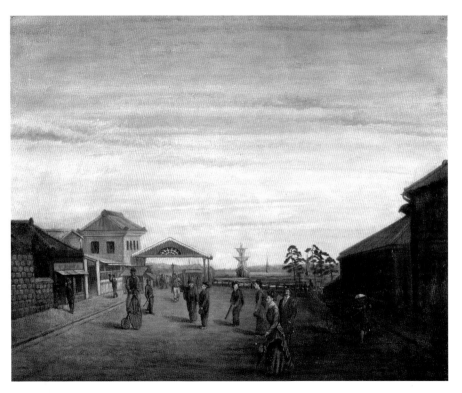

Plate 1 Goseda Yoshimatsu, *Port-Yokohama,* ca.1891, oil on canvas, 50 x 60.5 cm, Collection of the Museum of Modern Art, Kamakura & Hayama. Possibly by a student, signed by Yoshimatsu, circa late 1870s (a note by John Clark).

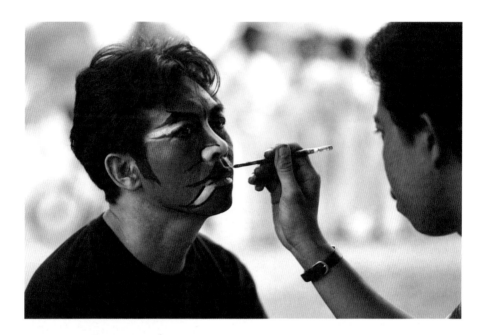

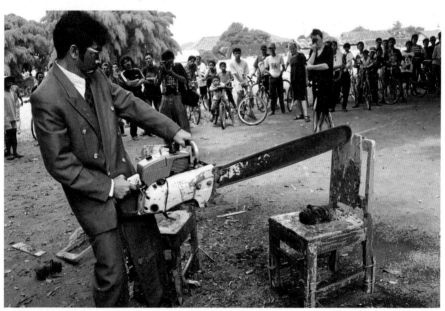

Plate 2 FX Harsono, *Destruction*, 6 April 1997. Detail from a performance in the South square, Yogyakarta Kraton, Indonesia. Courtesy of the artist.

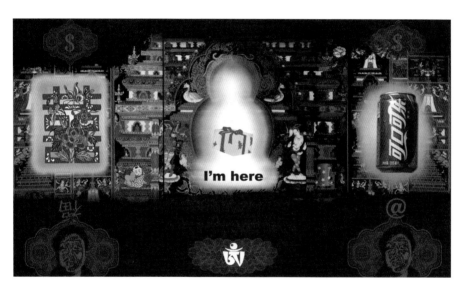

Plate 3 Keltse, *I'm Here,* 2007. Digital print on fabric. Courtesy of the artist.

Plate 4 Gonkar Gyatso, *Shambhala in Modern Times,* 2009. Stickers, paper cuts and pencil on treated paper. Courtesy of the artist.

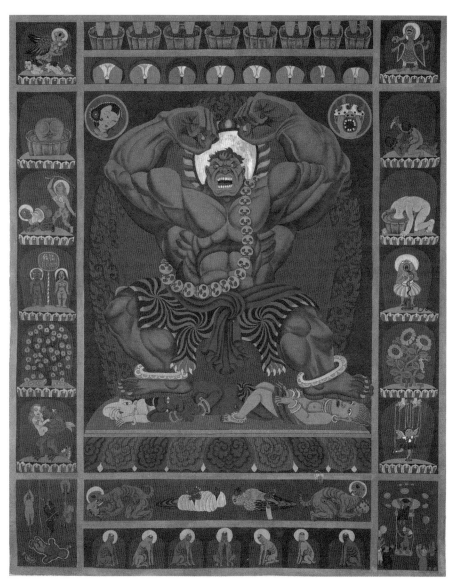

Plate 5 Gade, *Diamond Series: The Hulk*, 2008. Mixed media on canvas. Courtesy of the artist.

Plate 6 Nortse, *30 Letters,* 2010. Iron, earth, butter lamps installation. Courtesy of the artist.

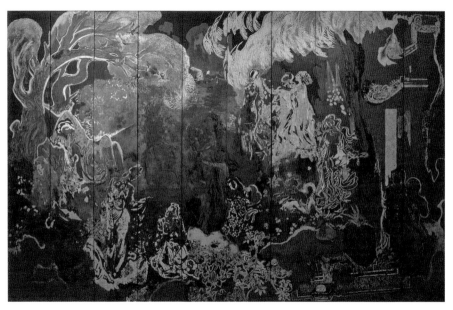

Plate 7 Nguyễn Gia Trí, *The Fairies,* ca.1936. Lacquer on board in 10 panels, 290 x 440 cm, Géraldine Galateau collection, Paris.

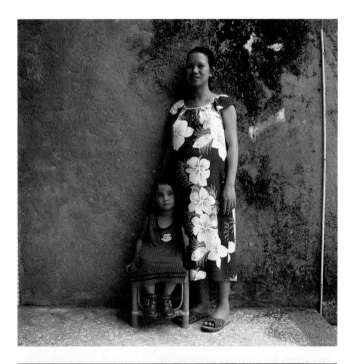

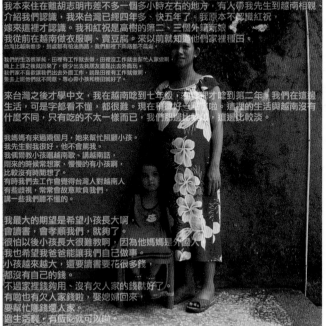

我本來住在離胡志明市差不多一個多小時左右的地方，有人帶我先生到越南相親，
介紹我們認識，我來台灣已經四年多、快五年了。我原本不認識紅祝，
嫁來這裡才認識。我和紅祝是高樹的第二、三個外籍新娘。
我從前在越南做衣服啊、賣豆腐。來以前就知道他們家裡種田。
台灣比越南進步，到處都有柏油馬路，我們那裡下雨路都不能走。

我們的生活很單純，田裡有工作就去做，田裡沒工作就去幫忙人家做啊，
晚上上課之後就回來了，很少出去找朋友還是出去外面玩。
我們家不喜歡讓我們出去外面工作，就是田裡有工作就做啊，
要去上班他們就不同意。專心帶小孩和種田就好了。

來台灣之後才學中文，我在越南唸到七年級，到這裡才唸到第二年啦，我們在這邊
生活，可是字都看不懂，都很難。現在稍微好一點點啦，這裡的生活與越南沒有
什麼不同，只有吃的不太一樣而已，我們那邊比較吵啦，這裡比較淡。

我媽媽有來過兩個月，她來幫忙照顧小孩。
我先生對我很好，他不會罵我。
我偶爾教小孩唱越南歌、講越南話，
剛來的時候常常想家，慢慢的有小孩啊，
比較沒有時間想了。
有時我們去工作會覺得台灣人對越南人
有些歧視，常常會故意欺負我們，
講一些我們聽不懂的。

我最大的期望是希望小孩長大啊，
會讀書，會孝順我們，就夠了。
很怕以後小孩長大很難教啊，因為他媽媽是外國人。
我也希望我爸爸能讓我們自己做事。
小孩越來越大，還要讀書要花很多錢，
都沒有自己的錢。
不過家裡錢夠用、沒有欠人家的錢就好了。
有啦也有欠人家錢啦，娶媳婦回來，
要幫忙賺錢還人家。
過生活啊，有飯吃就可以啦。

Plate 8 Hou Shur-tzy, *Border-Crossing/Diaspora—Song of Asian Brides in Taiwan (I). Kuei-hsiao and her child* (A) (B), 2005. Courtesy of the artist.

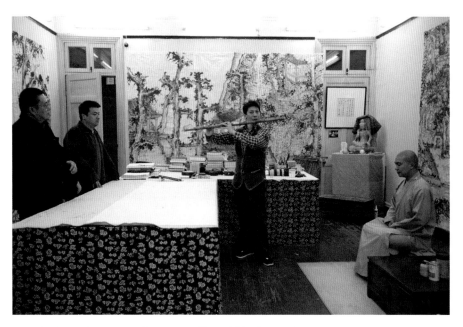

Plate 9 *Yaji* performance in Hangzhou, China, 2006. From left: Wang Shu, Lin Haizhong, Du Rusong and Zhi Guang. Photograph: Chen Mingkun. Courtesy of Lin Haizhong.

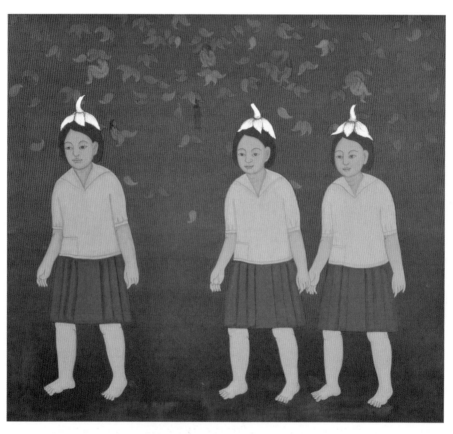

Plate 10 Phaptawan Suwannakudt, *Nariphon III b,* 1996. Acrylic on silk, 90 x 90 cm.
Photograph: John Clark. Private collection. Courtesy of the artist.

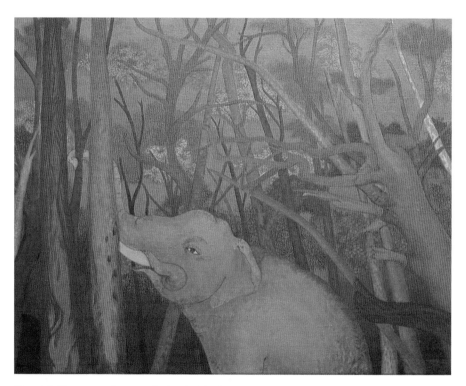

Plate 11 Phaptawan Suwannakudt, *The Elephant and the Bush* series #6, 2003. Acrylic on linen. 76 x 91cm. Photograph: John Clark. Private collection. Courtesy of the artist.

Plate 12 Phaptawan Suwannakudt, *An Elephant Journey 1,* 2005. Acrylic on canvas, ink on Perspex, 500 x 250 cm. Photograph: Krzyzstof Osinsky. Courtesy of the artist and Arc One Gallery.

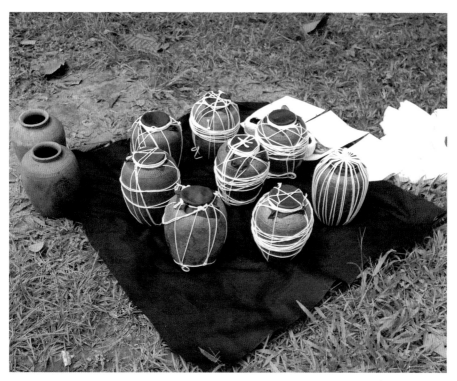

Plate 13 "Objects of memory" in jars at a workshop of the Womanifesto International Residency Program, Sisaket, Thailand, 2008. Photograph: Varsha Nair. Courtesy of Womanifesto.

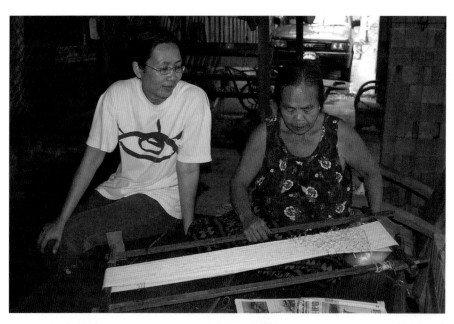

Plate 14 Phaptawan Suwannakudt learning weaving from Mae Pan, Sisaket, Thailand, November 2008. Photograph: Nitaya Ueareeworakul. Courtesy of Womanifesto.

Plate 15 Phaptawan Suwannakudt, *Cast-off* series, 2007–2010. Ink and pencil on handmade
paper, 15 x 10 cm; woven fabric object, 3 x 3 x 3 cm; each series consists of six sets.
Photograph: Krzyzstof Osinsky. Courtesy of the artist and 100 Tonson Gallery.

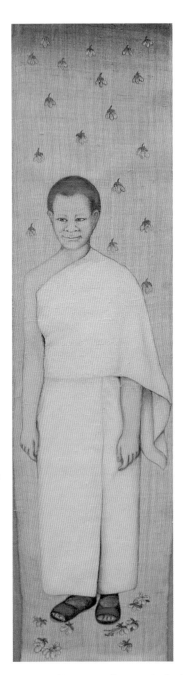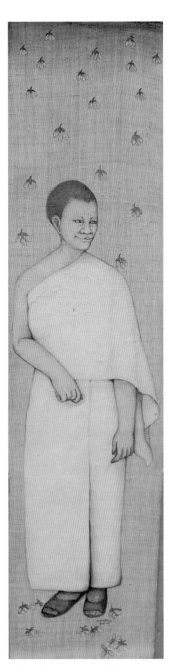

Plate 16 Phaptawan Suwannakudt, *My Mother was a Nun II (a)* and *(b)*, 1998. Acrylic on hemp, 130 x 35 cm each. Photograph: Phaptawan Suwannakudt. Courtesy of the artist.

Plate 17 Phaptawan Suwannakudt, *Three Worlds 9*, 2009.
Acrylic on canvas, 135 x 65 cm. Photograph: Krzyzstof
Osinsky. Private collection. Courtesy of the artist.

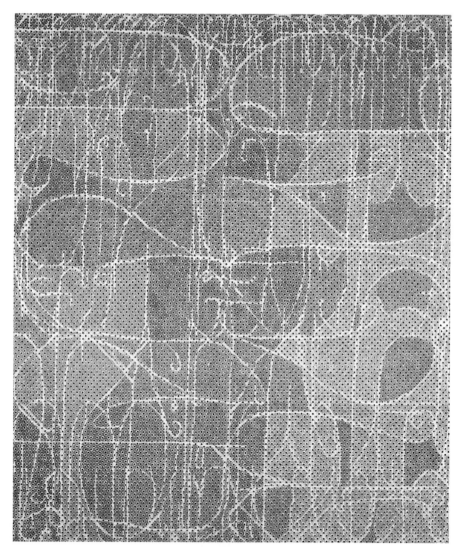

Plate 18 Savanhdary Vongpoothorn, *Bhava,* 2007. Acrylic on canvas with perforations, 180 x 154 cm. Photograph: Jenni Carter. Courtesy of the artist, Martin Browne Contemporary and Niagara Galleries.

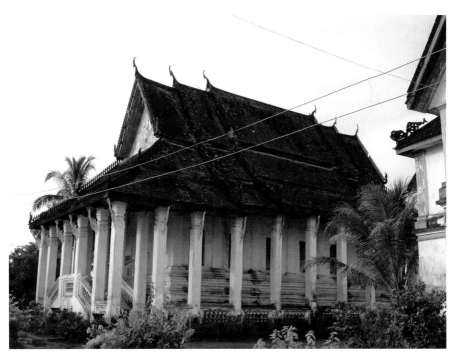

Plate 19 The *Buddhasimma* at the Muang Khang temple in Champassak, Laos, 2005.
Photograph: Savanhdary Vongpoothorn.

Plate 20 Savanhdary Vongpoothorn, *Lifting Words,* 2011. Acrylic on canvas with perforations, 180 x 150 cm. Courtesy of the artist, Martin Browne Contemporary and Niagara Galleries.

Plate 21 Savanhdary Vongpoothorn, *Gathering Leaves*, 2011. Acrylic on canvas perforations, 101 x 95 cm. Courtesy of the artist, Martin Browne Contemporary and Niagara Galleries.

Plate 22 Savanhdary Vongpoothorn working on *Floating Words,* 2005–2006. Colored pencils and acrylic on sheets of Vietnamese Braille. Five panels, each 6 sheets high x 8 sheets wide, 156 x 810 cm. Photograph: Martin Sorenden. Collection: National Gallery of Australia. Courtesy of the artist, Martin Browne Contemporary and Niagara Galleries.

Plate 23 Savanhdary Vongpoothorn, *Floating Words*, 2005–2006, (detail). Stack of Vietnamese Braille sheets, each 20 x 26.5 cm. Photograph: Jenni Carter. Collection: National Gallery of Australia. Courtesy of the artist, Martin Browne Contemporary and Niagara Galleries.

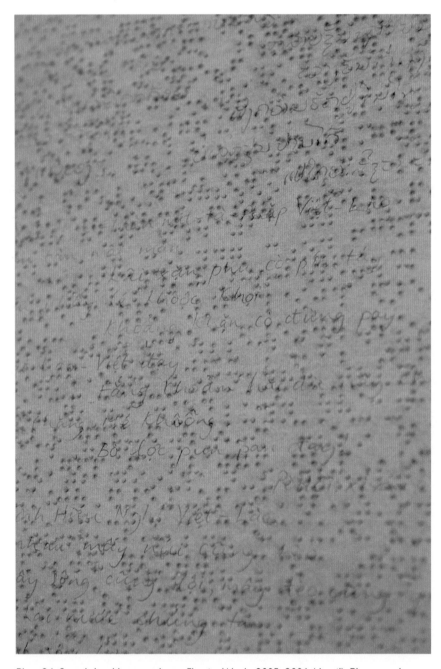

Plate 24 Savanhdary Vongpoothorn, *Floating Words*, 2005–2006 (detail). Photograph: Ursula Fredrick. Collection: National Gallery of Australia. Courtesy of the artist, Martin Browne Contemporary and Niagara Galleries.

Plate 25 Savanhdary Vongpoothorn, *Highland Mandala* I-VI, 2000–2001. Mixed media on paper, 19 x 19 cm each. Courtesy of the artist, Martin Browne Contemporary and Niagara Galleries.

Plate 26 Chihiro Minato, *Mothers of Letters,* 2005–2007. Gelatin silver print on paper, 43 x 35 cm. Courtesy of the artist.

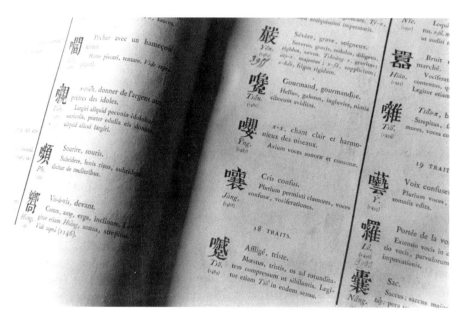

Plate 27 Chihiro Minato, *Mothers of Letters*, 2005–2007. Gelatin silver print on paper, 43 x 35 cm. Courtesy of the artist.

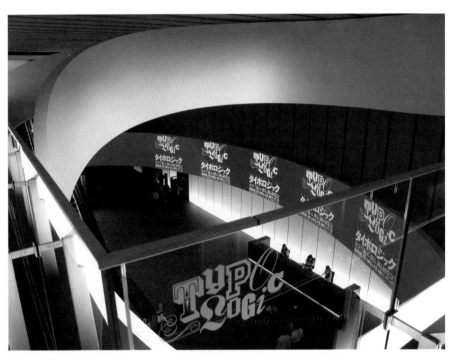

Plate 28 The *Typologic* exhibition at Nikkei newspaper building, Tokyo, 2009. Photograph: Chihiro Minato.

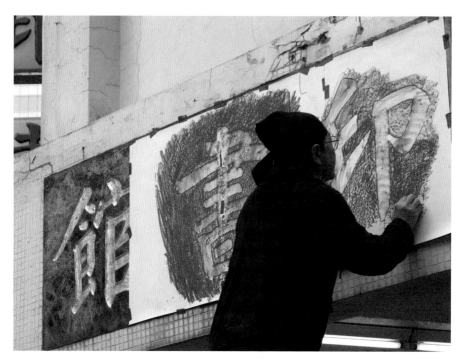

Plate 29 Artist Masao Okabe making a rubbing of the Chinese characters on the signboard of the Commercial Press publishing house on paper, Taiwan, 2009. Photograph: Chihiro Minato. Courtesy of Masao Okabe.

Plate 30 Chihiro Minato, *Ri Xing Typography*, 2012, Inkjet print. Courtesy of the artist.

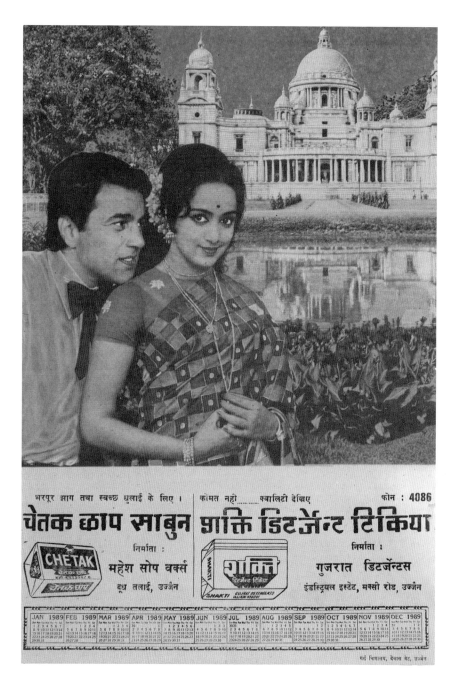

भरपूर झाग तथा स्वच्छ धुलाई के लिए । कीमत नहीं........क्वालिटी देखिए फोन : 4086

चेतक छाप साबुन शक्ति डिटर्जेन्ट टिकिया

निर्माता : महेश सोप वर्क्स दूध तलाई, उज्जैन

निर्माता : गुजरात डिटर्जेन्टस इंडस्ट्रियल इस्टेट, मक्सी रोड, उज्जैन

JAN 1989	FEB 1989	MAR 1989	APR 1989	MAY 1989	JUN 1989	JUL 1989	AUG 1989	SEP 1989	OCT 1989	NOV 1989	DEC 1989

गर्ग चित्रालय, देवास गेट, उज्जैन

Plate 31 Movie actors Dharmendra and Hema Malini in front of the Victoria Memorial, Calcutta, 1989. Garg Chaitralaya, Devas Gate, Ujjain, publisher. Calendar, chromolithograph, 47.6 x 31.5 cm. Private collection. This 'modern' couple could just as easily have been juxtaposed with the Taj Mahal or the Bombay skyline.

Plate 32 *Swami Vivekananda in Chicago,* ca.1942. H. Ganguly, artist; unknown publisher.
Chromolithograph, 28.2 x 21 cm. Private collection. Vivekananda is shown in Chicago of the
World Parliament of Religions in 1893.

8 *TYPOLOGIC:* INTERACTIONS BETWEEN THE INTELLECT AND THE SENSES

Chihiro Minato

Figure 8.1 Chihiro Minato, *Page-scape,* 2012. Gelatin silver print on paper, 43 x 35 cm.

THE HISTORY OF COLOPHONS, OR
PERHAPS THE BEGINNING OF A JOURNEY

A book is a piece of architecture. We enter by opening its door, or title page, and move through it by turning the columns of its pages. A book has a body. When we look at the spines of books lined up on the shelf, with our eye tracing the contours of the type, we are reading. At the very back of this building—usually notes in fine print on the last page—our journey begins.

This is the realm of printing and bookbinding. Sometimes a colophon includes not only the name of a printer but also the name of the studio that did the typesetting. While that is the last stage of production for a book in becoming a physical object, it is far from where reading is done. And letterpress printing in particular is probably the furthest process from the reader nowadays. To talk about the fast-disappearing movable type and letterpress is thus like embarking on a journey to trace the history of books through their colophons. At the very back of this building we call a "book," forgotten scripts are lying dormant. Such a journey, starting from a book's colophon, would rouse myriad forces we once associated with movable type, triggering memories of letterpress production filled with the aroma of paper and ink.

Although I had been publishing books for over twenty years, I had never thought about how a book was actually created. In this sense, my encounter with letterpress print studios became a chance to shift my attention to the physics of a book. The experience of photographing characters and letters was, to a writer and photographer such as myself, a rare opportunity in which these two worlds intersected. My project *Mothers of Letters* captured the last days of one of the world's oldest print workshops, the letterpress printing department at the Imprimerie Nationale in Paris; it, however, closed its doors in 2005. In Tokyo, I photographed the letterpress print department at Dai Nippon Printing Co., Ltd. (DNP)—but it too no longer exists. Now, backed by a wide selection of e-book readers, reading on electronic paper has begun in earnest, which might spell the end of the letterpress printing era that began with Gutenberg. There seem to be few inventions other than movable type that, while contributing so much to modern civilization, have so quietly disappeared from the world (Plate 26).

Japanese typography seems to bear the traces of a modern history in which it was necessary, amid the influence of Roman letter typefaces, to create unique typographic forms. In Japanese, movable type is called *katsuji,* using two Chinese characters meaning "living" and "character/letter" respectively. Here I wish to discuss the form and appearance of *katsuji*—their "way of living," so to speak—which unfolds by following the traces in the character forms. I also explore whether characters and

letters are one of the basic materials or spaces for society, due to issuing from an interaction between the intellect and the senses. First, I try to retrace the long-distance journey of movable type, which was invented in the East and then developed in the West, and later returned to the East again.

TRAVELING TYPOGRAPHY

The immediate source for the movable type used in Japan today comes from the sets of type imported from Europe via Shanghai in the nineteenth century, but several earlier attempts were made to use movable type. One was when the Tenshō Embassy—a Japanese embassy sent to Europe by a Christian samurai lord in 1582—brought a printing press and a set of Roman letter type back from Portugal in 1590, used for printing in Nagasaki. Called *Kirishitan-ban* (literally "Christian press," and known as the Jesuit Mission Press in Japan) because it propagated Christianity, the publications of the Christian press are thought to be the first case of letterpress printing in Japan, although most were lost during subsequent periods when Christianity was suppressed. Another case was *Sagabon* (Saga books), a generic term for books printed with wooden movable type in Saga, Kyoto, during the early Edo period (early seventeenth century). Printed on fine Japanese paper, these were a sort of luxury publication, mainly diary literature and poem anthologies from the Heian period (794–1185). However, the movable type used is important when thinking about contemporary Japanese typography.

The challenge of printing Japanese with movable type lies in the presence of *kana*, the two phonetic syllabaries known as *hiragana* and *katakana*. While *kanji*, or Chinese characters, could be independently typeset one by one, *kana* are based on a cursive script written with a brush, resulting in differently sized characters. To resolve this problem, the movable wooden types used for *Sagabon* were designed to treat a series of two or three *kana* characters collectively as one piece of type, which standardized the size of the printed type. It could be said that one of the characteristics of *Sagabon* was the way they retained the beauty of a handwritten script while realizing the mathematical standardization required for movable type. Movable wooden type subsequently went out of use, but as I discuss later, contemporary Japanese typography employs the same solution.

As I briefly stated earlier, the movable type Japanese people have become accustomed to originated from sets of Chinese characters engraved in Western Europe, which were then used to print the Bible in locations such as Macao, Hong Kong, and Shanghai, accompanying the spread of Christian missionary proselytizing in Asia. I attempted in *Mothers of Letters* to trace the way Japan's movable type had traveled from the West to the East.

The National Library of France has a set of wooden Chinese type created during the reign of Louis XIV. Based on the books brought back by the Jesuit missionaries, the Imprimerie Nationale used this set of type to print the first Chinese-Latin-French dictionary (1813) (Plate 27). During the nineteenth century, original movable metal types of Chinese characters were made in Germany, the Netherlands, and Great Britain. However, these earlier types were perfected, so to speak, in the set of Chinese characters produced by William Gamble (1830–1886), who led the American Presbyterian Mission Press in Shanghai. Because his technique for printing Chinese characters was considered the best in East Asia at the time, Gamble was invited to Nagasaki in 1869. There, his student in type founding was Motoki Shōzō, who had been actively studying European industrial technology since the Meiji restoration the previous year. The history of Japanese letterpress printing began when Motoki's disciples ventured to the Tsukiji area of Tokyo after inheriting Motoki's printing house in Nagasaki. This is where modern Japanese movable type originates.

When compared to a Roman letter typeface, the sheer number of types needed to print the Japanese language makes printing challenging. For instance, it was said that Japanese newspaper firms typically needed at least 2,500 different *kanji* types to compose a text in Japanese. Printing firms in Japan were said to stock more than 12,000 *kanji* types so as to print the body of a book. Designing and engraving such an incredible variety of *kanji* in a unified style was an incredibly tedious task, yet one Motoki and his disciples recognized would form the basis of modernization.

Japanese typefaces generally issue from one of two sources, Tsukijitai or Shūeitai (*tai* meaning body, form, or style), which were both created in the late nineteenth century during the Meiji period, and I chose the latter as the subject of my project. Shūeitai is an original typeface designed by the Shūeisha company, the predecessor of DNP, the largest printing firm in Japan. Along with Tsukijitai, this typeface has been consistently used to print a variety of Japanese texts for over a century, especially dictionaries, literature, and books on the humanities. It is no exaggeration to say that Shūeitai has been the most frequently seen typeface in Japan since the beginning of the twentieth century. While its design has changed not a little over the century or more since then, DNP has kept a near comprehensive record of Shūeitai, which enables us to trace all of these changes. This point alone makes Shūeitai an important typeface for the research of movable type.

Both of these typefaces belong to the Minchōtai (Ming dynasty-style) family of Chinese character fonts—known as Song-style typeface in China—and are commonly used for printing and word processing in Japan. The Minchōtai characters are characterized by thin horizontal strokes and bold vertical strokes. The ends of strokes, called *hane* (swift, upward strokes) and *harai* (sweeping strokes), are thin,

while the beginning and the end of single, horizontal strokes feature small triangular protrusions called *uroko*. All these particularities reflect the lingering traces of early character forms, achieved by carving out characters first written with brush and ink onto hard materials such as stone and wood. Chinese characters themselves originate from marks carved onto turtle shells and the scapula bones of animals such as ox and deer, and were later engraved on metals such as bronze or, again, hard materials such as wood or stone. Each period's typeface, while influenced by the characteristics of available materials, has been passed down to the present.

The French who endeavored to produce the first movable types of Chinese characters, from the seventeenth century to the early nineteenth century, probably tried to create a design that looked more or less well balanced in relation to the Roman letter fonts they had been using. The well-known typeface Garamond retains beautiful calligraphic elements from the period of hand-copied manuscripts. Looking at the earliest Garamond typeface suggests an attempt to allow the beauty of calligraphy to live on within a mathematically standardized type, thus showing a sensibility shared with the *Sagabon* designers. Likewise, one could say that the *hane* and *harai* elements of Minchōtai reflect an attempt to allow a handwritten sensitivity to remain in a mechanized typeface.

The Minchōtai typeface derives from the characters used in texts the Jesuit missionaries transmitted to Europe, which were first founded into movable type in cities such as Amsterdam and Paris. This type was reintroduced, via Shanghai, to the so-called Chinese character cultural sphere, referring to those Asian cultures, including Taiwan, Japan, Korea, and Vietnam, that have historically shared the use of Chinese characters while speaking different languages. The typeface further absorbed various elements from Japanese scripts while responding to rapid technological developments to transform into the Minchōtai we know today. As I retraced this long journey, I was especially fascinated by the way a sense of handwriting has firmly remained in Japanese movable type.

THE ADVENTURE OF *TYPOLOGIC*

Because of the peculiarities of its characters, Japanese typography has undoubtedly developed in a manner distinct from typography based on Roman letters. If typography represents interactions between the form and meaning of written characters during each historical period, how does it come about? To find this out, I organized an exhibition about written characters and typography, under the title *Typologic,* made up of two words: *typography* and *logos* (Plate 28). Characters, including letters, are the bearers of *logos;* however, they are not merely intellectual signs to convey

meaning. Meaning is underpinned by the senses; the interaction between the intellect and the senses forms each era's typography, producing in turn the characters we use. With the title *Typologic*, I wanted to refer to such interactions between written characters. In particular, a sense of touch and of play were two basic elements of the exhibition.

The exhibition was held in the Nikkei newspaper's new building, in Tokyo. The reason that Nikkei, a representative of the contemporary information industry, chose to host this rather experimental exhibition was because of a certain display in one corner of its futuristic building's multipurpose exhibition and information area, Space Nio. On display was the last issue of the newspaper printed with movable type, as well as a set of the type formerly used to print it, and a handwritten letter—a letter of thanks from the newspaper addressed to the movable type and expressing the paper's appreciation toward the movable type that had printed it for almost one hundred years, and saying how painful it was to now be parting (Figure 8.2). On reading this letter, I was absolutely determined to realize the typography exhibition there.

It was clear that, according to those who founded, selected, and set movable type for printing, such types were considered worthy of (and indeed given) respect, as

Figure 8.2 A letter of thanks to the movable type. Collection of Nikkei newspaper, 2009. Photograph: Chihiro Minato. Courtesy of Nikkei newspaper.

though they had individual personalities. The fact that they related to type as possessing its own personality signifies not only that movable type is the work of human hands, but that we human beings also issue from movable type. Ever mindful of the increasingly immaterial nature of contemporary information, of which the newspaper is a representative case, we worked on three themes revolving around the idea of interaction: 1) typography as material object; 2) typography as immaterial object; and 3) written characters as art.

The first section featured experiments with new font designs, focusing chiefly on works by art school students. The second section concentrated on developing both an original software to generate new characters in real time and a new application for displaying patterns composed of characters. For instance, one experiment consisted of using GPS to record the trajectory of an artist riding a bicycle on the streets of Tokyo, then converting this outline into a font. Another was an application that allows the same *kanji* to be reconfigured into different shapes, such as *hiragana,* other Chinese characters, Roman letters, or animal shapes, simply by changing the combination of the character's basic strokes. Interestingly, all of these works suggested how designers might treat characters as they become more immaterial and how we human beings will feel toward the new appearance of characters in the future.

The third section showcased artworks dealing with the act of writing characters, mostly assembled from works on the subject of poetry and translation. The two artists in this section were both prominent figures in Japan, and it was interesting to see how their works contrasted with sections one and two in the way they projected an appearance of ancient scripts. Poet Yoshimasu Gōzō continues the practice of engraving scripts onto sheets of copper with a chisel. His performance at the exhibition emphasized the way sound is an important element of written characters, questioning whether written characters contain, not only the sound of the voice that recites them as poetry, but also the sounds made when they are struck into stone or engraved onto metal.

Contemporary artist Okabe Masao's work was a pencil rubbing on paper of the Chinese characters on the signboard of the Commercial Press publishing house in Taiwan (Plate 29). As one of the oldest publishers in East Asia, the Commercial Press historically used the earliest movable types, produced in Shanghai. Okabe's work reminds us of the significant role ink rubbings have played in the history of Chinese characters. For example, model character forms for calligraphy learners in China and Japan are often studied from facsimiles of ink rubbings taken of inscriptions on stone monuments. Okabe's work describes an attitude toward written characters by which characters can not only be read, but also rubbed and copied over time, and should thus be preserved in their capacity as traces of human existence.

Through this exhibition and the related workshops we held, we learned that all kinds of imagination are at work in the process of creating characters. In Japan, the

advent of computers has brought about drastic changes to the environment in which written characters are used, in everything from typography through to printing, but a sense of handwriting has not been altogether lost. A number of calligraphic styles adopted for digital fonts are one example of this, and font designers tend to show a strong inclination toward handwritten styles. More than a few of them practice Japanese calligraphy. Touch-screen devices such as the iPad are now commonly used, and some designers create characters by drawing or writing directly onto the screen with their fingers. The beauty of a written character lies not only in its appearance but also in the order of its strokes when written and the space between them; it is also tactile. Hence, in the beauty of the Japanese script, touch remains a crucial sense.

Writing and reading characters is not done simply to communicate meaning. Characters are also *asobi,* a form of play or amusement. The Japanese word *asobi* also means margin or space. One could even say there is an ample margin or space that surrounds the meaning of Japanese characters. Usually, a character's form and transformation over time have the nature of intellectual play. The Roman letter alphabet, for instance, has been continuously transformed into new styles by being scribbled onto walls as graffiti. Likewise in China and Japan, people have played with Chinese characters by combining their form and reading, coming up with characters that do not really exist. A number of websites have also emerged where one can create characters or pictures by combining a variety of components provided by the site designers. Hence, characters are not just a medium to transmit meaning; they are also tools of play and enjoyment.

IN CONCLUSION: FOR THE FUTURE OF MOVABLE TYPES

Mothers of Letters and *Typologic* were but small endeavors, yet since then, metal movable type has unexpectedly received renewed attention in recent years, largely in conjunction with various moves to revive letterpress printing, led by younger generations. These seem to provide fascinating examples to consider how old technologies might survive in the digital age. Since I created the *Typologic* exhibition in 2009, new typographic works, using different kinds of technology and expression, have been produced. To show the latest trends from various parts of the world, I organized a second *Typologic* exhibition in 2012 in the hope of making it a typography triennale for typographic art and design (Figure 8.3).

Last, I would like to consider the future of movable types through a few examples. The year 2011 marked the centenary of the Shūeitai typeface and an exhibition about it was held in Tokyo before touring to Osaka and Fukushima. Leading

Figure 8.3 Chihiro Minato, *Page-scape* series at the *Typologic* 2012 exhibition.

Japanese graphic designers took part by producing posters using Shūeitai fonts; while well-known books published in Shūeitai were also exhibited, such as the *Kōjien*, regarded as the most authoritative Japanese dictionary. It was interesting that all the designers involved expressed a strong attachment to using the typeface. The oldest Shūeitai typeface, known as font #0, is still widely used for book titles and the like, showing that the impact of metal type lives on, even in digital design. Moreover, the typeface has just undergone a major redesign—dubbed the "Great renewal of the Heisei era (the current Japanese era beginning in 1989)"—allowing the typeface to be used on mobile phones. At the exhibition venue, examples of media art using the Shūeitai typeface were displayed alongside shelves containing old metal movable type, demonstrating the tactile and playful quality of characters.

Nevertheless, such trends, which could well be called the Movable Type Renaissance, may be exceptional events within Asia. Significant changes in the use of Chinese characters have taken place in the past half century in the Chinese character cultural sphere. In Vietnam and South Korea, Chinese characters are practically no longer used. Especially in South Korea, the abolishment of Chinese character education and rapid promotion of Hangul, the indigenous Korean phonetic script, means

generations of young Koreans can no longer read Chinese characters. There are also various forms of Chinese characters now in use: whereas mainland China uses simplified characters, Hong Kong and Taiwan continue to use traditional characters, and in Japan, *kanji* are somewhat simplified traditional Chinese characters. In all of these places, metal movable types are fast disappearing.

When the Chinese version of my photographic book *Mothers of Letters* was published in Taiwan, the only letterpress printing studio remaining in Taipei printed the title page using movable type. This studio, Ri Xing Typography, used to be a type foundry and has carefully preserved the matrices of a range of traditional Chinese typefaces in its collection. According to the owner, Mr. Chang, his studio is likely to be the last printing studio in Asia that has preserved a set of orthodox Kaishu (regular script) typeface and their matrices (Plate 30). Matrices are molds for casting characters and are called *bokei* in Japanese, written using two *kanji* characters literally meaning "mother form." If these matrices are lost, it will be impossible to found types of this style, and in this sense the matrices are the archetype of memory. They retain, in their form, a record of the transitions that movable Chinese character types have undergone since the nineteenth century, making orthodox Kaishu into what could be called an irreplaceable memory.

These two examples point to the fact that the materiality of characters is crucial to the way they are used. The weight and power embedded in Shūeitai and orthodox *kaishu* typefaces is the sensitivity of characters. They may not provide the efficiency and speed demanded by our current information society, but they are likely to survive as cultural matrices for the interactions between the forms and meanings of written characters. I believe that movable type is telling us something important. That is, written characters are an ongoing dialogue between their eternal memory and the personal manner in which they are used.

NOTE

This chapter is based on *"Moji no sōzō"* ("The Creation of Letters"), a chapter in my book *Geijutsu kaiki-ron* (*The Return to Art*) (2012, Tokyo: Heibonsha). The opening section comes from my book *Moji no hahatachi* (*Mothers of Letters*) (2007, Tokyo: Inscript). Translated from Japanese by Fuyubi Nakamura and Olivier Krischer.

PART III

IMAGE, REPRESENTATION, AND PERFORMANCE

9 SOME INDIAN "VIEWS OF INDIA": THE ETHICS OF REPRESENTATION

Christopher Pinney

To begin, an object that has two sides and tells two stories. A late nineteenth-century cabinet card by the Calcutta photographer S. C. Sen (about whom virtually nothing is known) carries a beautiful obverse (Figure 9.1). Delineated in a cochineal red on a delicate ivory background, Sen's standardized trade design pictures a south Indian temple and a Mughal pavilion in a manner that looks back toward the colonial concerns of earlier artists like William Hodges and Thomas and William Daniell. "Views of India" proclaims an ornate medallion set within this architectural mélange, and yet on the front of all the S. C. Sen cabinet cards I have encountered there is pasted not a "view," but rather images of Indian families or individuals who had posed in front of Sen's camera (Figure 9.1).

The disjoined faces of this cabinet card embody the historical paradox I hope to illuminate: many "Indian" views of India do not look like "views" of India at all. That is not to say, however, that within the popular visual culture of modern India there are no buildings, no traces of edifices that can be coded as monuments or architecture. I well remember interviewing the manager of the Prakash Talkies, a cinema in an industrial town in central India, in his small office made claustrophobic by the use of a billboard image of the New York skyline as wallpaper. Popular calendar prints depict buildings and cityscapes such as the Taj Mahal, Bombay's Marine Drive, and the Victoria Memorial in Calcutta (Plate 31); religious images show temples such as those in Varanasi and shrines in Ajmer; wedding photographs juxtapose brides and grooms with edifices such as the India Gate in Delhi or the Tower of Victory in Chitor. But although there is, indubitably, architecture in these images, it is usually

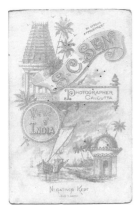

Figure 9.1 Cabinet Card, ca. 1880. S. C. Sen. Collodion printing-out paper, 11.2 x 16.7 cm. Group portrait (right) and the verso of the card (left), Chromolithograph. Private collection. This Indian studio's trade design suggests a continuity with colonial "views" but its portraiture does not.

present as a shadow of some other presence. This other presence is usually the human figure, which crowds out the architectural backdrop. The paradox, which in the case of Sen's image is split between the two sides of the cabinet card, is, in modern Indian engagements with architecture, compressed into a single complex surface.

Here, while acknowledging the presence of architecture in popular postcolonial Indian representations, I seek to explore the particular and complex valence of that presence, which I shall suggest is expressive of a certain ethical response. In describing a disjunction between the "colonial" and "postcolonial" representation of monuments, we need to recognize not simply the power of different traditions (which is indeed important) but also the complex translational zone in which self-consciously "Indian" representations need to be understood as (in part) a critique of colonial paradigms.

Anthropologists are given to citing Rousseau's dictum that to better understand man close-up one should view him from afar. In that spirit, consider popular Indian "occidentalist" representations of exotic monuments. By "occidentalist" representations, I mean those Indian images of the West that inversely mirror Western "orientalist" images of India. One series in which they appear depicts Swami Vivekananda in Chicago for the World Parliament of Religions in 1893. In these images, a resolute swami stands, with arms folded, before an anachronistic backdrop of Chicago highrises (Plate 32).[1] It is plausible to argue that the centering and frontality of this image embodies a transcultural popular aesthetic of clarity. One is reminded of Pierre Bourdieu's account, in his illuminating study of 1960s rural French photographic discourse, of an image of the wife of an informant standing directly beneath

the Eiffel Tower, which bisects the photograph. "What seems to us an act of barbarism or barbarity is," Bourdieu argues, "actually the perfect fulfillment of an intention: the two objects designed to solemnize one another are placed right in the center of the photograph, as centering and frontality are the most decisive ways of stressing the value of the object captured in this way" (1990 [1965]: 36).

In the case of the Chicago image, however, a moral message is also implied: Swami came and conquered a materialistic West. Worldly longing is embodied in the reach of the skyscrapers, but such materialistic aspiration is nothing compared to the spiritual heights attained by Vivekananda. For his backdrop, the artist (H. Ganguly) has clearly studied an early photograph of the Chicago skyline. But this was done not to record the spatial encounter of this remarkable Indian with Chicago architecture but to reveal a moral collision. The precise nature of the Chicago high rises do not matter, only their "Americanness" and their elevation.

Much colonial photographic documentation of buildings, by contrast, seems to have been driven by an intoxication with precision and exactitude, both descriptive and spatial. This was expressed through an enthusiasm for the photograph's indexical power (its ability to chemically record what passed before the lens) and the potential of a collective photographic practice to systematically order reality through the "archive." The "archive" here is a literal and metaphorical space: both an actual system of filed and arranged images and a conceptual project of ordering the world.

Early Indian colonial photographic images describe a space ordered by, as Heidegger would have it, a "mathematical knowing in advance" (1977: 118–119), by which Heidegger means the regular and predictable space for perspectival representation that was to prove ethically problematic to early Indian practitioners of "colonial" technologies such as lithography, photography, and film. For Indians, these technologies seemed to imply a particular ordered conception of space that is sometimes referred to as "hodological"—homogenous, ordered, and regular (Littlejohn 1967: 20). Colonial photographic images are usually underwritten by a sense of their continuity with other images in a colonial archive and the fantasy that ultimately they might be joined up in a space of total representation. Their allure is the promise they offer of a totalizing knowledge.

In colonial practice, the photographed building has frequently functioned as the trace of a movement through the space of what Heidegger termed the "world as picture," that is, the modern fantasy of the world as something separable from, and conquerable by, man. The positioning of a human body in front of a building (either within the space of the image or in the implicit presence of the invisible photographer) stages the duality of subject (figure) and world (ground). Each record of "having been there then" inscribes further the mobility of the subject, who hovers above the world as picture. Arranged in the album, such images are the molecules of

emergent subjects—of what Eduardo Cadava terms the "archived self" (1997). The colonial relationship to place becomes capable of divorce from phenomenological immersion and an "I" emerges that can be "mathematically" conjoined with a "here" or a "there". Both the "world" and "man" are divorced from their mutual co-presence and human subjects assume a new-found dominance over a passive and objectified "nature" comprised of territories and "other" peoples.

Ashish Rajadhyaksha has suggested that Indian artists who were confronted in the nineteenth century, by way of various media, with the Renaissance frame faced "massive formal, really *ethical,* problems" (1987: 53). We might see that ethical di-lemma as a recognition of what Partha Chatterjee calls the "calculating analytic" of the colonial "prisonhouse of reason" (1993: 65, 55). Indians increasingly recognized colonial rationality as morally problematic: colonialism's "efficiency" was not an ethi-cal form of power. To reproduce the Renaissance frame was to affirm the principle of "mathematical knowing in advance" (Heidegger) and the fundamental episte-mological infrastructure of colonialism. The impact of this ethical choice on film has been expertly analyzed by Rajadhyaksha. Elsewhere I have attempted a parallel account of a postcolonial, popular Indian photographic practice (Pinney 1997), and a companion volume traces the history of chromolithography. In the remainder of this chapter, I would like to explore both the ways the legacy of this ethical dilemma has hybridized with enduring local representational logics and the implications that has for the contemporary engagement with monuments and the built environment.

In short, these practices of representation might be characterized by a spatiality of presence and a pleasurable fascination with ontological indeterminacy. Clearly, many different practices coexist within the complex cultural landscape of contemporary India. The practice I describe here is the one I have come to recognize in the course of conducting anthropological fieldwork in a central Indian town and village and through researching the history of photography and chromolithography in north India. It may well be a practice that is very different from other more elite practices throughout India, and may be regionally specific to north and central India. While I make absolutely no claim to describe a "totalized" Indian practice, since such geo-graphic or cultural coherences are illusory,[2] I do aim to give an account of the prac-tices of several hundred million mainly rural and small-town Indians living in the center and north of the country.

Generic highrise buildings, reminiscent of those in the Vivekananda image (Plate 32), can be found in the backdrops used by the traveling photographic studios that migrate through rural India serving peasant customers. These hybrid amalgams of Chicago and Manhattan are always identified by rural clients as depictions of Bombay, the city that for them embodies the ambivalence of modernity. The

photographic studios usually provide the battered shell of a motorbike on which villagers may pose as fleeting inhabitants of a metropolitan space that repels and fascinates.

Part of the appeal of such backdrops to studio clients lies in their ability to sustain the indeterminacy of the photographic *mise-en-scène,* that is, the ultimate unknowability of the status of the image. The certainty that photography can offer (certainty of time and place, for instance) holds less appeal than its ability to deceive and its capacity to depict ideal rather than contingent and everyday worlds. Photography's ability to conjure multiple ways of seeing the world that escape a single determinate spatiality is a source of delight in contemporary central India. Popular practices and discourses celebrate the multiple encounters that costume, backdrops, and lighting can facilitate. Once, when copying an image that showed distant relatives of the owner of the image seated in front of the Taj Mahal, it became apparent that no one present could recall whether this couple had indeed been to the Taj, raising the question whether "this Taj" was the building located in Agra or a backdrop in a local studio.

That unknowability was the source of considerable enjoyment and resonates with Tobias Wendl's observations about popular Ghanaian photography. Wendl reports a wonderful popular slogan often found painted on Ghanaian buses and taxis: "Observers are worried!" This Wendl takes to be an emblem of a wider Akan fascination with undecidability and the "mysteries of exterior appearance" (2000: 154). Whereas European colonials might have been genuinely anxious about the limits of knowledge, postcolonial Ghanaians and Indians celebrate the limits of what is "mathematically knowable in advance." The celebration of indeterminacy is also the celebration of the containment or limitation of certain forms of oppressive power that depend on totality and the possibility of the "world as picture." The enjoyment of the space "in between" is incompatible with the totalizing logic of the "view."

In India, a parallel ontological indeterminacy has a long textual tradition that extends to the *Bhagavata Puruna* and the *Matsya Puruna,* which address the dilemma of parallel universes in which (inherently) one can never know whether one is "inside" or "outside" (Pinney 1997: 192). By contrast, many forms of colonialism were characterized by their ontological certainty, apparent not only through their oppressive "truths" but also through their antipathy to slippages such as "going native," which posed the threat of inverting a zealously guarded "inside" and "outside."

The space of the popular Indian imaginary is discontinuous, nonhomogenous, and fluidly unstable. Many locations within this zone have the features of Mircea Eliade's "sacred space"—irruptions which are "open above" and permit the "passage of one mode of being to another" (1959: 26). Images of pilgrimage sites often demonstrate this fluid sacrality and assume the form of the *pradakshina* or *parikrama,* the ritual circumambulation of a "crossing." Many ritual centers in India

have established circle pilgrimage routes that, when followed, establish and fix the centrality of the deity at the core of this microcosm. This circularity and desire to find, through a corporeal fluidity, a core power is a very different kind of spatial practice from that of the colonial land survey and the "mathematical" knowability within which it is necessary to position much of the nineteenth-century attention to Indian architecture. The popular Indian viewer does not seek a "place" so much as a position of effect whereby the topographic conflation of divine sites is able to fuse in a desired convergence (*sangam*) in which power and plenitude (*barkat*) "flow."[3]

In popular Indian practice, the monocular frame of the camera becomes a limitation rather than a liberation. I have already suggested that in the Euro-American tradition photographic technology emerged out of a Renaissance mode of visualization and mirrored existing space/time conventions. Because it lay so close to already valorized states of effectiveness, photography was thus easily able to establish its peculiar truth effects. The popular Indian regime of effectivity or power, very broadly conceived, was the product of a different set of encouragements and included a concern with concentricity, movement, and texture, effects photography in its purely technological incarnation was less able to embrace.

What might be termed the "replicant concentricity" of popular visuality—its tendency to endlessly reproduce a core relationship or configuration—can be explored through two images designed to appeal to devotees of the god Shiva. The first of these is one of the most popular of all prints sold by vendors in the central Indian city of Ujjain. A center of ancient civilization also known as Avantika, Ujjain is renowned among Hindus for its Mahakaleshvar temple, which houses one of the twelve *jyotirlingas* or luminous embodiments in phallic form of the god Shiva. The river Kshipra, around which the town is built, is also one of the four receptacles of the drops of immortal *amrit* (nectar) that fell from Shiva after the churning of the milky ocean. Because of this, and the river's ability to grant *moksha,* the city is one of the sites of the great *kumbha mela* held in Ujjain every twelve years.[4]

Pilgrims attracted to Ujjain may well undertake the *panchkroshi,* a ritual five-day-long circumambulation of the city whose shape is determined by the location of twenty-eight sacred sites where devotions are performed. The outer perimeter of this route defines a zone at the center of which lies the major Shiva temple of Mahakaleshver, a structure that suffered the depredations of Iltutmish in 1234 and was restored by the Scindias (a Maratha dynasty) in the nineteenth century. The print *Ujjain Darshan* (or *Darshan* of Ujjain) (Figure 9.2) places this temple at the center of the thirteen most important shrines in the city (such as the aniconic Chintamani shrine at the top left and the cobra-hooded Mangalnath shrine at the bottom right). *Darshan* has a multitude of meanings (including "insight" and "philosophy") and might be translated in this context as "seeing and being seen" by the deity. Its

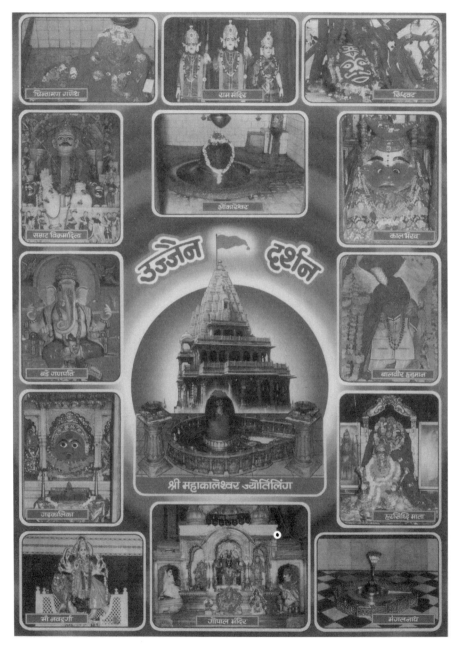

Figure 9.2 *Ujjain Darshan* (Glimpses inside the Mahakaleshvar Temple, Ujjain), 1992. Unknown publisher. Chromolithograph; 44.2 x 31.9 cm. Private collection.

similarity to and distance from the notion of "view" is highly instructive, for it connotes a phenomenological intimacy between seer and seen in a way the unidirectional gaze-like nature of the "view" does not (see Eck 1981).

This image draws on the very familiar template of the central form of a deity surrounded by temporal incarnations. Vishnu will be positioned at the center of a print and his various incarnations or "descents" (avatars) illustrated clockwise around him. This model is also used to depict politicians and other figures of note. M. K. Gandhi, for instance, will be depicted in archetypal form at the center, surrounded by temporal manifestations marking moments in his career (as a lawyer in South Africa, spinning in the Sabarmati jail, and so on). *Ujjain Darshan,* however, traces a spatial rather than temporal circularity, but the central dynamic remains that of a trajectory from the manifest forms of the periphery (temporal and/or spatial) to the transcendent zone of the center. *Ujjain Darshan* reflects this, for the circumambulation of the minor shrines is a way of defining and ultimately accessing the key central realm of power, that of the Mahakaleshver *shivalinga,* which the print depicts, at center, as a massive presence in front of the temple (though in reality the *shivalinga* can only be accessed through a claustrophobic tunnel in the basement of the temple).

The logic of the microcosm is replicational rather than finite; *Ujjain Darshan* makes sense only as an element within a larger structure of representation of the *jyotirlingas* or embodiments of Shiva. Pilgrims buying this image are likely also to buy a Bombay-produced image of all the *jyotirlingas,* which respects the same convention of periphery and center. In this, the *lingam* at the Mahakaleshvar temple in Ujjain is depicted at the top right and in the center is shown the ultimate form of Shiva, of which the twelve *jyotirlingas* are mere temporal/spatial manifestations.

My point in touching on this elaborately detailed cosmology is to suggest that the pilgrims who purchase images of the architectural edifice called the Mahakaleshvar temple are not seeking traces of the conjunction of their unique bodies with this unique place. Rather, the aspirations these images fulfill are best understood in the broader current of a fluid concentricity in which what matters is not to get close to a particular place as an end in itself. On the contrary, the visitors to Mahakaleshvar and the purchasers of its images engage it as part of a movement toward a powerful center precisely because it offers the prospect of an escape from time and place.

Another recurrent genre of popular images depicts temples as divine prostheses, extensions of the shape, spirit, and power of deities: the Dakshineshvar and Kalighat temples mirror the presence of Kali, while the tapering shape of a south Indian temple reflects the deity Murugan (Figure 9.3). Yet these correspondences are not metaphorical, not adequational mirrors; rather, they are metonymic continuations of the divine, part of a fusion of deity with the architectural. The visual proposition, which

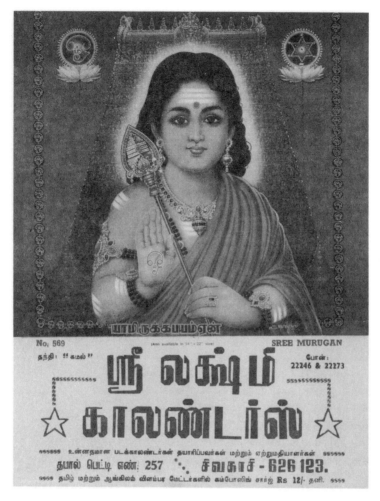

Figure 9.3 The god Murugan, ca. 1995. S. Murugakani, artist. Sri Lakshimi Calendars, Siva Kasi, Tamil Nadu. Calendar, Chromolithograph, 50.4 x 38.8 cm. Private collection. Murugan, an important deity in Tamil Nadu, mirrors the form of the *gopura,* or tower gateway, behind him. The Tamil caption below the image reads, "Why be afraid when I am here."

is continuous with what we know of the beliefs of the devout, is that the temple is not "like" the deity, and vice versa, but rather that the temple is an embodiment of the deity and that architecture should be read not as a manifestation of the technical and cultural conventions of human builders but as divine inscription.

The task of cultural analysis should always be to respect local nuance and complexity while resisting the allure of cultural essentialization. Here I have attempted to draw a strategic opposition between a "colonial" spatial practice evident in

photographs made by European photographers in colonial India and modern Indian popular practices. The continuity between diverse "vernacular modernisms" (Pinney 2003) and their concern with the body, frontality, and surface (popular Indian, Ghanaian, and French photographic practices share these preoccupations) suggests a more detailed analysis might reveal the crucial variable to be not "culture" ("India" versus "Europe") but paradigms of power (the world as "picture" or conversely the world as "presence"). A truly postcolonial approach (which took global disparities in power and class as its concern) might lead us to see more of the continuities between diverse subaltern practices, on the one hand, and continuities between diverse elite practices, on the other, rather than blinding us with the false allure of "culture." It is in this sense that I have set out to describe only "some" Indian views of India. An attempt to describe the totality of Indian views would inevitably place the category of "India" under threat of erasure.

NOTES

Originally published in English and French in *Traces of India: Photography, Architecture, and the Politics of Representation, 1850-1900,* edited by Maria Antonella Pelizzari. Canadian Centre for Architecture, Montreal and Yale Center for British Art, New Haven, 2008, pp. 262–275.

1. Vivekananda in Chicago was a popular subject for mid-twentieth-century commercial artists, and I have traced seven variants of this image. However, none currently remain in print. Images of Vivekananda on the rock at Kanniyakumari (Cape Comorin), the southernmost tip of India, to which he swam in 1892 and went into meditation, are currently produced in profusion.
2. Illusory in the sense that there are often likely to be greater differences within than between cultures, as I discuss in "The Indian Work of Art in the Age of Mechanical Reproduction: Or, What Happens When Peasants 'Get Hold' of Images" (2002). The romantic concept of culture as difference, inaugurated by Herder, has acquired enormous power over the last 150 years but is now starting to unravel. See Latour (1993).
3. The idea of *sangam* as convergence is one of the key spatial ideas in the popular imaginary. This convergence may be of actual geographic features, such as rivers, or of non-visible currents of power.
4. The other three sites are Allahabad, Nasik, and Haridwar.

REFERENCES

Bourdieu, P. (1990 [1965]), *Photography: A Middle-Brow Art,* Cambridge: Polity Press.
Cadava, E. (1997), *Words of Light,* Princeton, NJ: Princeton University Press.
Chatterjee, P. (1993), *The Nation and Its Fragments: Colonial and Postcolonial Histories,* Princeton, NJ: Princeton University Press.

Eck, D. L. (1981), *Darsan: Seeing the Divine Image in India,* Chambersburg, PA: Anima Books.

Eliade, M. (1959), *The Sacred and the Profane: The Nature of Religion,* New York: Harcourt Brace Jovanovich.

Heidegger, M. (1977), "The Age of the World Picture," in *The Question Concerning Technology and Other Essays,* New York.

Latour, B. (1993), *We Have Never Been Modern,* London: Prentice Hall.

Littlejohn, K. (1967), "The Temne House," in J. Middleton (ed.), *Myth and Cosmos,* New York: Natural History Press.

Pinney, C. (1997), *Camera Indica: The Social Life of Indian Photographs,* London: Reaktion.

Pinney, C. (2002), "The Indian Work of Art in the Age of Mechanical Reproduction: Or, What Happens When Peasants 'Get Hold' of Images, in F. D. Ginsburg, E. A. Lila Abu-Lughod, and B, Larkin (eds.), *Media Worlds: Anthropology on New Terrain,* Berkeley: University of California Press.

Pinney, C. (2003), "Notes from the Surface of the Image," in C. Pinney and N. Peterson (eds.), *Photography's Other Histories,* Durham, NC: Duke University Press.

Rajadhyaksha, A. (1987), "The Phalke Era: Conflict of Traditional Form and Modern Technology," *Journal of Arts and Ideas,* 14–15: 53.

Wendl, T. (2000), "Portraits and Scenery," in *African Photography,* Paris: Revue Noire.

10 FRAGILE POLYPHONY: TAKEDA TAIJUN'S LONGING FOR ASIA THROUGH THE LANDSCAPE OF SHEN CONGWEN

Barbara Hartley

CHINA AND TAKEDA TAIJUN

In 1934, a group of young men in Tokyo formed the *Chūgoku bungaku kenkyūkai* (The China Literature Study Society).[1] The aim of this society was to circulate information about cultural production in modern China—that is, China after the May Fourth Movement of 1919—among intellectuals, scholars, and writers in prewar Japan.[2] This objective, which accorded cultural value to contemporary China, was a clear subversion of the hegemonic Japanese view at the time of China as the "sick man" of Asia (Heinrich 2008: xiii).[3] While acknowledging China's magisterial classic tradition, this view dismissed that site as having little to offer the modern world. One of the young men who attended the inaugural meeting was Takeda Taijun (1912–1976). The son of a Pure Land (*jōdo*) Buddhist priest, Takeda himself was ordained into that order in 1933 at the age of twenty-one.[4] He had previously enrolled in the Chinese Literature Department at Tokyo Imperial University, but withdrew following his arrest for political activism. In the postwar era, Takeda became a prominent member of the Japanese literary establishment, recognized for his ability as a novelist, playwright, and essayist.[5] First traveling to China as a conscript of the Imperial Japanese Army, he visited China several times throughout his life and drew repeatedly on tropes of continental East Asia in his literary production.[6]

This chapter examines how, in a relatively early and little-known work, Takeda evokes the landscape of the West Hunan region of China in order to render tolerable the memory of Imperial Japanese Army atrocities on the Asian mainland. In other words, the writer evokes landscape to elide—although not necessarily completely evade—the issue of Japan's war responsibility. The specific text discussed here is a 1941 essay entitled "Wakaki heishi no tabi" ("The Journey of a Young Soldier"), a commentary on and partial translation of the 1932 autobiography of the pre-1949 Chinese literary luminary Shen Congwen (1902–1988).[7] While entitled "autobiography" and produced when Shen was thirty years old, this text in fact deals with Shen's life only until he left West Hunan for Beijing at the age of twenty. Particularly important for Imperial Army soldier Takeda was the account by the Chinese writer of his days as a boy soldier in the army of a local warlord. I argue that Takeda constructed "The Journey of a Young Soldier" as a precarious attempt to mediate between Japan, the homeland, and China, the discursive construction that repeatedly featured in his texts. In doing so the former Imperial Army soldier created a landscape of solace that might occlude and thereby suppress the memory of actions that he most certainly witnessed, and in which he perhaps even participated, during Japan's war of aggression against China.

The notion of "polyphony" is used here to invoke the manner in which in many of his China-related texts Takeda aspires to create a polyvocal narrative that, in the manner Mikhail Bahktin so admired in Fyodor Dostoyevsky (Bahktin 1973), can grant the right of both enunciation and reception to the various characters featured. However, as the chapter title suggests, this polyphony can also be illusory and marked by a fragility that renders it perilously liable to crumble partially or to even collapse completely. Thus, while "The Journey of a Young Soldier" purports to give voice to Shen Congwen, the voice we in fact hear is much closer to Takeda's own. Furthermore, in spite of the latter's sincere attempt to make sense of both the discursive space and the geographical lived experience that was the Asian mainland, the work is indelibly marked by the hegemonic discourses that dominated at the time of its 1941 production. A close reading of "The Journey of a Young Soldier" reveals a romanticization of landscape by means of which Takeda, in a manner that veers disturbingly close to a fascist aesthetic,[8] constructs the West Hunan region of China as a timeless paradise. This paradise becomes a sanctuary that permits escape from the scourge of being a subject of imperial Japan, an entity that bulwarked its ascendant position in Asia with bloody expansionist wars and the suppression of domestic resistance.

Although it was the literature of modern China that fired Takeda's imagination, his fascination with the Chinese discursive space commenced in high school through readings of Buddhist sutras and classical Chinese texts (Nishikawa 2005). Karatani Kōjin emphasizes the almost self-immolatory aspect of Takeda's affiliation with this

site, given the low esteem in which China was held in Japan (1995: 250).⁹ In the pre-war era, an interest in modern Chinese literature made Takeda one of the few young men in Japan to consider the possibility of traversing the border of and creating a connection between the privileged metropolis of *heimlich,* or homely, Japan and the uncanny *unheimlich,* or unhomely,¹⁰ space of the colonies or pseudo-colonies of mainland Asia. However, in "The Journey of a Young Soldier" at least, Takeda ulti-mately struggles to deliver the outcomes tantalizingly promised by his engagement with the continent. In fact, the work is marked by fracture lines that create a sort of two-dimensional, essentialized Orientalist space, in which imperial Japan is the substitute for Edward Said's imperial West and China the site that is simultaneously exoticized and despised by the imperial power. We will further see how Takeda's text suggests that the work of the "long-distance cultural specialist" can be motivated by a longing for contact with a constructed other that is little more than a simulacrum of an idealized self.

"The Journey of a Young Soldier" amalgamates extended accounts of Shen Con-gwen's early life as a youthful soldier in local armies with vivid depictions of the landscape of West Hunan (Figure 10.1). Constructed as it is of partial translation and authorial commentary, the text reads as a narrative pastiche or bricolage in which Shen's original material is overlaid with Takeda's personal reflections, historical

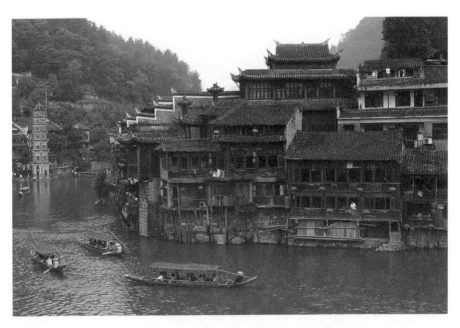

Figure 10.1 Fenghuang (Shen Congwen's hometown). © Henry Tsui/Shutterstock.com.

information, and theoretical speculation. This gives rise to an ambivalence of genre that corresponds to Takeda's own ambivalent attitude toward China, and his inability to reconcile what I argue were his fetishized expectations of that site with the brutality of his personal experience while a member of the Imperial Japanese Army.

This discussion of Takeda's inability to either successfully cross the hegemonic border that separated China from Japan or to emerge blameless from his Imperial Army experiences should not be read as a pious condemnation of the writer. Familiarity with the lonely fate of the authority-defying protagonist in Kobayashi Masa'aki's (1916–1996) screen adaptation of the novel *Ningen no jōken* (*The Human Condition*), by Gomikawa Junpei (1916–1995),[11] not to mention Slavoj Žižek's incisive commentary on the manner in which being given a choice to participate in atrocity is no choice at all (1997: 27),[12] should alert us to the immense complexity of the issues involved here. Rather than dismissing Takeda as a latent fascist or worse, I probe the strategies he deployed to manage memories of horror and the rabid nature of the Japanese imperial project toward the continental other. In one sense, "The Journey of a Young Soldier" can be read as a confessional text. However, this is not the self-indulgent form of systematic confession discussed by Karatani Kōjin, which valorizes the writer through the very revelation of weakness.[13] Rather, by providing a textual representation of Shen's account of and response to the extremes of human behavior, Takeda indirectly forces the reader to consider issues of Japanese war atrocity.

SHEN CONGWEN

Shen Congwen was born as the second son of a military family in the city of Fenghuang, West Hunan, where, after joining the local provincial army at age fourteen, he spent the following six or so years in either active or administrative military service.[14] West Hunan is a region of great scenic beauty which, as Jeffrey C. Kinkley points out, was regarded in the early decades of the twentieth century both as "China's Switzerland" and as "*shiwai taoyuan*," the Chinese Shangri-la (1987: 15–16). As a leading exponent of "native soil literature" (*xiangtu xiaoshuo*),[15] Shen was a master writer of landscape who foregrounded the rural over the more compellingly modern urban space.[16]

Takeda's commentary on Shen's autobiography provides contemporary readers with insights into the difficulties encountered by the Japanese writer as a "long-distance cultural specialist" attempting to ascribe meaning to the discursive site of China. It is clear that his experiences as an Imperial Army conscript created an intolerable burden for Takeda. This was a time that saw a twenty-five-year-old young

man from a devout religious background experience real life contact with forms of human depravity that defied articulation by the conventions of either the spoken voice or the written word. Shen's autobiography, however, provided accounts of atrocities that the Chinese boy-soldier had witnessed in the "pacification" campaigns conducted by his unit. In this text Takeda surely found an account of military experiences that resonated with his own and that thereby provided a means by which he could obliquely record his own contact with the atrocious. The confronting nature of Shen's account, moreover, was assuaged for Takeda by soothing images of the beauty of the environs in which the various campaigns took place. These images provided a momentary elision of the inescapable consequences of and responsibility incurred by merely being witness to, let alone a participant in, war atrocities.

Shen Congwen's larger corpus—particularly his West Hunan writings—encompasses a litany of gruesome scenes, including children scavenging among severed heads, dogs devouring corpses, and random decapitations drawn by lot. Yu-shih Chen's review of Kinkley's authoritative study of Shen and his work references a scene in which the nine-year-old Shen searches among "410 bloody heads that dangled, as a public warning, from captured scaling ladders" (Chen 1991: 171; Kinkley 1987: 30) for a cousin killed in a Miao purge. Images of this nature, however, are overlaid and offered in tandem with accounts of pristine scenery, redolent with paradisiacal adornment, that cut across and obscure—while contradictorily profiling—the atrocious acts depicted. David Der-Wei Wang identifies "a radical melancholy" (1992: 248) in Shen's Hunan texts, a notion that might well be applied to much of Takeda's own writing on China. It is perhaps this "melancholy" that attracted Takeda to Shen's autobiography, and which led the Japanese writer to reconstruct and re-valorize the West Hunan landscape Shen Congwen had so meticulously depicted in his original text. In this way, Takeda engaged in a process of self-consolation while also finding a language by which he could attempt to articulate the unspeakable experience of war.

IMAGINING CHINA AND TRAVEL

Takeda's first attempts to interpret China were made with no geographical experience of that site. In this respect, he might be compared to the writers referenced by Atsuko Sakaki in her discussion of the imaginary voyages to China that appeared in the Japanese classics between the tenth and eighteenth centuries (2006). These writers generated the contempt of critics who saw their works as flawed, for example, by imprecise topographical knowledge. However, Sakaki points to the value of investigating these imaginary acts of travel to "articulate the rhetorical configuration

of China" presented. She further argues that "in considering authorial intent, we should account for the point of imagined referentiality when there is no object to which to refer. Instead of dismissing textual production in this period as fabrication, I suggest that we see it as the purest form of rhetorical configuration of China" (2006: 19). In spite of his interest in modern Chinese cultural production, Takeda's interpretation of China prior to visiting the site was in many ways as flawed as that of Sakaki's much earlier imaginary travelers, especially with respect to the nature of Japanese aggression on the Asian mainland. In other words, while Takeda thought he "knew" China, upon arriving there he discovered that the place was unknowable in terms of his expectations. In the final instance, therefore, his only resort was to become like the writers Sakaki discusses, who "projected their own exotic infatuations" (Sakaki 2006: 19) onto the site they called China.

From this perspective, Sakaki cites Stephen Greenblatt on Christopher Columbus who, Greenblatt argues, "knew" what he would discover. If, Greenblatt continues, the sightings of the "known" unknown "fail in their promise, they will be demoted from the status of signs and not noticed any longer" (see Sakaki 2006: 19–20).[17] It is possible, however, that this "failure of promise" can be so disruptive that it traumatizes the viewer. When this occurs, rather than "being demoted from the status of sign," the site being viewed becomes obsessively fixed in the viewer's consciousness. One strategy to overcome this obsessive fixation is to reconfigure and fantasize the site into a transcendental literary landscape and to thereby elide what is otherwise an inescapable imperative to confront and deal with the lived sociohistorical circumstances encountered. In Takeda's case, this imperative required acknowledging the commission of atrocity in war. In the text considered here, the Japanese writer could only confront this lived experience by simultaneously creating a fantastic reconfiguration of China through the autobiography of Shen Congwen, a master of native place literature, which was itself a literature of the landscape fantastic.[18] Shen's writing enabled Takeda to imagine a "pure form" of a rhetorical China, an interpretation to which he resorted following the collapse of the "known" fantasy image he had constructed prior to his departure from Japan (Figure 10.2).

As the work of Mary Louise Pratt suggests, fantasizing or exoticizing the site of the other is a strategy common to all travelers (1992). However, Takeda's first encounter with China as a geographical site came as a member of the Imperial Japanese Army, a status we might regard as the perfect manifestation of the compliant subject of imperial Japan. One imperative of this status was support for commission of the atrocious against those who declined to acknowledge the expansionist will of a "benevolent" Japanese emperor. Traveling to China in this necessarily brutal role, it was impossible that Takeda would experience the China he had benignly "known" through scholarship prior to his departure. Traumatized by the mismatch between

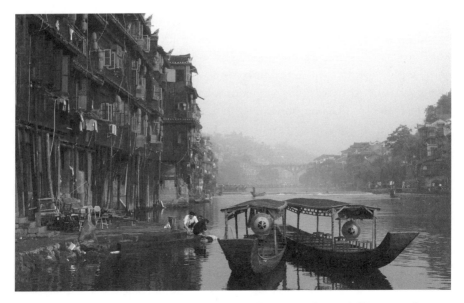

Figure 10.2 Women at the riverbank of present-day Fenghuang. © tuyoshi/Shutterstock.com

what he "knew" as a China aficionado identifying with the discursive space of China from afar, and what he "experienced" as an Imperial Army conscript charged with support for the commission of atrocities that both figuratively and literally mutilated this discursive space and its inhabitants, Takeda resorted to mediating China through Shen's writing.

ATROCITY IN THE TEXT

Through his paternal grandmother, Shen Congwen was a member of a branch of the minority Miao. This was one of the groups in southern China subjected to "a horrendous downward spiral of war casualties, epidemics, decimation of herds and famines" (Culas and Michaud 2004: 69) in the ethnic strife that was a function of the modernization of the region and that resulted in a total of ten million deaths.[19] As a member of a local warlord's army, "Shen witnessed repeated massacres. His unit undertook ethnic cleansing activities and fought with other warlord groups. His own group too sometimes faced annihilation."[20] Although written in 1932 when he was in his thirtieth year, I have noted that Shen's autobiography abruptly ends at the time that he forsakes his military activities to depart for Beijing at age twenty. This focus is testimony to the impact on Shen of his experiences as a "young soldier."

What attracted Takeda to this writer's life story? In the work of Shen Congwen, Takeda felt the fascination of the other who is none other than oneself. The two men had many compatible experiences. "The Journey of a Young Soldier" opens, for example, with the comment that travel and "observing the reality around you with youthful ears and eyes" is the best training for a prospective writer. This is followed by an account of Shen's departure from his homeland by boat. Takeda also left Japan by boat, and the opening entries of his service diaries—bequeathed by his daughter to the Museum of Modern Japanese Literature in Tokyo, but then withdrawn when scholars used the material to speculate upon the nature of his military activities—express the unease and anxiety of a young conscripted man en route to the battlefield. Thus when Takeda writes the following about Shen, we see hovering almost corpse-like beneath the text the palimpsest of the young Japanese Buddhist:

> In the year and four months that his unit spent suppressing unrest, he witnessed approximately seven hundred killings. The source of Shen's distinctive sensibility as a writer can be traced to this time, when he grew weary of viewing these executions... In the pit of his stomach he felt the relentless love and hate generated from the values, both good and bad, of the people [of West Hunan]. (1971a: 298)

In discussing "*Huanghun*" ("Twilight") (1934), a Shen Congwen narrative that features scenes of decapitation, Wang notes that what "baffles" the reader about this text is the "understated, familiar, casual tone" (1992: 212). This understatement is evident, too, in Shen's material presented and discussed by Takeda. There is a discomforting sense of how banal the act of killing can become, and how this banality numbed the sensibilities of the young men so engaged.

Takeda's annotated translation of Shen's autobiography notes that because "to kill was the only way to suppress unrest," for both the officers and soldiers of Shen's unit, "watching killings was the most common way to pass the time." At the execution ground, these men would comment, Takeda tells us, on the visage of decapitated heads or how an executed prisoner, although clearly deceased, might remain standing. Furthermore, things were "particularly lively" when the execution coincided with market days, at which time the executioner killed a few beasts with a sword still "smeared with the fresh blood of his victims." The meat from these carcasses would be taken back to camp, where, after simmering the food over an open fire, the men would "tear at the cooked flesh" as they "tossed back glass after glass of strong drink." With everyone "dead drunk" and "laughing uproariously," some of the men "grabbed their chopsticks" and "held them to the throats of their companions" (Takeda 1971a: 299). The extract recalls the chilling testimonies of aged Imperial

Army veterans in Matsui Minoru's 2001 documentary, *Riben guizi* (*Japanese Devils*), who relate how they filled battlefield time with a range of atrocious "entertainment" activities.

PROBLEMATIZING LANDSCAPE

Yet, overlaying these accounts is the seductively enveloping and comforting cloak of landscape. Karatani has argued that the "discovery" of the "epistemological constellation" (1993: 22) of landscape in Japanese literary endeavor at the end of the nineteenth century provided the writer with the almost perverse license to valorize people who "are of no consequence to him [*sic*]" (1993: 25), and to thereby construct himself as a subject detached from the social milieu. An author thus assumed the authority to view, in the anatomically analytical enlightenment sense, the other from a distance, reflect cognitively upon, and to some extent possess that other as an object of inquiry. Any emotive response was confined merely to reflection on the viewer's own feelings and disconnected from the lived circumstances of the viewed other (Karatani 1993: 22–25). I would argue that this at least partially theorizes Takeda's whole approach to China—as a vast, extended landscape that he viewed from afar—to possess, reflect upon, and respond to emotively. In a sense, even when in China he was unable to leave Japan.

This is not to say that Takeda did not seek to go beyond the confines of the local and to enter what Pratt refers to as the "contact zone" (see Pratt 1992: 1–12), a space in which the visitor might approach and engage with local people in the unfamiliar site. While Pratt notes that this zone features elements of "coercion, radical inequality and intractable conflict," it nonetheless offers the possibility of an "interactive" and "improvisational" dimension that acknowledges what is often "ignored or suppressed" by invader rhetoric (Pratt 1992: 8). In "The Journey of a Young Soldier," however, these possibilities often conclude in a manner that forecloses any real understanding of either the landscape viewed or the lived experiences of the residents. While Takeda creates the impression of engaging directly with Shen as a subject, it is clear that this engagement only occurs at those points at which the Japanese writer can respond to Shen's experiences as his own. In other words, "The Journey of a Young Soldier" is more about Takeda than it is about Shen. This is not necessarily an absolute negative; however, it does indicate limits to Takeda's capacity to open himself to the Chinese other and to grant that other an authentic right to enunciate using her or his own voice.

Not all of Takeda's texts collapse in this way. One extraordinary example of the voice of the other is seen in a text in which Takeda articulates in dialogue format the brutally suppressed anguish of a son and his mother after Imperial Army soldiers

have forced the young man to rape the woman (1971b). However, the degree to which other voices are heard in Takeda's commentary on Shen is moot.

Regardless of voice, atrocity is a persistent trope in the Takeda/Shen text. Under the guise of "preserving social order," Shen's unit embarks on a campaign of "cleansing the area." Readers are told that "the simplest way to preserve order is to kill people." Yet there is a stunning capriciousness to this strategy. When a local headman brings forty-three captured peasants before the chief of command:

> Twenty-seven were beheaded, although those that surrendered guns and ammunition were released... The number of killings grew each day but [other units were more ferocious] and the numbers killed by Shen's unit was fewer rather than more. (Takeda 1971a: 298)

Both Shen and Takeda were immersed in surroundings made hellish by war. While Zygmunt Bauman has famously theorized the Holocaust as the logical endpoint of modernity (1989), I would argue that the scenes depicted earlier in this chapter demonstrate how these ideas can be relevant to sites outside the confines of European theory.

How precisely, then, does landscape articulate with the atrocious? Nishikawa notes that Takeda used landscape as a way to manage the experience of war (2005: 175). While not all of Takeda's China-related texts feature romanticized descriptions of local scenery, this element is particularly prominent in "The Journey of a Young Soldier":

> Shen Congwen decided to walk along the city's riverbank with its unidentifiable atmosphere of the unfamiliar. In the cramped, uneven, rickety houses, there were opium dens, noodle shops, shops selling varieties of rope, a butchery... The river was full of little boats, between which plied larger vessels carrying cow-hide. The children who lived in the cramped houses and on the riverboats were watching a cockfight. Boats selling snacks beat bamboo clappers while those selling sweets beat a gong. Rocking around these craft were even smaller boats selling pork dishes and devil's tongue starch noodles (Takeda 1971a: 301–302).

This account, referencing Shen's autobiography but with Takeda embedded firmly in the fabric of the text, is a detailed, even loving, catalog of an exotically unfamiliar West Hunan. There remains a clear boundary, however, between the viewer and the viewed. The latter are fixed as third persons and rarely assume the position of second, let alone first person. The happy children, the quaint residences, the exotic foods—these are all the substance of the Orientalism of *Time-Life*, *National Geographic*, or *Manchurian Illustrated*, which provide putatively apolitical representations of the

timelessly innocent native, unsullied by modernity. Nowhere do we see William Carlos Williams's bitter acknowledgment, cited by James Clifford,[21] that this "native" had long disappeared; there is merely a longing for the viewer's interpretation of what a native should be—an object that offers consolation and aesthetic pleasure, a version of Said's "sublime" East, which simultaneously confirms the "benevolently" superior optics and rationality of the viewer.

Takeda was certainly not the first Japanese writer to flee the terror of the modern for the rural premodern. Tanizaki Jun'ichirō (1886–1965) abandoned the city to seek the same solace in his textual representations of the remote Mount Yoshino area of Nara prefecture, Japan (see Tanizaki 1982). Takeda, on the other hand, retreated to a Chinese landscape. And although as a young man he had rejected the Chinese classics in favor of modern cultural production, in "The Journey of a Young Soldier" Takeda takes flight from the demands of modern military life to embrace Shen's literary evocation of the same scenes that had inspired the Chinese ancients:

> Not far upstream from the town, wild orchids grew in a site known as Hundred Swallow Gorge…One could not help but be struck by their flawless beauty…The unfamiliar blossoms, with their dim, ghostly fragrances, and the tiny eddies of the gorge waters created a two-tiered sacred place, and it seemed not at all strange that Qu Yuan of [the kingdom of Chu] had wandered the area… "The wild orchids of Feng, the perfumed orchids of Ruan," or "Boarding a boat, I make my way up the river to Feng." From these verses, we can easily picture the poet from ancient times, the turmoil of the vagabond far from home in his heart, seated in a small boat rocking upon the water. (Takeda 1971a: 300–301) (Figure 10.3)

Immersion in the de-historicized world of the wandering scholar poet was the salve that assisted Takeda to momentarily erase memory and his own "turmoil" as a "vagabond far from home."

Yoneyama Masafumi has provocatively argued that even the most altruistic Japanese desire for Asia—here China—was marked by a sense of ownership and possession that must logically end in invasion (2006: 1). I would suggest that, in the case of Takeda, participation in this invasion and the brutal attempt to possess generated a sense of excess that the writer sought to appease through an evocation of the landscape, much as he had configured this in his imagination prior to traveling there. That landscape might be the ethereal beauty of an orchid-filled gorge or the idyllic innocence of the quotidian riverbank lifestyle of local people. Both give rise to a sphere of nostalgia that precipitates a sense of isolation within the unfamiliar. This

Figure 10.3 A small boat rocking upon the water in West Hunan. © Maitree Laipitaksin/ Shutterstock.com.

mood of isolation, moreover, can furnish a perverse strategy whereby, rather than seeking equal exchange in Pratt's "contact zone" with local residents, the invader attributes blame for his manifold failings to the very people whom he would brutally possess, all the while quivering with righteous indignation at having his invasive overtures rejected:

> [Painfully alone,] Shen yearned for a companion with whom to converse... Wearing his grey uniform, the young soldier walked [on towards the

city walls and saw] in the distance a group of beautifully-clothed girls coming towards him. They cried out, however, "A soldier! A soldier!" and ran in the opposite direction…At times like this the young man resented his uniform. "I am not a bad soldier," he wanted to say, "I am fond of reading and have great knowledge." But he was unable to voice his thoughts. Despondently, he returned to his room, where he practiced his writing on official paper. (Takeda 1971a: 299)

There is a palpable elision of responsibility in this passage, a rejection of the culpability incurred through association with atrocity, and a maudlin attempt at self-consolation through the production of the text.

CONCLUSION

Notwithstanding the possibility of his association with atrocious military acts or the questionable self-defense presented in the excerpt just cited, it is unlikely that the scholarly Takeda was motivated by Yoneyama's desire to invade, although he certainly sought to view and thereby possess. This is notwithstanding the fact that, from one perspective, even when in the space of geographical China Takeda remained located, perhaps against his will, in the discursive space of Japan. This was the Japan of the imperial system—against which Takeda had protested as a young man—a system famously theorized as an empty center,[22] a vortex-like vacuum into which even reluctant subjects were drawn. One role of this vacuum of *mu,* or nothingness, was to facilitate the erasure of responsibility for the commission of the atrocious. For Takeda, implication in this process, voluntary or involuntary, created an almost impenetrable barrier in the face of which he was unable to develop the strategies necessary to engage in polyphonic dialogue with either the discursive or geographical site of China. Like Shen before him, Takeda therefore had no recourse other than to seek solace in literary texts, with a particular attraction to texts adorned by the fantasy of landscape.

"The Journey of a Young Soldier" is an important prewar literary attempt to resist the hegemonically sanctioned Japan-China divide. It is clear from this and other works that Takeda Taijun, as a long-distance cultural specialist, yearned for exchange with China. Yet, in this particular narrative at least, the writer was unable to border cross or create even a fragile hybrid identity—no matter how conflicted and imperfect that may have been—that could interrogate a desire for the simulacrum of the idealized yet damaged self and also permit the expression of the unmediated voice of the Chinese other.

NOTES

1. The founder of the society was Takeda Yoshimi (1910–1977), a prominent postwar left-wing thinker and Japanese authority on Lu Xun (1881–1936). The first meeting was held in March 1934. Personal names are given in Japanese order with the family name first, except in the case of scholars who write in English, such as Atsuko Sakaki, whose name order follows Western convention.

2. McDougall and Louie note that although Lu Xun's *Diary of a Madman*—the work usually acknowledged as the turning point in modern Chinese literature—appeared in 1918, the "distinctively new mode of expression and subject-matter" of this narrative "foreshadowed a period of sustained analysis of Chinese culture in general, which later became known as the May Fourth Movement" (1997: 19).

3. This view was not confined to the Japanese but also held by Lu Xun. In discussing such notions, Itoh notes that the "Japanese have had a preconceived notion of Asia as being backward and inferior to this day" (2000: 69).

4. Biographical material for Takeda comes principally from Nishikawa Masa'aki, *Takeda Taijun den* (*The Life of Takeda Taijun*) (Nishikawa 2005).

5. Takeda's corpus runs to a collected works of twenty volumes. He also worked, for example, on movie scripts and treatments.

6. In the chapter entitled "Chūgoku taiken" ("China Experience"), Nishikawa gives the figure seven in comparison to Takeuchi Yoshimi who visited China four times (see Nishikawa 2005: 155). For more on Takeuchi in China, see Olsen (1981: 319–348).

7. Although he is acknowledged as one of modern China's first novelists, Shen was subjected to "re-education" by the Chinese Communist Party in the mid-1950s. After being given a post at the National History Museum, when not being "sent down to the countryside" or similarly reprimanded, he produced texts on Chinese material culture, including lacquerware, textile design, Ming dynasty brocades, and folk art. See Kinkley (1987: 261–274).

8. For a discussion of this aesthetic, see Alan Tansman's analysis of Yasuda Yojurō's 1935 essay "Japanese Bridges" (Tansman 2009: 49–108).

9. The chapter on Takeda in Karatani's collection is entitled "Rekishi to tasha" ("History and the Other"). Karatani also notes that Takeda's affiliation with Buddhism gave him a marginal status.

10. Freud notes that the "uncanny," while unknown, is also marked by a trace of what has "long been familiar." See Freud 2003: 124.

11. Gomikawa Junpei, *Ningen no jōken* (*The Human Condition*) (Tokyo: San-ichi shobō, 1956–1958). Kobayashi's three-part screen adaptation appeared between 1959 and 1961.

12. This discussion is entitled "The Empty Gesture."

13. Here Karatani notes that what Uchimura Kanzō's Christian compulsion to confess "amounts to is an assertion that the reader is hiding the truth while 'I,' however inconsequential a person I may be, have exposed it" (1993: 86).

14. For Shen's biographical details, see Kinkley (1987).

15. While David Der-wei Wang notes that "Shen Congwen has long been regarded as one of the important native soil writers in modern Chinese fiction" (1992: 247), Rosemary Haddon points out that the term "native soil" (or "nativist") "defies one simple, all-inclusive definition" (1944: 98).
16. This necessarily implies a valorization of the rural. Lu Xun, often discussed as a "native soil" writer, was highly critical of the "backwardness" of the Chinese countryside.
17. Sakaki here refers to Greenblatt's *Marvellous Possessions: The Wonder of the New World,* Oxford: Clarendon Press, 1991: 88.
18. Kinkley suggests that Shen's construction of West Hunan is as "an imaginary kingdom like Faulkner's Yoknapatawpha" (1987: 4–5).
19. Culas and Michaud cite this figure from John K. Fairbanks and Ssu-yu Teng, *China's Response to the West: A Documentary Survey 1839–1923.* They give no page numbers.
20. This commentary appears on the website of Shen's publisher, Hakuteisha. http://www.hakuteisha.co.jp/gakkai/xiangxi.html. Accessed February 30, 2012.
21. James Clifford cites the 1923 William Carlos Williams poem "To Elsie," or "The Pure Products of America," and argues that Williams, while longing to invoke a lost past, is nonetheless aware that "[a]ll the beautiful, primitive places are ruined" (1988: 4).
22. This notion was put forward by Roland Barthes in *The Empire of Signs* (1982).

REFERENCES

Bahktin, M. (1973), *Problems of Dostoyevsky's Poetics,* Ann Arbor, MI: Ardis.
Barthes, R. (1982), *Empire of Signs,* trans. Richard Howard, New York: Hill and Wang.
Bauman, Z. (1989), *Modernity and the Holocaust,* New York: Cornell University Press.
Chen, Y.-s. (1991), "Review of 'The Odyssey of Shen Congwen' by Jeffrey Kinkley," *Chinese Literature: Essays, Articles, Reviews,* 13: 170–174.
Clifford, J. (1988), *The Predicament of Culture: Twentieth-Century Ethnography, Literature and Art,* Cambridge, MA: Harvard University Press.
Culas, C. and Michaud, J. (2004), "A Contribution to the Study of Hmong (Miao)," in N. Tapp, J. Michaud, C. Culas. and G. Y. Lee. (eds.), *Hmong/Miao in Asia,* Changmai: Silkworm Books.
Freud, S. (1976), *The Interpretation of Dreams,* Harmondsworth: Penguin Books.
Freud, S. (2003), "The Uncanny," in *The Uncanny,* trans. David McLintock with introduction by Hugh Haughton, New York and London: Penguin Books: 121–162.
Gomikawa, J. (1956–1958), *Ningen no jôken (The Human Condition),* Tokyo: San-ichi shobô.
Haddon, R. (1944), "Chinese Nativist Literature of the 1920s: The Sojourner-Narrator," *Modern Chinese Literature,* 8: 97–125.
Heinrich, L. N. (2008), *The Afterlife of Images: Translating the Pathological Body between China and the West,* Durham, NC: Duke University Press.
Itoh, M. (2000), *Globalization of Japan: Japanese Sakoku Mentality and US Efforts to Open Japan,* New York: St. Martin's Press.

Karatani, K. (1993), *Origins of Japanese Literature,* Durham, NC: Duke University Press.

Karatani, K. (1995), *Shūen wo megutte (On the "End"),* Tokyo: Kōdansha gakujutsu bunko.

Kinkley, J. C. (1987), *The Odyssey of Shen Congwen,* Stanford, CA: Stanford University Press.

McDougall, B. and Louie, K. (1997), *The Literature of China in the Twentieth Century,* Hong Kong: Hong Kong University Press.

Nishikawa, M. (2005), *Takeda Taijun den (The Life of Takeda Taijun),* Tokyo: Kōdansha.

Okuno, T. (1976), "Sekai wo ukogasu tame no bungaku: Takeda Taijun ron" ("Literature that Moved the World: An Essay on Takeda Taijun)," *Subaru,* 26: 137.

Olsen, L. (1981), "Takeuchi Yoshimi and the Vision of a Protest Society in Japan," *The Journal of Japanese Studies,* 7 (2): 319–348.

Pratt, M. L. (1992), *Imperial Eyes: Travel Writing and Transculturation,* London: Routledge.

Sakaki, A. (2006), *Obsessions with the Sino-Japanese Polarity in Japanese Literature,* Honolulu: University of Hawai'i Press.

Tansman, A. (2009), *The Aesthetics of Japanese Fascism,* Berkeley, Los Angeles, and London: University of California Press.

Takeda, T. (1971a), "Wakaki heishi no tabi," in *Takeda Taijun zenshū, 11 (The Collected Works of Takeda Taijun,* Volume 11), Tokyo: Chikuma shobō.

Takeda, T. (1971b), "Nare no haha o," in *Takeda Taijun zenshū, 11 (The Collected Works of Takeda Taijun,* Volume 11), Tokyo: Chikuma shobō.

Takeda, T. (2004), *Fuji,* Tokyo: Chūō kōron shinsha.

Tanizaki, J. (1982), *The Secret History of the Lord of Musashi and Arrowroot* (a translation of *Bushūkō hiwa and Yoshinokuzu* by Tanizaki Jun'ichirō, 1930), New York: Alfred A. Knopf.

Wang, D. D.-w. (1992), *Fictional Realism in Twentieth-Century China: Mao Dun, Lao She, Shen Congwen,* New York: Columbia University Press.

Yoneyama, M. (2006), *Ajia/Nihon (Asia/Japan),* Tokyo: Iwanami Shoten.

Žižek, S. (1997), *The Plague of Fantasies,* London and New York: Verso.

11 UNFRAMING THE NATION: THE MOVING IMAGE AND ITS *PARERGON* IN SOUTHEAST ASIA

David Teh

In 1998, a substantial book was published on the work of contemporary artist Rirkrit Tiravanija. Cloth-bound and weighing two pounds, *SUPERMARKET* offered a summary of the artist's previous work as he was nearing forty, an age at which an art star might look for a mid-career retrospective. But the institutional exhibitions it accompanied—in Zurich, Amsterdam, Dijon, and Columbus, Ohio—did not really amount to one. Nor is this book really a catalog, for, like many of Rirkrit's productions, it evinces a determined resistance to the art world's generic packaging, subverting expectations of the retrospective monograph. Instead of academic essays, we find a miscellany of brief, personal anecdotes from a host of Rirkrit's collaborators and friends. If anything, the format is that of a cookbook, its six sections corresponding to key "ingredients" of his practice: food, home, a lot of people, saffron, market, and moving.

The book's photographs in particular are subject to a special design strategy. Many are large, bled to the edges of the page; others are shrunken to thumbnail dimensions or tiled to make a kind of abstract wallpaper. Some have been paired, nested one inside the other, then reversed, frustrating an art publisher's (or gallerist's) preference for the "money shot" that encapsulates a seminal or iconic work. This photo survey, true to Rirkrit's nomadic and inclusive practice, covers much of contemporary art's global *ecumene*. Yet one context bleeds into the next, for with the exception of page numbers, metadata has been assiduously vacuumed out of the layout.

Rirkrit's identity has been a prominent theme in discussions of his work. At that point in his career, this son of a Thai diplomat—born in Argentina, educated in

North America—had begun to reconnect with his Thai heritage. And it is saffron, the most specific yet least literal of his artistic "ingredients" that, at the center of the book, *frames* this uncertain inheritance. The saffron section offers distinctively Thai scenes, not quite touristic stereotypes, but a kind of minor picturesque, glimpses of everyday life on which the aesthete's eye might linger. The Buddhist clergy (*sangha*), when not directly pictured, are implied by the chromatic signature of their robes. But the contexts framing them are profane, not sacred. In a subtle, recursive symmetry, they map the other ingredients of Rirkrit's very secular practice.

At the knotty heart of this national symbolic riddle, two pictures defy all the rules, photos of Thailand's long-reigning monarch, King Bhumipol Adulyadej, touring at the fringes of his realm. In the first, attended by military officers, he inspects rice fields at Mae Salong at the country's northern extremity, in 1979. The second finds him in the far south the following year, "conversing" with villagers near Sungai Kolok (Rirkrit et al. 1998: 155). These two sites represent the fingertips of what Thongchai Winichakul (1994) has dubbed Thailand's "geo-body," the furthest points from its symbolic and political heart in Bangkok. Indeed, ethnologically, there is nothing very Siamese or Buddhist about either of them, and Thai sovereignty has been disputed in both, under arms, in living memory.[1] The photos appear to come from some royal publication, complete with captions, reporting His Majesty's movements without naming him, as if part of a series. Each occupies a double page framed by a slim white border.

In 300 richly illustrated pages, the only images not subject to the carefully unconventional framing of the artist's oeuvre are those of the *sovereign,* and what underscores the exception, what inscribes it, are precisely conventions of framing. These suggest deference to institutional order, in a book that would defy and scramble institutional formatting. They are the only images that cannot do without their metadata. For an ethnically Thai artist discovering his roots but more engaged with Western aesthetics, it is hard to avoid the conclusion that this exception marks a kind of limit. It attests to a field of images that lies beyond the would-be global language games of contemporary art, images that are modern, yet sacrosanct, subject to a sovereign exception.

This anxious gesture summons all the tensions I will assemble here under the sign of the *parergon.* In *The Truth in Painting,* Jacques Derrida notes that the delineation of a frame can be more than just spatial, but also ontological: neither of the work, nor foreign to it, neither inside nor outside, the *parergon* "stands out, both from the *ergon* (the work) and from the milieu" (1987: 61). This wider enframing might describe the drape, the clothing of a statue, or captions. For moving images, which are my focus, it could include subtitles, credits, or a soundtrack; or even more widely,

the whole theater of exhibition, not to mention the discursive framings of promotion and curatorship, of collection and exhibition. This *parergon,* which disconcerts the opposition between inside and outside, has phenomenological implications for the work of art. Yet as images enter an increasingly global circulation, might there also be ramifications—for artist and viewer alike—at the level of a more properly political ontology, at the uncertain borders of an ethno-national being?

FRAMING *UNREAL ASIA*

In 2009, I co-curated with Gridthiya Gaweewong a program of film and video from Southeast Asia for the Kurzfilmtage, the International Short Film Festival Oberhausen. We were uncomfortable with this geography: "Southeast Asia" was originally a product of the colonial-military imagination (British, Japanese, and American), and later of Western academia. Its discourse still operates primarily top down, from supranational and national institutions to lesser players reliant on their patronage. In art, too, "the region" is a bureaucratic construct; curators and historians entertain it, but few artists have much need for it. The cultural diversity of these places, and their divergent experiences of modernity, have made for an unruly set of forms and themes.

Despite our reservations, we settled on a Southeast Asian focus, though we included work from elsewhere. The material was arranged thematically: one subprogram, called "State Fictions/Fictional States," looked at tensions between official histories and minor ones; "Corridors" investigated the social impacts of migration; "Uncanny Geographies" explored Asia's rapidly expanding cities (Gridthiya and Teh 2009: 79–88). Our intention was to interrogate familiar curatorial frames, to confront the transcultural cinéphile gaze with more fundamental, ontological questions. If film had long enjoyed a privileged relation to the real, recent experiments in digital filmmaking obliged us to challenge this assumption. Since the 1990s, Asian artists had been playing their part, ushered into the global contemporary by eager museums and festivals. But what could "realism" mean for an Asian aesthetics of the moving image?

This was not really an art historical gesture—of course there *is* a discourse on Asian realism, largely attendant upon that of modernity and thus, tightly hinged in turn to the discourse of nation (see Clark 1998, 2010). But as many of the cultures finding expression in moving images, especially digital ones, are older than the nations that now encompass them, "Asian modernity" seemed an inadequate backdrop. A guiding premise of our program, *Unreal Asia,* was that reality in contemporary Asia is still informed by notions foreign to Western rationalism. Animist, feudal, and

even primitive behaviors are embedded in modern social and political life in ways that defy the binary logic of modern and traditional and that disarm the teleological assumptions of developmentalism. Even where industrialization is advanced, older, "irrational" beliefs remain potent. Feng shui masters and fortunetellers still advise CEOs and presidents, to say nothing of artists and curators.

The spectacular technology of film has been exemplary of this mixed modernity, cracked in myriad ways—mobilized, tropicalized—in conjunction and competition with local cultural forms. If the cinema long carried the veneer of newness, it often served old powers and old stories. Hence the acuteness of both its appeal and its threat to the modern state, a form whose constitutive anxieties have turned on precisely such articulations of new order on old terms. The aestheticization of politics, though, has not always been met with a politicization of the aesthetic. Despite an explosion of activity, Southeast Asia's video makers seem disinclined to compete with the official truths of the nation. Decades of authoritarianism have cheapened film's epistemological claim, and artists generally seem unconcerned with restoring it. But was veracity ever part of its make-up here? Or had some *presumption* of reality merely slipped into regional film discourse on the coattails of the medium itself? Historiographies of "national cinema" have encouraged this transfer. But if the moving image had different prehistories in these places, might these account for some trends in recent practice? How might digital media engage with these older, precinematic cultures?

In Thailand, for example, even mainstream cinema history has not been without its quirks. Historian May Adadol Ingawanij (2010) notes the inordinate longevity of live dubbing in Thai cinema, which continued throughout the Cold War, and hence the survival of 16mm technology there long after it was superseded elsewhere. Local producers worked in utterly local ways with the old apparatus. Movies were shot fast, on unsealed sets, but also silent—decades after synched sound recording had become the norm elsewhere. Just as distinctive were the performances of "versionists" (dubbers) who, like Japanese *katsuben,* often became stars in their own right (see Anderson 1992). This form of presentation bolstered an older distribution dynamic, that of the mobile cinema that introduced film to most of the Thai population, and which is not quite extinct today. The versionists' art had a kinship with musical theater and puppet traditions and the framing that went with them—parochial, seasonal, architectural, and commercial. It was a creative interpellation that oralized and localized the industrial film text.[2]

However, it is not orality that concerns me here, so much as a broader sociality: the community—imagined or otherwise—that film inscribes within its spaces, and which the latter thereby mark out within a wider *socius.* These formal peculiarities

gave a distinct flavor to the Thai cinema diet, favoring material suited to this modern, performative mode. May Adadol (2012) focuses on the consumption of 1960s Hindi films, their humor and melodrama ripe for local voicing. Again, this suggests older, deeper resonances—the shared legacy of the Ramayana, part of the DNA of narrative throughout Southeast Asia—that helped shape the cinema experience even in the US-dominated postwar era. Advertisements of the period reveal demographic, class, and gender dynamics. Marketed mostly to women in the fast-growing city, such films also thrived in the majority non-Siamese southern provinces: the women of a growing petit bourgeoisie, newly subscribed to urban capitalist economy, and peripheral subjects only recently enframed by nation, who shared, if not the same cinema, then at least the same films and the same *parergon*.

THEORIZING MIXED MEDIA: GETTING AROUND THE NATION

Ironically, cinema's circumscription by national markets retards historical consciousness of the form, streamlining both the putative audience and the perceived appeal of films made in intercultural ways with transcultural ambitions. Studies of national cinema, emphasizing the arrival of the apparatus and development of technical competencies, tend to insulate industrial production from its low-tech competition. But with careful attention to the *parergon,* to the framing and translation of moving images, we might do better justice to their layered contexts.

One of the videos in *Unreal Asia* offers a neat example, a four-minute excerpt from a compilation of "filmed jokes" called *Phapphayon kom* (*Kom Movies,* 2009; dir. Suphong Phatham). At a checkpoint on a country road, a Thai policeman stops an ordinary-looking chap riding a motorcycle. He asks where the rider is headed; the rider replies, "*bpai bang-kork*" ("I'm going to Bangkok"). This is the punch line: he has given himself away as a foreigner, since any Thai national would have used the capital's Thai name (*krung thep*). That he is an undocumented visitor, and thus liable to be deported, is assumed; that he is Lao is self-evident from his accent and his destination, the obvious place for economic migrants from neighboring countries to head.

The humor is base, but not without its layers. For a metropolitan Thai viewer, a racial stereotype is confirmed, as the rube from up-country gives himself away. However, this film was made not primarily for a national audience, but for a regional one. Such compilations, distributed as VCDs, are unabashedly lowbrow, full of bawdy innuendo and homespun slapstick. They are common in the markets and temple

fairs of Isaan, Thailand's northeast, and in central Laos. Some, like this one, are co-productions between Lao and Thai companies. These regions, partitioned only since the colonial era, share cultural affinities much older than the partition. So this racist joke is not malicious; it plays equally well on either side of the border, as either self-effacing fun or tongue-in-cheek mockery. Isaan people—although many are proud of their Thai nationality—are under no illusions about their kinship with the Laos. For them, the butt of the joke is the arbitrary and abstract geographical border.

This transnational production illuminates an alternative, transnational audience and market. But perhaps more revealing is the framing of these sketches, which together make up only half the VCD. For they are films within a film, cutaways from a longer scene in which a politely attired village elder tells humorous stories to a crowd of villagers, who listen intently, in genuine mirth. While national stereotypes are rehearsed, for fun, in the sketches, the scene that enfolds them could be set in any village, on either side of the border.

Any regional historicization of DV must therefore look to, but also beyond, the national framing typically given to the cinema. Genealogical approaches to media have gained ground as convergent digital platforms put renewed emphasis on remediation, on the synchronic interactions between media (Bolter and Grusin 1999; Manovich 2001). Analog video in many ways anticipated this convergence: Roy Armes's treatise *On Video* (1988) cautions that the medium cannot be understood apart from the economies of film and television. But technocentric accounts do not leave much room for the social contexts that often shape the moving image in places happily behind the curve of spectacular innovation. As DV rechannels older forms, including oral and ritual traditions, it is a cultural rather than technical affinity that proves decisive.

A better guide, for our purposes, is the visual anthropology of Rosalind Morris's *In the Place of Origins* (2000), ostensibly a study of spirit mediumship in northern Thailand. Beginning with the absorption of print technology in the nineteenth century, Morris offers an expanded history of photography, its pivotal role in the construction of national modernity, and its ultimate integration into global, electronic media flows. But the object of this media history only appears once a range of *other* media—and the local practices that anticipate and co-opt them—have been carefully historicized. Morris is especially sensitive to the old uses to which new media are put: What happens to royal ceremony, for instance, when photography first frames the inner sanctum of the palace? (2009). The result is not a history of one medium, but a genealogy of social processes of mediumship. This approach illuminates the transitions and transferences between written, performative, and mechanical media, a suppleness that in Southeast Asia—syncretic and multicultural to begin with, then colonized, and now globalized—we can scarcely do without.

FOR AND AGAINST TRANSLATION: SUBTITLE AS *PARERGON*

Digital media have made the dissemination of video easier and faster, lowering national and linguistic barriers. Meanwhile, media convergence and wider access to desktop media tools have broken the monopoly film and television institutions once held over captioning. With massive, informal video markets comes a whole gamut of unregulated translation, facilitated by open source subtitling programs and formats. Social media, chat, and other peer-to-peer networks bring millions of users together, sharing data internationally, often in languages other than their mother tongue. Southeast Asia is a region of extraordinary linguistic diversity. National languages instituted in the last century jostle within a rainbow of dialects that inflect them differently from place to place. Further slippages occur between spoken and written language, especially where writing is a relatively new skill for much of the class spectrum, cultivated at a national rather than a provincial level. Add to this the residues of imposed colonial languages, and the patois of global English, and it is little wonder the region's video makers have found in captioning a special site for aesthetic play, particularly where marginal identities are concerned.[3]

The subtitle was pivotal in two of the Thai works we screened in Germany. The first was Marut Lekphet's elliptical *Burmese Man Dancing* (2008; DV, 6min), which dwells on Thai stereotypes about Burmese migrant laborers, solicited by way of a short questionnaire. Presented in split-screen, two video channels show scenes from the decks of fishing boats in the port of Phuket. Close, static shots of nautical paraphernalia alternate with longer, dynamic landscape shots of the working portside; the voices of fishermen are heard above the din of the engines, but we do not see them. Subtitles, drawn from the questionnaire responses, appear below the frames, but in "an encoded, unreadable language (Symbol font)" (Marut 2009). Some samples later appear—intelligible, in Thai and English—with the closing credits.

At first glance, Marut's video is inscrutable, but it rewards analysis. The political subject flagged in its title offers a starting point. The Burmese are a prominent, if marginalized, minority in the Thai *socius,* especially in the filmmaker's province of Phuket, though few of Thailand's video makers concern themselves with their plight. They form both a "legitimate" underclass and a standing reserve of exploited *sans papiers.* At the time, the Thai navy was drawing criticism for towing hundreds of Rohingya refugees out to sea and setting them adrift, on the pretext that they were economic migrants rather than victims of ethnic persecution. Yet what makes the video compelling is the artist's displacement of the aesthetic conventions through which such social issues would normally be made legible in moving images.

The footage—black-and-white DV from fixed cameras with local sound—is clearly observational. But claims to transparent recording are troubled by the double framing of the split screen; we are constantly reminded of the inadequacy of either viewpoint and of the vast off-camera world we cannot see. The "Burmese Man" never appears. And voice, that privileged vehicle of testament, is all but drowned out by the droning engines, any hope of comprehension dashed by the unintelligible subtitles. Rather than giving insight into the problem, this video puts all viewers equally on the outside, disarming prejudice through an arbitrary translation.[4]

Prateep Suthathongthai's *Explanation of the Word "Thai"* (2007; DV, 3min) is another sober take on ethnic exclusion, using another strategy of typographic decoy. As the artist explains: "Having moved to Thailand's northeast…I found that the definition of Thai identity is not adequate to [the country's] diversity…[D]ialect can be a clear indicator of ethnic identity. This project features readings of 'Thai history' [the nineteenth-century *Chronicle of Yonok*] by Phu-Thai or Thai who have retained their ethnic minority identity and thus experienced the history that was being read" (Prateep 2008). Even though this minority has some place in "Thai" history, the subtitles are opaque to most Thai speakers. "While they seem to aid translation," writes the artist, they ultimately spell out "an incomprehensible reading" (Prateep 2008).

These videos turn on the dual role of language as both lubricant *and* retardant of cultural exchange. Comprehension, in both, demands additional layers of framing, some textual accompaniment—credits or a synopsis—or that more variable enframing provided by a curator. But additional framing by no means guarantees smooth communication. For enframement, as Morris insists, is always a matter of "mediation by the foreign," and is just as likely to open new pitfalls, as with a piece by Indonesian artist Muhammad Akbar (2009: 133). In *Noise* (2008; DV, 4min), the monologue of a Japanese exchange student is rendered phonetically in Sundanese, the language of West Java and the artist's hometown, Bandung. This language's neglected script, derived from Chinese characters, has more in common with Japanese *kanji* than with Bandung's other dominant scripts, (Romanized) Bahasa Indonesia and (Sanskrit-based) Javanese. The video's format is that of the *vox pop*: the girl gives formulaic responses to generic questions—name, nationality, what she is doing in Indonesia—but again, the subtitles are no help. Though my co-curator and I neither read Sundanese nor speak Japanese, we did not hesitate in selecting the piece for *Unreal Asia*. But little did we know that this *second* framing—curators from elsewhere, presenting the work elsewhere again, in a third, self-consciously international context—risked bringing all our frames unstuck.

Oberhausen is a Mecca for European cinéphiles, and festival staff take the job of presenting an international smorgasbord of film very seriously. A few days before

opening night we were contacted by the translation team, which had discovered, to its horror, that it had no dialogue list for *Noise*. Could we provide one, posthaste? None existed. Seizing the initiative, the team had its Japanese translator transcribe the girl's lines from the audio track. When the work screened, viewers had the benefit of simultaneous German translation and could thus understand every word, exposing the hapless curators to the possibility of a compromising interrogation in the post-screening discussion! This soundtrack was deliberately made to be understood by Japanese speakers only, who are bound to find it quite dull. For others— even those who read Sundanese—the work is an exercise in non-comprehension, designed for a play of interpretation whose cues are visual and symbolic, not discursive. With the right framing, the alacritous viewer might deduce that the linguistic abyss indexes a cultural divergence from an earlier affinity, a gap left unclosed by colonial encounter, as well as a loss of linguistic diversity. But it is hard to imagine what this abyss looked like from the high-speed gondola the festival set up to span it. Despite their good intentions, in translating, had they not done a disservice to the work?

The work of enframing that the European art/film festival enacts takes as read both the a priori possibility of translation as a transparent communication (as untransformative as possible); and the desirability, even the necessity, of translation for cross-cultural communication, comparable to the so-called salvage paradigm in anthropology. These films are deliberately geared *against* this communication. The subtitle, in each, is exploited to excommunicate certain normative viewers in favor of mis- or underrepresented others, outsiders at large within the geo-bodies of modern nations (ethnic minority; migrant worker; exchange student). And in each case it is the frame—that *parergon,* supplementary to the image, neither inside nor outside it—that short-circuits the protocols of representation.

ANOTHER FRAME: THE LIMITS AND LIMITATIONS OF "GRADUATED SOVEREIGNTY"

I began by highlighting a certain insecurity in the national framing sought by an internationally recognized Thai artist. In its cautious, equivocal pursuit of Thainess, Rirkrit's quasi-catalog imbued the nation with a spiritual tint, yet one consonant with the profane, global everyday his art engages. But when this vision then enframed the walking, breathing embodiment of nation—Thainess in its most exemplary and unmistakable, *sovereign* figure—a special distinction, a special *parergon,* was called for. (There are few places on contemporary art's radars where such an accommodation would be necessary, especially for an artist of Rirkrit's stature.)

Here, sovereignty operates in two distinct registers: that of sovereign individuals, where it is synonymous with personal freedom; and at a collective level where it denotes a shared self-determination or autonomy, commonly that of a nation. But the two registers are intertwined. They are mutually constitutive, insofar as the former autonomy may be safeguarded by the latter, and the latter might stake its very legitimacy on the former. We thus find ourselves in the sort of breach that Jean-Francois Lyotard (1988) called a *différend,* for while popular sovereignty may be a globally operative norm, it is not a globally operative reality. This is one reason Thailand often falls through the gaps in political analyses of the region, for while its modern economy exemplifies global integration, its society—and the sovereignty that binds it—belong to another order altogether.

Following the regional financial meltdown of the late 1990s, anthropologist Aihwa Ong (2006) sketched a new structure of sovereignty for the "post-developmentalist" economies of Southeast Asia as they repositioned themselves (with encouragement by the IMF) to court multinational capital. Her transposition of a Foucauldian "bio-power" onto this geography reveals little that we do not already take for granted. Yet I wish to isolate the shape of the sovereignty she projects there, and the particular transnational framing that attends it. For Ong, sovereignty still rests on a discrimination interior to nation, and to this extent akin to the strategies of modern, authoritarian regimes of the past. But rather than the affirmative (inclusive) nationalisms of the postwar era, she sees now a tendency towards gradation, a spectrum of citizenship patterned so as to plug diverse populations into an exterior matrix of multinational corporate power. Sovereignty now is less about the citizen-state relationship, and more about one's valence in transnational labor markets. And transnational media, Ong argues, play a special role in constituting this new spectrum. They not only represent its subjects—albeit, like the state, unequally—but also themselves represent *the global:* both materially, as vehicle of the orbital trade in information; and ideologically, as champions of the connectedness we have come to associate with it. The media not only reflect the architecture of graduated sovereignty but, like a politics, also construct it, internally and externally. They frame the graduated subject, even as they destabilize (like a *parergon*) earlier oppositions between inside(r) and outside(r).

But if global media thus effect a kind of sovereign framing, they also permit sovereign interruption. This is palpable in the so-called social web (or Web 2.0), at once the site of unprecedented global convergence and the reactionary resurgence of national policing. Some nations have found ways to dampen its effects: China's censorship of search engines, for example; or in Thailand, the prosecution of bloggers and Facebook users under the feudal *lèse majesté* law (Streckfuss 2011). Governments in the Arab world have had less success, outflanked as the transnational media enshrine

all manner of informal and user-generated content, overcoming long-cherished protocols of verification and technical standards.

DV enjoys a special currency in this new market. Yet if gains are being made by this democratic medium, they are not made in national games of representation, but in the engagement of external, transnational interests and pressures.[5] Ong's reframing of sovereignty makes sense, then, insofar as a place—such as Thailand—may be considered a nation in a multinational context, an inside surrounded by an outside. But Thailand, while economically permeable, is politically insular—an inside whose outside, whose others, primarily lie within.[6] This structure is not unique, but its effects are more sharply felt, and more carefully repressed, in a people whose origins are murky and mixed, long beholden to ethnic myths of independence, a nation facing an acute crisis of sovereignty. In such a nation, the anxieties attending foreign mediation make the frame an especially unstable and dangerous border.

THE ANTHEM: CONSECRATION AND ENTITLEMENT

I conclude with an artist who by no means resolves the complexities uncovered here, but whose penchant for critical reframing invites renewed focus on the elusive category of Thainess (*kwampenthai*), its sovereign symbolic linchpin, and the cinema's special role in maintaining both.

The work of Apichatpong Weerasethakul leaves plenty of room for interpretation. A film one viewer might find benign and sentimental, another will find utterly subversive.[7] Despite his obvious sympathies for various marginal figures (including gay soldiers, children, and migrant workers), Apichatpong's stance has remained irreducible to any clear political or ideological position. This stems partly from his background: he grew up middle class in Khon Kaen, at the heart of Thailand's chronically underdeveloped northeast, an internal margin between the national and the provincial, and the fault line of the conflict that blackened the streets of Bangkok in May 2010.[8] Apichatpong has cultivated a studied ambivalence on the polarized political atmosphere since the 2006 ouster of Prime Minister Thaksin Shinawatra (May Adadol and Teh 2011; Teh 2011). And this is evident in *The Anthem* (2006; 35mm, 5 min), a film pitched unambiguously at the national imaginary, but which manages to destabilize it precisely by isolating the *parergon*—a live, aural, theatrical enframing at that—as pivotal in the cinema's construction of Thai identity and belonging. *The Anthem* was shot on 35mm film and bears Apichatpong's trademark binary structure.[9] In the first half, three middle-aged ladies are chatting; one has brought a CD to their canal-side meeting, containing a song she says she wants to play in the cinema where she works. The song bridges the cut to the gym across the canal, where in the

second half a single, circular tracking shot surveys the action. The ladies prepare ceremonial floral arrangements in the center of a badminton court, while younger folk exercise around them, uninhibited.

Titles have been the site of structural play in Apichatpong's work before, notably in his early features: the wry intertitles of *Mysterious Object at Noon* (2000); and in *Blissfully Yours* (2002) where the credits, that textual framing that normally demarcates inside from outside, instead bisect the film (Langenbach 2010). In *The Anthem,* the subtitles are not subversive, but simply diegetic. However, the title itself serves not only as the usual *parergon,* naming the work, it also specifies and names the *parergon*—an enframing peculiar to Thailand, where a royal anthem is played in every cinema, before every film, during which the audience stands in subjection before short propaganda films of the monarch.

As usual, Apichatpong takes no literal political position. The context is urban middle class. The ceremonial preparations—the gift, the broaching of the sacred— do not in any way interrupt the quotidian bourgeois leisure playing out around them. We are tempted to read this as a portrait of a people who observe ceremony, but do not stand on ceremony—Thailand's much-vaunted *mai pen rai* ideology, that figure of the masses' indifference in which the elite so often secretes its indifference to the masses.[10] Yet the subject of this film, as announced in its title, is after all not visual but aural: the song and the ritual of cinematic consecration it announces and accompanies. Hence, perhaps, the vaguely sacrificial tracking of the camera around profane space and activity. The soundtrack, meanwhile, is the site of a cunning subversion, the arbitrary substitution of a royal-national anthem with a very unregal pop song, the foreign mediation of the *phlaeng farang,* somewhat implausibly favored by the middle-aged Thai cinema attendant.

If we were in any doubt as to the artist's concern for the *parergon,* the work closes with a final framing of its own, a sly signature that underscores the fraught symbolic valence of a ritualized cinema:

"The Anthem"
Certified for all Theatres
Preceding Audio-Visual Purification Service
By Apichatpong Weerasethakul

It is a singular irony of Thailand's symbolic economy that, even with a royal succession crisis looming, this equivocal framing may pass for a blessing. For what is broached in this polite, formal substitution of the sovereign with the popular is the very real question facing the nation: What sort of sovereignty will be next? What sort of consecration, what rituals of fidelity and respect, will be required to sustain

it? And what role for the modern media so long enjoined in propping an older sovereignty up?

If there is an image that can answer these questions, it will not be an image of Thainess. For like the rest of their compatriots, Thai artists know they will need new kinds of sovereignty to reckon with a new, global reality. For many, framing has offered ways to defer this reckoning, while for others, it permits glimpses of a sovereignty to come.

NOTES

1. Mae Salong was founded by Kuomintang units, stranded after Mao's ascendancy in 1949, who controlled the narcotics trade over the mountain passes into Burma and Laos. Sungai Kolok lies in the majority Muslim southern borderlands ceded to Siam by the British in 1909. Separatist violence has claimed over three thousand lives there in the last decade. The king's rituals of encompassment might be contrasted with those of neighboring heads of state in the same period (Barker 2005).
2. In the cinema of the 1920s and 1930s, a printed pamphlet, like a *libretto,* was often distributed, although this practice was less enduring (Boonrak 1992).
3. Some projects widen the franchise of digital culture, such as Santiphap Inkong-ngam's *Xiang Rama* (2009), an ethno-musical survey of the Mekong highlands. Elsewhere, subtitles are supplementary channels for humor and innuendo, as in Amir Muhammad's acerbic video essays about Malaysia's political culture.
4. See the "equivocation" Lastra (2003) identifies in Luis Buñuel's "surrealist ethnography," *Las Hurdes* (1933).
5. There is disquiet in Southeast Asia about Western film festivals funding productions in poor countries that then win accolades at the metropole without being screened at home. Some filmmakers have good reason to bypass national frames, but this discourages efforts to dilate local publics for challenging work.
6. While its army has fought many border skirmishes, its main job has been dousing eruptions of political otherness within. Since the 1982 amnesty that dissolved a communist insurgency, the "others" have been foreigners (Marut's "Burmese Man"), stateless indigenes (Prateep's *Explanation*), and Thai-Muslim "separatists" in the south.
7. Apichatpong's work is celebrated more abroad than at home, where it has often met with indifference and censorship. Local recognition spiked, however, when *Uncle Boonmee who can recall his past lives* won him the Palme d'Or at Cannes (2010).
8. Following months of protest that brought Bangkok to a standstill, the royalist government launched a crackdown in which scores of "red-shirt" protestors were slain, Thailand's worst political violence since 1976.
9. Locations, for example, might oscillate between exteriors/jungle and interiors/town, underscoring divides between social and individual experience (Rayns 2009: 140).

10. The phrase *mai pen rai* means "it's nothing" or "no problem." It is often invoked in ethno-national stereotyping—Thais see themselves as laid back.

REFERENCES

Anderson, J. (1992), "Spoken Silents in the Japanese Cinema; or, Talking to Pictures: Essaying the Katsuben, Contextualizing the Texts," in A. Nolletti, Jr. and D. Desser (eds.), *Reframing Japanese Cinema: Authorship, Genre, History,* Bloomington: Indiana University Press.

Armes, R. (1988), *On Video,* London: Routledge.

Barker, J. (2005), "Engineers and Political Dreams: Indonesia in the Satellite Age," *Current Anthropology,* 46 (5): 703–727.

Bolter, J. and Grusin, R. (1999), *Remediation: Understanding New Media,* Cambridge, MA: MIT Press.

Boonrak, B. (1992), "The Rise and Fall of the Film Industry in Thailand, 1897–1992," *East-West Film Journal,* 6 (2): 62–98.

Clark, J. (1998), *Modern Asian Art,* Sydney: Fine Arts Press.

Clark, J. (2010), *Asian Modernities: Chinese and Thai Art Compared, 1980 to 1999,* Sydney: Power Publications.

Derrida, J. (1987), *The Truth in Painting,* trans. Geoff Bennington and Ian McLeod, Chicago, IL: University of Chicago Press.

Gridthiya, G. and Teh, D. (2009), "Unreal Asia," in *Festivalkatalog 55. Internationale Kurz-filmtage Oberhausen,* Oberhausen: Karl Maria Laufen.

Langenbach, R. (2010), "Subtitling Apichatpong Weerasethakul's *Thirdworld,*" *Contemporary Visual Art + Culture Broadsheet,* 39 (4): 282–283.

Lastra, J. (2003), "Why is this Absurd Picture Here? Ethnology/Heterology/Buñuel," in I. Margulies, (ed.), *Rites of Realism: Essays on Corporeal Cinema,* Durham, NC and London: Duke University Press.

Lyotard, J.-F. (1988), *The Differend: Phrases in Dispute,* trans. Georges van den Abbeele, Minneapolis: University of Minnesota Press.

Manovich, L. (2001), *The Language of New Media,* Cambridge, MA and London: MIT Press.

Marut, L. (2009), "Burmese Man Dancing," artist's synopsis, in *Festivalkatalog 55. Internatio-nale Kurzfilmtage Oberhausen,* Oberhausen: Karl Maria Laufen: 107.

May Adadol, I. (2010), "Dubbing *nang khaek:* Laughter, Tears and Voice Performance in the Space of 'Thai Film History,'" presentation at *Performing Space and Asian Cinema* workshop, Asia Research Institute, Singapore, February.

May Adadol, I. (2012), "Mother India in Six Voices: Melodrama, Voice Performance and Indian Films in Siam," *BioScope: South Asian Screen Studies,* 3.2.

May Adadol, I. and Teh, D. (2011), "Only Light and Memory," in *Yang Fudong / Apichatpong Weerasethakul* (exhibition catalog), Adelaide: Contemporary Art Centre of South Australia.

Morris, R. (2000), *In the Place of Origins: Modernity and its Mediums in Northern Thailand,* Durham, NC and London: Duke University Press.

Morris, R. (ed.) (2009), *Photographies East: The Camera and Its Histories in East and Southeast Asia*, Durham, NC and London: Duke University Press.

Ong, A. (2006), *Neoliberalism as Exception: Mutations in Citizenship and Sovereignty*, Durham, NC and London: Duke University Press.

Prateep, S. (2008), "Explanation of the Word 'Thai,'" artist's synopsis, in M. Pansanga and D. Teh, (eds.), *The More Things Change… The 5th Bangkok Experimental Film Festival* (festival catalog), Bangkok: Project 304 and Kick the Machine Films: 79.

Rayns, T. (2009), "Touching the Voidness," in J. Quandt (ed.), *Apichatpong Weerasethakul*, Vienna: Synema Publications.

Rirkrit, T. et al. (1998), *SUPERMARKET*, London and Zürich: Art Data /migros museum für gegenwartskunst.

Streckfuss, D. (2011), *Truth on Trial in Thailand: Defamation, Treason, and lèse-majesté*, London and New York: Routledge.

Teh, D. (2011), "Itinerant Cinema: The Social Surrealism of Apichatpong Weerasethakul," *Third Text* 112, 25 (5): 595–609.

Winichakul, T. (1994), *Siam Mapped: A History of the Geo-body of a Nation*, Chiang Mai: Silkworm Books.

12 THE "NATIONALITY" OF *LOLITA* FASHION
Masafumi Monden

In a Japanese magazine dedicated to street fashions, iconic fashion model Misako Aoki poses wearing calf-length *Lolita* dresses named "Marie Antoinette one-piece dress" or "Trianon chiffon one-piece dress," decorated with lace, ribbons, flounces, and flared sleeves (*Kera Maniax* 2007: 136–139). The italicized *Lolita* here refers to a particular fashion subculture originating in Japan—the topic of this chapter—which is not unrelated, but distinct from connotations normally associated with the word "Lolita". Derived from Vladimir Nabokov's eponymous 1955 novel and its pre-adolescent heroine, seen by the older male narrator as a nymphet, the "Lolita" look typical in the United States, for example—generally characterized by highly eroticized adolescent or preadolescent girls—has stirred controversy in many Western societies. *Lolita* fashion, on the other hand, is characterized by images of women adorned in elaborate dresses with delicate fabrics, inspired by stylistic interpretations of early modern European clothing such as Rococo and Victorian dresses. The style thus exudes the look of European bisque dolls (Miller 2011: 25; Steele 2010: 34), yet one senses something odd about these Japanese "European" dresses.

Lolita style also references various forms of contemporary popular culture, including Western Goth subculture, *manga, anime* and Visual-*kei* (Visual-Rock) music—a Japanese music genre popular in the 1990s, typified by musicians wearing elaborate make-up and hairstyles, with flamboyant, rather androgynous costumes (Miller 2011: 21). Although it is practiced by a small group of people, *Lolita* fashion has received substantial media and academic attention, perhaps because of its visually spectacular, eye-catching nature. Moreover, the presence of *Lolita* fashion has

increasingly been noted in locations worldwide. But why do people wish to dress in *Lolita* fashion?

When discussing cultural flows within a transnational context, often the focus of debate is the issue of whether cultures tend toward unification or fragmentation (see, for example, Appadurai 1993; Nederveen Pieterse 2004). In this chapter, however, I am interested in whether flows of culture override or dissolve cultural differences in the places they reach, via an examination of *Lolita* fashion. The first section focuses on *Lolita* fashion in the Japanese context. Paying particular attention to its stylistic aspects, I examine one of the ways historical European clothing has been appropriated in Japan. The second section looks at the *Lolita* trend outside Japan by way of a textual analysis of an Anglophone online community for *Lolita* fashion lovers, *EGL (Elegant Gothic Lolita) The Gothic & Lolita Fashion Community.* In so doing, I explore how concepts such as local and global have been relativized or renegotiated in *Lolita* fashion.

LOLITA AESTHETICS IN JAPAN

In Japan, *Lolita* fashion emerged in the mid- to late 1990s. There is no clear definition of *Lolita* style; rather, it functions as a general term for a number of subtly different trends. These include *Kuro-Loli* (Gothic/Black *Lolita*); *Ama-Loli* (Sweet *Lolita*), which uses predominantly pastel shades; the slightly less elaborate *Kurashikku-Lolita* (Classical *Lolita*); and *Panku-Loli* (Punk *Lolita*), which could consist of a punk T-shirt with a frilly, tutu-like mini skirt (Monden 2008: 24–25). *Lolita* style sometimes includes characteristics from traditional East Asian dress, such as the Chinese cheongsam or Japanese kimono, while other minor variations include *Guro-Loli* (Grotesque *Lolita*) and even *Ero-Loli* (Erotic or Sexy *Lolita*).

Orthodox *Lolita* fashion combines Black, Sweet, and Classical styles. It consists of a highly elaborate Victorian calf-length "little girl" dress hooped with layers of pannier, frilly knee-length socks, and Mary Jane or strap shoes—typified by Vivienne Westwood's "Rockin' horse ballerina." The look is completed with intricate headdresses or bonnets. The relatively little-known status of this fashion changed when the film *Shimotsuma Monogatari* (known in English as *Kamikaze Girls*), an adaptation of the best-selling novel of the same title by cult novelist Novala Takemoto, became a Japanese box office hit after its release in 2004. The narrator and protagonist of the story is a seventeen-year-old *Lolita* girl, for whom the style represents a highly romanticized notion of the Rococo nobility, its fashion, and life philosophy.

The style's origins remain largely undecided. Some believe *Lolita* was first practiced by the fans of Visual Rock singers to impersonate their favorite stars (Monden 2008: 24). On the other hand, Mariko Suzuki (2003: 119) argues that *Lolita* may

have been modeled on children's dresses, attracting girls and young women dissatisfied with the lack of frills and lace in mainstream fashions, or those who appreciated gothic subcultural elements and wished to dress in frilly clothes.

This fashion, when practiced in its full-on form, is often accompanied by "demure" mannerisms by the wearer, such as walking in a ladylike fashion sporting a lace-trimmed parasol. Such behavior may also be partly due to the physical restrictions the style imposes on the wearer. Akinori Isobe (quoted in Pia 2004: 110), the owner of the renowned *Lolita* fashion brand Baby, the Stars Shine Bright (abbreviated as Baby), once admitted that the opulent use of lace and frills makes his garments both heavy and impeding. Echoing this impression, actress Kyoko Fukada, who wears *Lolita* garments (including some by Baby) in *Kamikaze Girls,* commented that they were not as physically impeding as she had expected (quoted in Pia 2004: 112).

Women's elaborate dresses in nineteenth-century Europe, by which *Lolita* style is partially inspired, have been perceived as symbolic of feminine oppression largely because of the restrictive nature of the garments. Some have argued that such dresses forced women to become living trophies of the peculiar strength of men, who (financially) clothed them, while also making them submissive to a male (sexual) gaze (see Veblen as cited in Carter 2003: 48). However, assuming these dresses merely endorsed feminine oppression is rather simplistic as clothes, whether men's or women's, may never have been completely functional or "natural" (Entwistle 2000: 158; Wilson 1985: 224). Moreover, the agency of the women concerned, in the act of dressing in such garments, should be considered (Steele 1985: 4). It has also been suggested that the large physical size of women so dressed may have also given the wearers a degree of power, visibility, and an awareness of their existence in society (Smith 1981: 55). Besides highlighting the important issue of fashion and gender, arguably these points are equally applicable to the case of *Lolita* style and its wearers at the turn of the twenty-first century in Japan.

For some who wear this style, *Lolita* is not merely a choice of clothing, it also defines their identity and lifestyle (Godoy 2007: 144). Their fashion and demure body language are closely associated with their romantic views of privileged young women in the idle, aristocratic, elite social classes of eighteenth- and nineteenth-century Europe (Marie Antoinette of France and Alice in *Alice's Adventures in Wonderland* are favorite reference points). This association is likely to have come from Japanese popular culture (e.g., girls' *manga*), to which I return.

To what extent does *Lolita* style actually embrace and appropriate styles of European historical dress, or more specifically what Valerie Steele calls "a nineteenth-century French doll or *jumeau*"? (2010: 34). European women's clothing itself did not gain ground in Japan until the Taishō period (1912–1926), when the "modern

girl" and "garçonne" look emerged, and Western buildings and furniture styles also became prevalent in the country's urban centers (Slade 2009: 101). Yet *Lolita* references an earlier period of European dress that incorporated cross-cultural elements, for instance, Chinoiserie textile designs and painted silks. Japonisme in dress also became notable in the early twentieth century in the work of such renowned couturiers as Madeleine Vionnet (1876–1975), before diminishing in the late 1920s and early 1930s (Mears 2010: 145–147). Fashion can thus be a useful means of investigating the flow of culture between geographically distant locations, with *Lolita* fashion but one example from our times.

Close observation of *Lolita* style reveals that its incorporation of European fashion aesthetics has not necessarily been concerned with historical or stylistic authenticity. The manner in which historical accuracy gives way to aesthetic preferences in *Lolita* style is representative of Walter Benjamin's philosophy of fashion. As Ulrich Lehmann summarizes it, "a particular style or stylistic element is taken from costume history and brought into present fashion to create reference and friction simultaneously, along with new commodities" (2010: 69). *Lolita* incorporates the *ideas* of certain aesthetic elements from historical European dresses, but its actual style is considerably contemporary. Moreover, the Europe apparently presented via this style might more precisely be described as a romanticized Europe that has never existed, which makes no attempt to offer a straightforward replication of dresses specific to certain periods. In this sense, it is a "transtexual" style, in which references to other texts or sources are deployed (Mackie 2009). This significantly highlights the agency of such a style. In addition to the aesthetic sensibilities conceptualized and romanticized by *Lolita,* we shall also see how Japanese understandings of historic European dresses have been influenced by Japanese popular culture.

THE INTERWEAVING OF REALITY AND ROMANCE

The saturation of lace and frills seen in the aesthetics of *shōjo manga* ("young girls' *manga*") and pop idols in the 1970s and 1980s was a likely precursor to *Lolita* fashion. Matt Thorn points out that, especially in the 1970s, aesthetic expressions of the "*otome-chikku*" (maidenesque) in *shōjo manga* "were heavily infused with a dreamy, 1970s-style femininity characterized by frilly cotton dresses, straw sun bonnets, herbal tea, and Victorian houses" (2001: 48). Japanese clothing brands such as Hitomi Ōkawa's Milk (est. 1970), Isao Kaneko's Pink House (est. 1972), and Megumi Murano's Jane Marple (est. 1985) were founded during this period. These brands are considered part of the so-called Japanese Designer and Character (DC) brands, which boomed during the bubble years in the 1980s. DC brands, such as Rei Kawakubo's Comme des Garçons, have wider consumer appeal than *Lolita* style, and

despite not identifying with the fashion, their somewhat romantic, girlish aesthetics are shared by later *Lolita* fashion brands such as Baby (est. 1988).

The link between *shōjo manga* and *Lolita* aesthetics is indicated by the long-lasting popularity of Riyoko Ikeda's comic book series *The Rose of Versailles (Berusaiyu no bara,* affectionately abbreviated as *Berubara,* 1972–1973), in which Marie Antoinette is portrayed as a tragic yet sympathetic princess adorned with lace and ribbons. The influence of *shōjo manga* on the individuals who dress in or create *Lolita* fashion is well noted. For instance, Fumiyo Isobe (Street Mode Kenkyukai 2007: 66), a designer and cofounder of Baby, acknowledges the influences of Yumiko Ōshima's *shōjo manga* on her designs. Similarly, Yukari Ōba (Street Mode Kenkyukai 2007: 119), costume designer of Visual-*kei* band *Malice Mizer* (1992–2001), notes 1970s *shōjo manga* such as *Berubara* and the costumes of female pop idols in the 1980s as among her childhood inspirations. Moreover, it is not surprising that these precursors were themselves inspired by romanticized notions of Europe and princesses in the first place. How, then, have Japanese fashion designers sartorially translated and adopted such ideas?

Baby's "Gingham Check Creeping Rose Dress" (2010), for instance, exudes an air of the mid-eighteenth-century *robe à la française* (French dress) style, which was characterized by hooped petticoats known as panniers. To emphasize this aspect, "the skirt was open in front to reveal a decorative petticoat," even an "ordinary" *robe à la française* "was highly decorated, made of patterned silks covered in ribbons, ruffles, furbelows, and lace" (Steele 1998: 35). Baby's cotton dress has sleeve flounces and an overall design that emulates the frilled *robe à la française,* with a matching petticoat on which white lace trims separate the skirts into three parts, as if the petticoat were in front.

Another *Lolita* dress, designed by Innocent World (est. 1998), is called the "Pompadour Bustle Jumper Skirt (Dress, 2010)". Using a Rococo reference, "Pompadour" refers to Jeanne Poisson (1721–1764), known as the Marquise de Pompadour, a famous mistress of French king Louis XV, who was considered "the personification of the rococo in costume" (Ribeiro 1991: 331). Accordingly, the *échelle* of three detachable ribbons placed vertically on the bodice of this twilled cotton dress corresponds with "the three-dimensional ornamentation of the [eighteenth century French] dress that was an essential part of the rococo" (Ribeiro 2002 [1985]: 140). Combined with the classical rose patterns and the *robe à la française*-style skirt, these qualities bear resemblances to the dress the marquise wears in her famous portraits by François Boucher. The back of Innocent World's dress, however, is bustled. Although it was not an invention of the Victorian period, the bustle became fashionable in Europe between 1882 and 1889 (Steele 1985: 65).[1] The bustle in the *Lolita* dress thus references late nineteenth-century European dresses. Garments such as the Pompadour

Bustle Dress are likely to be worn with added layers of separately sold cotton or-gandy or tulle pannier to better form and accentuate the bell shape, all of which reinforces the feeling of the *robe à la française*, thus thoroughly mixing the design's temporalities.

Judging from its appearance, a *Lolita* pannier might be described more pre-cisely as a hooped petticoat of the twentieth century rather than the authentic eighteenth-century French garment. The knee-length of these dresses is not a style of the *Ancien Régime*, but possibly draws on a ballet skirt or a Victorian "little girl" dress (Rose 1989: 126–127). Further adding to this mix of appropriation and "trans-periodic" quality, one might argue that the *Lolita* dress's silhouette is sty-listically closer to a 1950s American formal gown—as immortalized by the prom dress—rather than to the eighteenth-century French court *robe*. While the 1950s American dress was popular at the same time in Japan, and again briefly in the late 1970s, *Lolita* style has rarely been considered in relation to 1950s American cul-ture, either by *Lolita* brands or the community. Instead, the style is commonly cor-related with historical Europe, reinforced by descriptive terms such as "princess," "maiden," and "ballerina." Arguably, what is important for the style is the opulent feeling created through the emphatically hooped skirt, produced by wearing layers of filmy undergarments à la Marie Antoinette. In this sense, while the actual shape of the dress is considerably more contemporary, it aspires to the quintessence of rococo aesthetic sensibilities, namely "frills, ribbons and flounce" (Ribeiro 2002 [1985]: 136).

The authenticity of historical European dresses has also been negotiated in terms of practicability suited to our time. While *Lolita* style's elaborate qualities can impede the movement of the wearer, the calf-length dress, made of such fabrics as cotton or nylon, hooped with the (petticoat-like) pannier, is lighter, less restrictive, and more affordable than a long, full-length velvet, silk, or wool dress with a heavier crinoline. Such apparently functional concerns contrast with *Lolita* fashion's avoidance of a lighter and more practical structure to craft and sustain the bell shape—such as the plastic hoops implemented in Vivienne Westwood's Mini-Crini skirts (1986)—and is worthy of attention. The use of panniers can create a more opulent, aristocratic feel than plastic hoops. For aesthetic reasons, the layers of cotton tulle or nylon sheer bear a striking resemblance to a bell-shaped ballet skirt. *Lolita* style may therefore be a negotiation between the fashion aesthetics of early modern Europe and the kind of functionality appreciated at the turn of the twenty-first century. Rather than being unfamiliar with European sartorial history, Japanese designers have strategi-cally referenced certain aspects of historical European dress, producing something new.[2] Hence, transnational appropriation can be systematic and tactical rather than "chaotic" (Maynard 2004: 22).

Another notable characteristic of *Lolita* style is its emphatic display of sweet, almost infantile, girlish aesthetics. *Lolita* adds a shade of girlish style favored in Japan—notably a *kawaii* (cute) aesthetic—to a frilly European aristocratic dress form. The concept of *kawaii* is too diverse to fully explore here (McVeigh 2000: 135; Miller 2011: 24), but one archetypal quality of *kawaii* in fashion is when something is "deliberately designed to make the wearer appear childlike and demure" (Kinsella 1995: 229). Mixed with *kawaii* aesthetics, *Lolita* reinvents historical European dresses as something novel and girlish. The projection of the *kawaii* aesthetic as embodied by the shortened length of skirts, exemplifies a conscious, creative adoption of foreign cultural forms.

The newness of this cute, infantile clothing style has also attracted a small yet firm number of followers outside Japan. Renowned *Lolita* brands such as Baby, metamorphose temps de fille (est. 1993), and Innocent World now accept online orders from international customers. Baby opened its first overseas store in Paris in 2007, followed by San Francisco in 2009. In 2010, Angelic Pretty (est. 1979 as Pretty) opened stores in Paris and San Francisco, followed by one in Shanghai in 2012. This indicates the fashion's potential to reach overseas markets, although, as in Japan, these may be niches on the fringes of urban life. Moreover, these focused or limited locations may correspond to places where Japanese pop culture has become familiar and accessible. Nonetheless, the increased visibility of *Lolita* fashion, especially in urban Euro-American societies, forces us to question the style's relationship to a Euro-American "Lolita" look.

EROTICISM AND INNOCENCE

Euro-American "Lolita" is not an established style, but a descriptive term for young girls who dress in a highly sexualized, mature way, or adult women looking infantile with such items as a short, high-waisted dress, known as a babydoll and a barrette (Merskin 2004). What is striking about this Euro-American "Lolita" look is that it not only includes the eroticization of pre-adolescent or adolescent girls, but also the infantilization of adult women. These effects are perceived as two sides of the same Lolita coin. For instance, the trend for mature-aged women to dress like prepubescent girls is perceived by some as operating exclusively for an unhealthy, objectifying male gaze (Durham 2008:119; Merskin 2004: 122). Consequently, these authors articulate the possibility that fashion such as Japanese *Lolita* style might be read as signifying the objectification and infantilization of women.

Although stylistically different, wearers of *Lolita* style outside Japan, particularly in Euro-American cultures, are well aware of the sexual meanings people might infer

from the name *Lolita* and from infantile fashion aesthetics. This point is highlighted in a newspaper article about the increased appreciation of the fashion in Brisbane, Australia (Dorfield 2010). While the twenty-three-year-old interviewee claims that the style has its own aesthetic standard of feminine beauty that allows the wearer to appear attractive without "being revealing," some of the comments posted to the story online offered opposing views. For example, one individual left a comment saying that *Lolita* fashion is a "fetishist" style, as provocative and sexual as young women who dress "like strippers" (Dorfield 2010).

This is not the only comment posted to the story suggesting sexual perceptions of fashions such as *Lolita* in Western societies. It is generally assumed that *Lolita* style and a girlish cuteness associated with it are largely "pre-sexual" despite the possibility of the style veering into the sexualized (Steele 2010: 48). One member of the shop staff at Baby in Japan who dresses in the style regularly, for instance, has said her initial motivation to dress in *Lolita* was a desire to wear cute, doll-like clothes (Godoy 2007: 144). Moreover, "[a]bstinence, girlishness and virginity"—albeit qualities often considered sexually desirable in various societies—characterized this style in late 1990s Japan (Godoy 2007: 135) in contrast to the overt sexual connotations ascribed to Nabokov's novel. It might, of course, appeal to certain fetishist tastes, and it is also possible for some women to deploy *Lolita* style to attract sexual attention, but this does not seem to be the aim for most *Lolita* wearers.

Does the increased visibility of *Lolita* aesthetics abroad, particularly in Western cultures, have any impact on the local conception of cute, infantile, or girlish fashion? In the next section I turn to *Lolita* followers outside of Japan, paying particular attention to their perceptions of the fashion, and look at some of these issues in the context of the cultural globalization surrounding the style.

LOLITA GOES GLOBAL: EGL THE GOTHIC & LOLITA FASHION COMMUNITY

EGL The Gothic & Lolita Fashion Community is one example that alludes to the growing recognition of *Lolita* outside Japan.[3] This English-speaking online community offers a place where participants from various global locations (predominantly Western) socially interact, discussing cultural and aesthetic issues related to *Lolita* style.[4] To analyze the currency of *Lolita* fashion outside of Japan, I observed this community weekly for seven months, from November 2004 to June 2005, and have revisited the site several times since. Participants ranged in stated age from twelve to thirty-five years old, and were from more than fourteen different countries. While this is an analysis of the relatively active participants, the community in fact has

many more members who rarely participate in discussions yet visit and view the site. I participated in forums as an informed observer, in order to neither disturb nor influence discussions. My analysis of the community is informed by three questions. First, what are the main reasons the participants are attracted to this fashion? Second, how do they perceive the fashion in relation to the notion of sexualized "Lolita"? And third, where do they think the fashion comes from?

Around 2005, *Lolita* was perceived by many participants as something new and alternative to their local fashion cultures, which were said to encourage young people to dress more casually. One American male participant commented admiringly: "GL is so beautifully feminine that it's refreshing in a world overpopulated with the voleur [*sic*] tracksuit *gags*"" (November 23, 2004). A number of comments followed lamenting the current mainstream trend of relaxed casual fashion, with one participant replying: "Track suits frighten me…People in LA (where I live) are TOO casual sometimes in my opinion. I mean, some kids in my school wear their pjs to school" (November 24, 2004).

When the question of "Why are you interested in this type of clothing?" was asked by a participant, most answered that the appeal lies in its emphasis on femininity, cuteness, elegance, and elaborate detail. One U.S. participant summarized it: 'It's very feminine, very detailed…combines childlike cuteness and mature elegance, and when done well is excellent for showing off wonderful fabrics and laces" (January 22, 2005). These comments indicate that the participants who dress in *Lolita* style are not particularly fond of prevailing casual, untidy, or revealing fashion trends. Combined with a cultural preconception that perceives "cute" as girlish or infantile, and hence somewhat passive and unfavorable (Paechter 2006; Reay 2001), fashions with hyperbolic girlishness and sweetness are rarely popular in contemporary Western societies. In this sense, *Lolita* seems to provide an alternative to current fashions for those who admire opulently flounced dress styles.

Although *Lolita* fashion suits the preference of the participants, the issue of prejudice toward individuals dressing in infantile clothing is frequently discussed. This seems to be at least partly due to the perception of an eroticized "Lolita" based on Nabokov's novel, and its deviant sexual connotations.[5] One Canadian participant, for example, commented: "Many people seem to think I look tarty or silly" (May 12, 2005). Another Canadian participant, answering the question "Is there anything you dislike about Lolita fashion?" noted: "I guess the name. Lolita. Whenever people hear it they assume I'm some sort of whore" (May 12, 2005).

Many participants in the community strongly deny any direct correlation between *Lolita* fashion and the concept of a sexualized "Lolita." One participant put it: "Most girls who wear the style are exactly the opposite as [*sic*] Lolita from the book by Nabokov" (May 12, 2005). This misconception of the fashion still seemed valid

when I visited the site in 2010. When an Australian participant posted a link to Dorfield's article about Brisbane's *Lolita,* her entry attracted twenty-five comments, including some voicing strong opposition to the notion of the fashion being a form of fetish wear. These commentators defended the style's intentions, one writing: "I personally think there's probably a large difference in the number of men who would fetishize Lolita (not meant to be sexual) versus strippers (meant to be very, very sexual)—you can't really compare the two" (November 5, 2010).

Criticism of the *Lolita* concept assumes a direct correlation between the practice of adults wearing cute, infantile garments and pedophilic fantasies or pornography. However, this may be different in Japan, where the fashion emerged, and where the concept of *kawaii* is not restricted to the realms of children or women. Japanese people generally engage with the notions of (infantile) cuteness differently, for they are culturally allowed to appreciate the concept longer into adulthood than, for example, their American counterparts (Steele 2010: 45; White 1993: 126–127).

Lolita style has attracted its share of criticism in Japan as well, but for different reasons. As *Lolita* wearer Momo Matsuura writes, criticism there has focused more on the flamboyant and infantile aesthetics the fashion manifests, which diverges from the mainstream, culturally more acceptable fashions. It has often been perceived as mirroring the wearer's rejection of maturity and social conformity to the normative mode of femininity (Godoy 2007: 144; Matsuura 2007). In other words, *Lolita* fashion stirs criticism in Japanese society less because of its embodiment of infantile eroticization or fetishization, and more because it signifies a form of subversion and resistance to assumed norms. Whether it has been subject to less hostility in Japan depends on locations *Lolita* wearers can frequent without attracting undue attention. For instance, Harajuku—Tokyo's Mecca for street fashion and youth culture—attracts *Lolita* fashion lovers, but this seems to simply confirm that the style remains a particularly urban subculture. It is clear, however, that many participants in the EGL online community perceive Japan generally to be the place where *Lolita* fashion is most accepted by mainstream society.

An English EGL participant in fact argued: "I would say Japan would probably be the only ACCEPTING place where you could run about and no-one blink twice. I've found the UK is probably the worst because we are a very reserved and set-in-our-ways country!" (January 30, 2005). This argument is reinforced by an Australian participant living in Japan who says: "In Japan there are guys who dress in EGL and hang out in Harajuku, but I don't think the rest of the world would be too accepting," and even young women who dress in *Lolita* "in most countries would get harassed" (January 29, 2005). As these posts indicate, *Lolita* followers tend to see Japan as the only society in which the freedom to dress in *Lolita* style in an everyday context is guaranteed.

It is also noteworthy that some North American participants in these communities say that although teenagers and young people who follow mainstream fashions in their own societies tend to dislike *Lolita* fashion, senior citizens and small children admire it. Here we might recall Fred Davis's proposition that what a clothing style or fashion signifies "is highly differentiated in terms of taste, social identity, and persons' access to the symbolic wares of a society" (1992: 8), a view seemingly shaped through the works of earlier writers such as George Simmel, Thorstein Veblen, and Pierre Bourdieu in his *Distinction* (1984). A Canadian EGL participant writes: "Most older adults, especially women, seem to like the way I dress" (June 4, 2005). Another participant says: "Little girls LOVE it! 'Cause pretty much we're dressed like princess dolls to them" (June 3, 2005). These comments indicate that *Lolita* reception can depend on generation as much as location, and whether the visual is the prominent factor in appreciating the style.

THE NATIONALITY OF *LOLITA*

Whether or not *Lolita* is a specific variant of a nation-based (i.e., Japanese) fashion depends on participants' interpretations. The online community generally treats *Lolita* brand clothing from Japan as authentic, with the majority of participants considering the trend Japanese, or at least Japan-oriented. As for which variant styles are included in the term *Lolita,* one participant argues: "It is the Gothic AND Lolita community, meaning it encompasses all of Japanese Gothic and Lolita fashion" (November 24, 2004). Some participants even express a concern that *Lolita* has been inappropriately interpreted by Westerners, as illustrated by an English participant's comment: "westerners [*sic*], instead of bringing loli straight from Japan, decided to modify it a bit, so now it looks tarty and sort of kinky, which I believe Lolita clothing is trying to avoid" (May 12, 2005).

However, the complex history of the fashion—inspired by eighteenth- and nineteenth-century European clothing, developed in Japan, and now re-exported to Western countries, among other places—seems to provide the background for divergent interpretations. Several participants in fact raise objections to the common perception of *Lolita* as a Japanese fashion. For example, following a comment posted by a Dutch participant who raised objections to other Western participants' incorrect interpretation of *Lolita* aesthetics, another participant claimed: "But the Japanese stole the style original [*sic*] from Europe, so what?" (May 12, 2005), to which a Canadian participant agreed: "True" (May 13, 2005). Furthermore, another participant denies the Japanese origin of the fashion, saying: "it isn't an original fashion or Japanese fashion at all" (May 11, 2005).

Referring to Ulf Hedetoft, this mix of globalization and national identity can be understood as one in which the "receivers" (participants) engage with the fashion as either Japanese or European culture, depending on their prior understanding of *Lolita* as being either Japan-oriented or European-influenced (2000: 281–282). The sender (the "Japanese" fashion trend) has itself emerged from the hybridization of European fashion and a Japanese aesthetic, and is likely to become more diverse than monocultural. In this sense, it can be argued that for Western participants, *Lolita* seems to represent difference from, as well as affirmation of, their own cultures.

CONCLUSION

Despite the fact that *Lolita* style combines elements of historical European dresses, its doll-like hyperbolic cuteness, associated with the concept of *kawaii,* derives from Japan. The style's references to early modern European dresses are highly romanticized and "trans-periodic," and its numerous references to other texts or cultural products such as *manga* and Japanese popular culture make the style an example of the process whereby fashion recycles stylistic elements from the old to create the novel. The style's appreciation of delicate aesthetics without overt sexualization has, in turn, attracted wearers outside of Japan. As a clear fusion of several European and Japanese cultural forms, *Lolita* illustrates the possibility of perceiving globalized cultural forms no longer as either/or, but as both/and, without relinquishing the possibility of alluding to specific cultures and contexts, and without denying individual agency.

Wearers of *Lolita* may wish to identify with the Japanese aspects of the fashion at one point, and assumed or imagined European "origins" at another. It is clear that to these wearers, viewing the style through an either/or dichotomy elides its subtle power and dynamic entirely: *Lolita* aesthetic can be both European and Japanese, just as it continues to be adopted or adapted by other geographical and cultural locations.

NOTES

1. In the 1770s, the *robe à la polonaise,* with the skirt bustled at the back, was considered practical.
2. For instance, Kumiko Uehara, a designer for Baby, says she studied European dress history at university and it benefits her designs (Street Mode Kenkyukai 2007: 69).
3. *Lolita* style has sometimes been called *Elegant Gothic Lolita (EGL),* especially in the initial stages of its introduction to the Anglophone West.

4. This Internet community was created in the United States and the participants must use English to participate. Perhaps because of this requirement, many active participants are from North America, the United Kingdom, and Australia.
5. It should be noted that the Lolita character in Nabokov's novel is seen as a nymphet only through the eyes of Humbert, and the sexual connotation associated with her is largely a misunderstanding that emerged after the novel was published.

REFERENCES

Angelic Pretty official website. [http://www.angelicpretty.com/]. Accessed September 30, 2012.

Appadurai, A. (1993), "Disjuncture and Difference in the Global Cultural Economy," in B. Robbins (ed.), *The Phantom Public Sphere,* Minneapolis: University of Minnesota Press.

Baby, The Stars Shine Bright official website. [http://www.babyssb.co.jp/shopping/baby/onepiece/134317.html]. Accessed May 16, 2012.

Bourdieu, P. (1984), *Distinction: A Social Critique of the Judgement of Taste.* London: Routledge & Kegan Paul.

Carter, M. (2003), *Fashion Classics: From Carlyle to Barthes,* New York and Oxford: Berg.

Davis, F. (1992), *Fashion, Culture, and Identity.* Chicago, IL: University of Chicago Press.

Dorfield, S. (2010), "Brisbane 'Lolitas' Change Fashion Landscape," *The Age,* November 5. [http://www.theage.com.au/lifestyle/fashion/brisbane-lolitas-change-fashion-landscape-20101105–17grh.html]. Accessed December 1, 2010.

Durham, M. G. (2008), *Lolita Effect: The Media Sexualization of Young Girls and What We Can do About it,* Woodstock and New York: The Overlook Press.

EGL The Elegant Gothic & Lolita A Live journal Community. [http://www.livejournal.com/community/egl/]. Accessed 2004–2005, 2010–2012.

Entwistle, J. (2000), *The Fashioned Body: Fashion, Dress and Modern Social Theory.* Cambridge: Polity Press.

Godoy, T. (2007), *Style Deficit Disorder: Harajuku Street Fashion Tokyo.* San Francisco, CA: Chronicle Books.

Hedetoft, U. (2000), "Contemporary Cinema: Between Cultural Globalisation and National Interpretation," in M. Hjort and S. Mackenzie (eds.), *Cinema and Nation,* London: Routledge.

Innocent World official website. [http://innocent-w.jp/shopping/093709/index.html] Accessed February 10, 2011.

Kera Maniax (2007), 7/8 Special Issue.

Kinsella, S. (1995), "Cuties in Japan," in L. Skov and B. Moeran (eds.), *Women, Media, and Consumption in Japan,* Richmond, Surrey: Curzon Press.

Lehmann, U. (2010), "Walter Benjamin" in V. Steele (ed.), *Berg Companion to Fashion,* London and New York: Berg.

Mackie, V. (2009), "Transnational Bricolage: Gothic Lolita and the Political Economy of Fashion," *Intersections: Gender and Sexuality in Asia and the Pacific,* 20.

Maynard, M. (2004), *Dress and Globalization,* Manchester: Manchester University Press.

Matsuura, M. (2007), *Sekai to watashi to Lolita fashion (The World, Lolita Fashion and I),* Tokyo: Seikyu-sha.

McVeigh, B. J. (2000), *Wearing Ideology: State, Schooling and Self-Presentation in Japan,* Oxford and New York: Berg.

Mears, P. (2010), "Formalism and Revolution: Rei Kawakubo and Yohji Yamamoto," in V. Steele (ed.), *Japan Fashion Now,* New York: Yale University Press.

Merskin, D. (2004), "Reviving Lolita? A Media Literacy Examination of Sexual Portrayals of Girls in Fashion Advertising," *American Behavioral Scientist,* 48 (1): 119–129.

metamorphose temps de fille official website. [www.metamorphose.gr.jp/].

Miller, L. (2011), "Cute Masquerade and the Pimping of Japan," *International Journal of Japan,* November 20: 18–29.

Monden, M. (2008), "Transcultural Flow of Demure Aesthetics: Examining Cultural Globalisation through Gothic & Lolita Fashion," *New Voices,* 2: 21–40.

Nabokov, V. (2006, first published 1955), *Lolita,* London: Penguin.

Nederveen Pieterse, J. (2004), *Globalization and Culture: Global Mélange,* Maryland: Roman & Littlefield Publishers.

Paechter, C. (2006), "Masculine Femininities/Feminine Masculinities: Power, Identities and Gender," *Gender and Education,* 18 (3): 253–263.

Pia, (ed.) (2004), *Kyoko Fukada in Shimotsuma Story,* Tokyo: Pia.

Reay, D. (2001), "'Spice Girls,' 'Nice Girls,' 'Girlies,' and 'Tomboys': Gender Discourses, Girls' Cultures and Femininities in the Primary Classroom', *Gender and Education,* 13 (2): 153–166.

Ribeiro, A. (1991), "Fashion in the Eighteenth Century: Some Anglo-French Comparisons," *Textile History,* 22 (2): 329–345.

Ribeiro, A. (2002 [1985]), *Dress in Eighteenth-Century Europe 1715–1789,* New Haven, CT and London: Yale University Press.

Rose, C. (1989), *Children's Clothes since 1750,* London: B. T. Batsford Ltd.

Slade, T. (2009), *Japanese Fashion: A Cultural History,* Oxford and New York: Berg.

Smith, B. G. (1981), *Ladies of the Leisure Class,* Princeton, NJ: Princeton University Press.

Steele, V. (1985), *Fashion and Eroticism: Ideals of Feminine Beauty from the Victorian Era to the Jazz Age,* NY and Oxford: Oxford University Press.

Steele, V. (1998), *Paris Fashion: A Cultural History* (second edition), Oxford and New York: Berg.

Steele, V. (2010), *Japan Fashion Now,* New York: Yale University Press.

Street Mode Kenkyukai (ed.) (2007), *Street Mode Book.* Tokyo: Graphic-sha.

Suzuki, M. (2003), "Gothic & Lolita wa kansai kara umareta (The Gothic & Lolita fashion was emerged from Kansai Region)" *Yaso # Goth:* 118–119.

Thorn, M. (2001), "Shoujo Manga: Something for Girls," *Japan Quarterly,* 48 (3): 43–50.

White, M. (1993), *Material Child,* Berkeley: University of California Press.

Wilson, E. (1985), *Adorned in Dreams: Fashion and Modernity,* London: Tauris.

13 THE IMPOSSIBILITY OF PERFORMING "ASIA"

Catherine Diamond

Theater, although once a core feature of royal ceremonies, urban entertainment, agrarian leisure, religious rituals, and one of the central means of transmitting cultural stories and values to succeeding generations for many Asian cultures, has become marginalized in contemporary society. In the last decade of the twentieth century, several performing artists tried to find common aesthetic roots by exploring the shared antiquity of their traditional theater and forging new styles from their shared colonial and postcolonial experiences to stage intercultural pan-Asian productions intended to represent the region.

These enterprises, that were to "represent" Asia to Asians and non-Asians, had to first conceptualize a vision of what "Asia" meant, and in the process were inevitably also misrepresentations in terms of who was excluded in the production, who determined the interpretation, and its intended audience. The first four productions discussed here show that some Asian dramatists felt compelled to represent Asia collectively to respond to a perceived threat by globalization. Only in the fifth production were the performers comfortable with a multifaceted Asian identity and no longer felt the need to represent themselves as a single, comprehensive whole.

THE "MULTICULTURAL" CONTEXT

Much of the impetus for Asian intercultural theater productions occurred at the end of the twentieth century in response to Western directors' use of Asian classical theater styles, but it was Peter Brook's play *Mahabrahata* (1985) in particular that

sparked controversy over Brook's interpretation of, and right to appropriate, a sacred Hindu text. While some Europeans, such as French theorist Patrice Pavis, defended the work, saying: "Brook looks for a balance between rootedness and a universalizing imaginary...The acting style of this 'immediate theatre'" creates a direct link with the audience (1992: 187), Indian critics took exception to Brook "universalizing" their religious epic. Gautam Dasgupta wrote, "Underlying all this experimentation is, I suspect, a belief in a syncretic cultural universe, where the stage is all the world. A grand and perhaps even a noble vision, granted, but one that inevitably raises the problematic specter of what Edward Said has termed 'Orientalism'" (1991: 76).

In 1989, the year the *Mahabharata* film came out, the fall of the Berlin Wall signaled the end of Soviet communism, leaving the 1990s open to the unimpeded spread of global capitalism. Asian performers, directors, and playwrights began to take control of their representation and asserted a regional identification that culturally countered Western Orientalism. Their intra-Asian theatrical experiments negotiated between the claims of traditional cultural icons and the need to express an Asian modernity tantamount to that of the West.

In addition to Brook's use of an Asian text, Japanese director Yukio Ninagawa's *Medea* and *Macbeth*, which toured Asia in the 1990s, offered a new kind of Asian fusion that combined a canonical Western text with traditionally trained performers and a contemporary mise en scène. Both the Japanese and the British productions suggested paradigms for the first intra-Asian experiments: *Lear* (1997, 1999) and *Realizing Rama* (1998). As expensive spectacles that required state funding, these were showcases for Asia's theatrical antiquity and richness, as well as platforms to assert its control over its representation on the world stage. As Jennifer Lindsay notes, they were:

> performances actually designed for an imagined audience beyond the local or national (beyond even the regional) as opposed to the plucking of something out of its local setting to display elsewhere. Furthermore, the global imagining extends beyond audience to a self-conscious staging as the actual performance itself. The imagining of audience and the imagining of production feed each other—they are both an imagined global. (2009: 2).

Also conscious of the gaze of the "imagined global," but on the opposite end of the financial spectrum, two productions of "people's theater" focused on the economic underbelly of globalization—its constant search for low-wage labor in Asia. *Cry of Asia!* (1989–1997) and *The Big Wind* (1994–1995) arose from the shifting relationships not only between Asia and the West, but also between North and South/Southeast Asia, which have provoked twin upheavals of exploitation and opportunity. The hidden costs of Asian prosperity had already been critiqued by one

of Asia's most politicized theaters—the Philippines Educational Theater Association (PETA)—which inspired the creation of both *Cry of Asia!* and *The Big Wind.*

By the twenty-first century, the need to present a united cultural front by Asian dramatists waned, in part because of their increased international participation as individual artists. Small-scale intercultural experimentation was ongoing, including newly established intra-Asian regional festivals (Diamond 2010: 5). Large-scale intercultural projects no longer seemed so necessary and social activist theaters engaged in more focused collaborations rather than trying to fit their agendas under one all-encompassing banner. One exception was *Hotel Grand Asia* (2003–2005), which wove together scenarios based on concerns of the Asian middle classes, depicting Asian diversity on the basis of individuality in recognition that a contemporary performer can only represent him or herself.

These five intercultural productions were responding to the universalization of culture, the foreign appropriation of representation, and the globalization of labor. Yet several directors and participants' reports document the fractious relations behind the staging of Asian unity: the stress of finding financial sponsorship, differing political ideologies, conflicting concepts of power, and artistic priorities. All five had to contend with three performative aspects integral to their intercultural agendas: (1) choosing or creating an appropriate text; (2) creating a presentation style that either preserves cultural specificity, or is generically "Asian"; and (3) deciding on a language of performance that neither excludes nor privileges any of the Asian cultures involved and is still comprehensible to a wide range of audiences.

LEAR

Lear, the first intra-Asian production of a Western classical drama, was produced with a budget of 1.2 million dollars from the Japan Foundation's Asia Center, to take on "the top Western play," encourage "Asian artists to cooperate and create new plays, and to present a new direction for Asian theater" (Kawashima 1999). The collaborators, Singaporean director Ong Keng Sen, Japanese playwright Kishida Rio, and Japanese producer Hata Yuki, ostensibly chose the Shakespearean text for its "neutrality" in Asia, yet the play's historical renown gave the project high status within the region and marketability outside of it. However, Kishida retained only the basic plot line—the father's betrayal by a seemingly loving daughter—and deconstructed the text by combining characters, removing their individuality by changing their specific names to indicators of relationships (e.g., "Older Daughter" or "Loyal Attendant"), simplifying their relationships, and adding new characters such as the Ghost Mother, a chorus of Earth mothers and a contemporary tourist. Thus Rustom Bharucha's accusation that the choice was disingenuous: "as for Shakespeare, he does

not matter to his New Asian proponents except as a canonical brand and symbolic capital, divested of his language, poetry and metaphor. This foreignization of Shakespeare, based on a glib erasure of his textuality, is yet another form of intercultural philistinism" (2004: 15).[1]

Primarily of Japanese-Singaporean collaboration despite the additional participation of Thai, Indonesian, and Chinese traditionally trained performers, *Lear*'s mise en scène reconfigured five traditional theater styles by extricating the gestures and dance movements from their accompanying music, such as when the Peking Opera performer as the Older Daughter enters to the intense clanging of Indonesian gamelan to kill the Father, performed by the Noh actor. Ong essentialized both the character and Asian performance style by linking them, such as associating age and dignity with Noh and the character of the Old Man (Lear), and the "'extroverted passion' of the Chinese Opera to capture the Older Daughter's flamboyance and 'bitchy camp,' just as the rough idiom of the Indonesian martial art of *silat* is linked to the musculature of the Retainer (Kent)...while the 'lyrical and sinuous movements' of Thai dance evoke the androgynous figure of Cordelia" (Bharucha 2000: 28), thus reducing Shakespearean characters to allegorical personifications and their conflicts to an open-ended morality parable.

The resulting decontextualized cultural geste, such as traditional movement, and the reductive characterization that was then reinvested with extra-textual symbolism had to be explicated in the program notes because the connections were not evident in performance. Some European critics praised this recombination as an apt representation of contemporary Asian globalized culture, saying the "aesthetic experience it enabled comprised a particular kind of liminal experience, embracing fascination as well as alienation, enchantment as well as reflection" (Fischer-Lichte 2009: 397–398). However, Asian critics were more disturbed by both the deracination of traditional forms and the new uses to which they had been put.

> Despite a beautifully and brilliantly staged polyphonic vision, *Lear*'s polyphony is not held together by enough of a consciousness of its inherent contradictions and tensions. The play remains an elite montage of cultural fragments of Asian high traditions filtered into the contemporary world...rather than an intercultural project with semi-voluntarist negotiations of culture. (Wee 2004: 136–137)

Kishida replaced Shakespearean language with portentous utterances that suggested Zen *koans,* but were overburdened with unstated meaning. The script was translated into the five performance languages so that each performer recited in his or her own language, resulting in an exotic soundscape accompanied by English subtitles, leading an Australian critic to write, "The multi-cultural encrypting becomes

decodable via an essentially anglicized offering, nuanced through a western sensibility...Shakespeare's universalism—the 'neutral' quality the collaborators sought in a text that would not privilege one culture over another coerces the audience to track the displacement of *Lear* in relation to our understanding of his *King Lear*" (de Reuck 2000).

While revolutionary as the first pan-Asian spectacle to stage a Shakespearean text, from the perspective of the twenty-first century, *Lear* appears as an example of "self-Orientalizing," a trap of the collective representation relying on the exoticizing gloss of Asian classical dance-drama.

REALIZING RAMA

In 1998, struggling to recover from the 1997 economic crisis, the Association of Southeast Asian Nations (ASEAN) sponsored the creation of *Realizing Rama* to celebrate the common cultural heritage of its ten members, as well as to promote a unified twenty-first century presence in the world order.[2] The Ramayana, which underpins the classical literary and dramatic heritage of many ASEAN countries, was condensed into a one-and-a-half hour contemporary dance drama that attempted to synthesize all the classical Southeast Asian dance traditions. The choice of the Hindu epic clearly differentiated the Southeast Asians from their northern neighbors who had predominated in *Lear,* but it also potentially excluded Vietnam and the Philippines, which have no Ramayana tradition yet still had to contribute to the production's modern interpretation (Tiongson 2000b: 27).[3]

Filipino librettist Nicanor Tiongson created a modern parable, and as in *Lear,* complex characters became personifications: Rama resisted Ravana, no longer merely a demon king but Rama's own Ego, and exorcised his Self of lust and desires for wealth and power, thereby achieving the balance of heart (represented by his wife, Sita) and mind (represented by his brother Lakshmana) (Tiongson 2000b: 27). The program notes explained the creators' contemporary interpretation of each scene, such as Rama's final confrontation with Ravana after his abduction of Sita:

> Rama fights Ravana in hand-to-hand combat, symbolizing the struggle between good and evil inside a person, as well as the battle that a leader today must wage against the evils of poverty, destruction of the environment, exploitation of labor, women and children, and drug trafficking. (*Realizing Rama* synopsis from program notes quoted in Lindsay 2009)

Such psychological and political symbolism superimposed upon the scenes had to be explicated in program notes because they were far too complex to be integrated dramatically, especially without dialogue.

Working with two dancers from each country, Filipino choreographer Denisa Reyes blended their respective dance traditions, adding contemporary movements and stage patterns. A generic Asian style, based on the wide stance of the male dancers, the diagonal or off-balance hip position, and the graceful articulation of the fingers, was extended with balletic leaps and pirouettes. The traditionally trained dancers had some difficulty relaxing the precision of their specific gestures and moving to the newly composed music by Indonesian Rahayu Supanggah, which did not have the customary music cues. Despite the initial obstacles, several participants found the experience creatively liberating. Cambodian dancer Chey Chankethya said, "There was no place to practice modern or experimental dance movements in Cambodia at the time" (Cited in Chan and Shapiro-Phim).

Filipino set designer Salvador Bernal's mise en scène cleverly put familiar Asian objects to new use—an abstract lotus dominated the background through which characters could enter and exit, twirling umbrellas became the chariot wheels of Ravana's army, long fingernail-like extensions were used to suggest a bamboo forest, yo-yos became weapons, and armor was made from compact discs (Doctor 2002). The production used no language other than physical gestures, though in rehearsal English was the only common idiom. The participants' differing levels of comprehension not only required constant translation, but also impacted the degree of their involvement in decision making.

After premiering at the 1998 ASEAN congress in Hanoi, the production was bedeviled by a lack of funding to tour, but eventually performed in all ASEAN countries. In North Asia, where the Ramayana is unknown, it was met with little curiosity or enthusiasm.[4] In Europe, it was presented only for invited guests among the bureaucratic and diplomatic community. *Realizing Rama* was perhaps most well received in India, for not only were audiences accustomed to seeing variations of the Ramayana, the production played to India's cultural pride as the birthplace of the original text. Indian critics were uniformly enthusiastic, expressing no conflict of misrepresentation with the production's concision and stylistic fusion. That it was brought to India was perhaps seen by Indians as a form of respect, though Southeast Asian cultures had long before adapted the text to their own cultural specificities. Lindsay emphasizes the text's repositioning among the various audiences: *"Realizing Rama's* statement of otherness was also *against* 'Asia.' The choice of *The Ramayana,* and the way that choice was portrayed, stated that ASEAN is not India, but also, and more significantly, is *not* East Asia, where *The Ramayana* is not found" (2009).

Realizing Rama was a breakthrough in presenting the first state-supported pan-ASEAN collaboration, but by blending the various different classical styles it created a local version of nonspecific Orientalism similar to that which Western dramatists created in the nineteenth century, but one stripped of exotica and sexual fantasy, and

instead plied with political and social motifs. This work, self-consciously assembled to express a "seamless and harmonious" regional identity, served bureaucratic rather than artistic aspirations, and as such did not produce a work of independent artistic significance. And while *Realizing Rama* "did not crack the global arts circuit, and merely fell back into the ASEAN mold of commissioned performances for commissioned audiences" (Lindsay 2009), it broke through the hold of tradition on some of the individual performers, emboldening them to experiment.

CRY OF ASIA!

In 1989, seventeen artists from twelve Asian-Pacific countries, led by Filipino playwright Al Santos, began *Cry of Asia!* (1989–1997), aiming to create a grassroots theater that represented the lower echelons of Asian society. Their performances evolved by adopting themes shared by all their cultures and protesting their common exploitation from unscrupulous capitalist development.

In the first of *Cry of Asia*'s three productions, Santos, trained in collaborative theater activism at PETA, assumed that despite their diverse backgrounds and political views the participants would find a single common narrative to bind them. "Rehearsals started without a script and only with a clear intention: that we were to conceptualize, create and improvise the play together" (Rustia [Santos] 2002). The group first improvised around the region's eclipse myths, and then Santos composed an allegorical script in which the good spirit of the sun was eaten by bad spirits, thus making a Manichean division between good and bad, East and West. The corrupt tribal priest Inao sells his soul to the bird Minokawa to obtain absolute power, and dominates the villagers by use of his magic (technology), thought to have caused the eclipse. Santos remarks: "This starting point of a common legend led us to even more meaningful discoveries about our similarities (as well as differences) in cultures and historical experiences. The same story of colonization and regaining and revitalizing lost identities became a running theme in our discussions, workshops, improvisations and final production" (Rustia [Santos] 2002).

The performance demonstrated an original harmonious existence with women washing at the river and the shy courtship of a boy and girl. When masked demons attack the sun and the evil bird performs a wild demonic dance, the river becomes polluted, and people sicken and die. Generally, the performers employed modified movements or gestures from classical and masked dances, as well as martial arts, but as they were not precisely choreographed or executed, they gave the overall impression of rough amateurishness. Aside from the spirits in Korean and Javanese masks, most actors portrayed village people wearing simple sarongs, and thus their class orientation downplayed the actors' own cultural differences to portray the masses

of suffering Asia. The Indian and Pakistani musicians provided lively percussion on tabla and harmonium, while a Korean singer accompanied herself with a drum, and so the production attempted to feature participants' particular skills within a more generically conceived Asian context.

The production used a simple mise en scène because it was constantly underfunded and on the go, traveling and interacting with audiences in the Asian hinterlands, where Santos recalls: "We learned that multiculturalism is more than just 'unifying,' the 'interweaving' and the 'juxtaposing' of Asian art traditions into a blend of exotic tableaus, but is what insights and experiences we want to pass on to the next generation of artists" (Rustia [Santos] 2002).

Its "cultural caravan" also journeyed through Holland, France, Germany, and Austria, where the Asian performers confronted the plurality of European cultures, challenging their previous view of a monolithic, evil West, and aided by local volunteers, they learned that not all Europeans were rich. Yet, Eugene van Erven, who helped in Europe, felt the project did not fulfill its potential: "*Cry of Asia!* was his [Santos's] brainchild, instead of a collaborative project of an international artistic movement...Although brilliant in concept, *Cry of Asia!* thus unfortunately gave Europe an imperfect picture of the true artistic and sociopolitical potential of the theatre of liberation" (1992: 235).

Although the working language of the group was English, many performers had only sparse knowledge of it or none at all, and this hampered them from sufficiently learning about each other before undertaking the project, and later led to misunderstandings. Though the final performance included ten languages, it was not language dependent, and instead used movement, mime, and music to enact its narrative. The two later *Cry of Asia!* productions (1995, 1998) had stronger narratives, and the music and dance was more professionally executed and integrated, but they continued to depict a simplistic good-bad social dichotomy against globalization. Though initially wishing to present a unified front, Santos concludes that the most important lesson was for Asians to learn about their differences:

> Asians share things in common: food, religion, arts, culture, history, war and revolutions, etc., etc. That a common world exists among Asian traditional theatres, where borders blur between time and space, dream and reality, history and folklore, past and future, here and the life after...most importantly, we learned about our differences. (Rustia [Santos] 2002)

THE BIG WIND PROJECT

Influenced by *Cry of Asia!*, Hong Kong director Mok Chiu Yu initiated *The Big Wind Project: A Collaboration of Popular Theatre Workers East and West* (1994) with the

San Francisco Mime Troupe and performers from Hong Kong, Nepal, Bangladesh, Thailand, India, Pakistan, and Taiwan. The original intention had been to restage the Mime Troupe's production *Offshore* (1993), which satirized American companies moving their factories to Asia to exploit cheap labor, but then it was decided to create a new play about the exploitation of South and Southeast Asian workers by North Asia. The Mime Troupe was able to get seed funds of twenty-five thousand US dollars from the Rockefeller Foundation, but later Mok had to keep the show going with his own money (Mok).

The aim of the project was for Asian theater activists to learn how to adopt the Mime Troupe's technique of using musical comedy to present serious social issues, while the American participants wanted to learn traditional Asian forms (Holden 1995: 17). Seven writers gathered in Hong Kong to produce a script depicting the plight of illegal workers there, by dramatizing the comic side of their dilemmas, created through ignorance, prejudice, and misunderstandings. An Indian, Babul, goes to Hong Kong; but after he is deceived by job recruiters, he wants to become an employment agent to help his fellow workers. He first needs a Hong Kong ID, and seeking a Hong Kong woman to marry, he mistakes a star-struck Thai maid for a local Chinese. She mistakes him for a *talent* agent because they miscommunicate in languages neither of them speaks well. The maid's employer, a Hong Kong land developer needing laborers, makes a deal with Babul to hire his migrants, but it is discovered they have overstayed their visas, so are arrested by the Hong Kong police.

When questioned about her nationality in order to be deported, Anzu, an older woman, "the ultimate migrant worker in Hong Kong," spoke only gibberish and had a passport in a language that *no one* understood. Her predicament, revealing the failure of language, inspired not only laughter but also the greatest sympathy from audiences everywhere (Mok). Thus, it seems that the true trans-Asian identity resided in the one who could not be identified by nationality, race, religion, or any factor other than economic desperation and concomitant exploitation.

Emphasizing its comic narrative, *The Big Wind* was very language dependent, but because some of the actors were non-English speaking, the dialogue was carried out with one character speaking English to another who responded in the local audience's language of Cantonese, Nepali, or Urdu. Thus, the script not only utilized the participants' various languages, it turned the difficulty of not having a common language and their own traumas of not being understood into the modus operandi of the play's humor. Mok notes that at its three Hong Kong performances, it "played to Westerners, local theater-goers, migrant workers (Nepalis, Bangladeshis, Filipinas, etc.) and local workers and labor organizers. Really a great mix and a very good response, people obviously were laughing and enjoying the show, and interestingly, different people laughed at different things" (Mok).

Members initially disagreed about whether to authentically represent their dance traditions or blend them into something new. The musicians, unhappy that their compositions were expected to be subordinate to the script, challenged the authority of the Mime Troupe director and playwright and questioned the nature of the collaboration as well as that of "peoples' theater"—what was it and who was it for? The group had not solidified its style until it encountered the Bengali *jatra,* a vibrant hybrid folk theater combining exaggerated melodrama interlarded with comic scenes, replacing mythic content with contemporary social reality. The motley *jatra* aesthetic helped *The Big Wind* cast visualize a style it could adopt (Holden 1995: 20).

After its last performance, Mok joined the second *Cry of Asia!* (1995). These two productions dealt with the exploitation of migrant labor, with the notable difference being that *The Big Wind* employed humor, while *Cry of Asia!* emphasized pathos. Although the hoped-for cultural fusion of an East-West people's theater aesthetic did not emerge, the experience inspired several of the participants to continue working as theater activists, addressing specific local community issues and using some of the techniques they learned in *The Big Wind* (Mok).

HOTEL GRAND ASIA

Hotel Grand Asia was the result of a three-year Japan Foundation-funded Asian Contemporary Theatre Collaboration from 2003 to 2005, which brought together sixteen actor-director-playwrights from Malaysia, Indonesia, Singapore, the Philippines, Thailand, the United States, and Japan. They were second-generation Asian interculturalists and without any design imposed upon them, they initially created forty separate vignettes interwoven by four main themes: identity, alienation, and isolation; migration and economy; terrorism, and the later addition of the December 2004 Indian Ocean tsunami.

Wanting to avoid both modern realism and postmodern pastiche, the group broke into think tanks to focus on the particular themes and develop a plot. They came up with three scenarios: the first, *Miss Gumamela,* was about a Filipino transvestite who wants to become a singer in Japan to earn money for a sex change operation. She eventually succeeds, but marries a Yakuza gang member who beats her up when he discovers she is a transsexual, and she ends up taking refuge in drugs. In the second, titled *The Man and Woman,* the two characters play a game writing scripts for each other in which they discover they have both become suicide bombers. *The Three Sailors,* the third scenario, begins with the sailors sarcastically commenting on the other two scenarios, and then combines the devastation of the tsunami with the Mahabharata epic. The deserted sailors, who collectively represent a forgotten god who conjures a gigantic wave, meet up with Bima, the strong man in the epic, who

battles a serpent, and then, diving into its belly, meets a deity who says, "I am no one but yourself" (Thammapruksa 2006). Working on a mostly bare stage, the actors relied only on lighting effects and simple props—chairs, tables, swathes of cloth.

As with all the other intra-Asian performances, no single language adequately served as a common language for all the participants, and communication problems were often highlighted in the practice vignettes, as when the Filipino dentist with heavily accented English tries to compel his Indonesian patient, who does not understand him, to speak English. The patient attempts to oblige but finally explodes, "I paid you. Can't you speak in Indonesian?" to express his anger, arising both from frustration at not being able to communicate and in response to the arrogance of English speakers (Mandal 2008: 169–170). Nonetheless, the final performance was largely in English peppered with other languages, and accompanied with subtitle summaries in Japanese, Tagalog, and Thai.

Being middle class, college educated, and raised in relative peace and prosperity, the director-playwrights, who were accustomed to being leaders, had to subdue their wills and negotiate to create anything, even though the results rarely satisfied them all. One of the Japanese members, Takeshi Kawamura, testified: "This play may be a kind of product of chaos, but I think this is one result of our quite Asian forms of decision-making in this group—nobody decided anything and we never set a goal" (Tanaka 2005). Neither were they afraid of self-parody, as their choice of title mocked the materialist aspirations of an increasingly prosperous Asia. "Wherever we traveled in Asian countries we would find hotels with grandiose names beginning with the word 'Grand' or with the word 'Asia' to make them look fancy, but inside they may have been only squalid establishments" (Thammapruksa 2006).

As individual contemporary Asian artists, they were ready to cross borders rather than be obsessed with the representation of traditional cultures or national identities. The social issues they explored, however, were often abstractions rather than drawn from direct experience, but this did not stop them from adamantly expressing their opinions, producing much unproductive talk and exasperation.

Observer Sumit Mandal noted participants had substantial disagreements to overcome precisely because they were accustomed to exerting their views rather than giving in to group consensus:

> Everybody got along and yet they did not. Moments of deeply felt differences spliced the intense solidarities formed. Cultural divides were not easily bridged and egos not easily accommodated . . . the project put into practice what is easy to theorise but hard to realise: recognising differences and accepting them through dialogue. Through theatre, the project showed the possibilities and challenges of belonging across national boundaries, of assuming a credible transnational self (Mandal 2007).

Discovering or creating a "transnational artistic persona" seemed to be one of the aims. Though they had been selected according to national origin, they had to decide how to craft both art and identity, and how that representation should interact with that of the others. Herbie Go of Tanghalang Pilipino theater in Manila summarized it:

> If you try to define Asian identity, you would go crazy. It's impossible to define it. For example, you are an Asian, but also you are an individual. The play addresses some issues about identity, but we did not define Asian identity...I do not like plays that are always defining, and I do not want to show a new "Asian theatre" style (quoted in Tanaka 2005).

Given the unwieldy nature of the enterprise that had to include everyone's voice, it is not surprising that more thoughtful performances occurred afterward, when some of the participants developed their ideas more selectively, such as *Break-ing/Ji Po/ Ka Si Pe Cah* (2008), three pieces about language by the Malaysian directors.

CONCLUSION

Such attempts to stage a representative Asian identity in the 1990s were, by 2005, no longer even desirable, according to the younger generation of Asian directors. Cultural specificities of the performance traditions had been sacrificed to create a form of Asian "self-orientalizing" to express regional unity in diversity. The codified classical styles became unmoored from their contexts, and the language that located them firmly in cultural narrative was eliminated or universalized. The texts were both simplified and superimposed with artificial, overly constructed symbolism, while moral conflicts were reduced to melodrama or fable. The two grand, well-financed spectacles both stripped the original canonical texts of their ethical and psychological complexities, and the two ambitious but modestly funded social activist plays created parables that did not probe the complexities of globalization in ordinary people's lives. Whether exotic or mundane, the characterizations were overly determined by the cultural and political agendas of the creators. The productions were provocative at the time they were staged and in their unique composition of Asian participants, but because of their costs and logistical difficulties there was little impetus to repeat them on a similar scale once the point of Asianness had been first realized, then challenged and finally jettisoned. For, within the creative process of each production, differences became more apparent and significant than the sought-after similarities, already presaging the impossibility of collaborative representation. Thus Asia-centricity not only turned out to be the flip side of Euro-centricity, but it also

revealed real intra-Asian tensions and fragmentations suggesting that interculturalism represented not Asia, but more accurately the *impossibility* of "Asia".

Recently, artists are increasingly exploring individuality vis-à-vis the nation and region, making it difficult to imagine they will readily submit to traditional communalizing or nationalistic ideologies that render the individual inconsequential. The theatrical representation of an Asian individual remains a daunting challenge however, even within the Asian region, due in part to the difficulty of being recognized by one's cultural identity while not being restricted by preconceptions of it.

Without imposing a too strictly linear trajectory, in these five productions one can see a change that transcends aesthetic, political, financial, and organizational differences. *Lear* and *Realizing Rama* were intentionally grand productions dealing with the confluences of Old and New Asia and incorporated aspects of Asian high traditions to represent modern societies confidently rooted in antiquity. *Cry of Asia!* and *The Big Wind* idealistically attempted to represent the millions of Asians disenfranchised by globalization, and who are the oppressed work force upon which New Asia has been built. In *Hotel Grand Asia* not only were many of the participants accustomed to intercultural discourse, they were the most free to explore on their own, unfettered by the global ambitions of star directors, the sensitive "face" of government bureaucrats, and the necessity of improving the plight of the poor. They had the time, sufficient financial backing and complete control over aesthetic decision making. A collaboration from the ground up, without leaders and defined goals, this project testified to the impossibility of representing Asia other than as a tapestry of individual perspectives woven through a multiplicity of stories.

NOTES

My thanks to Chung Chiao of Assignment Theatre in Taipei, Taiwan, for sharing his video tapes of *Cry of Asia!*.

1. One Singaporean performer even boasted that she had not read *King Lear,* saying, "That's the cleverness of Keng Sen! You don't have to read the work to understand it!" See "King Lear: The Avoidance of Love." http://www.substation.org/magreview/king-lear-the-avoidance-of-love.html. Accessed November 12, 2009.
2. ASEAN countries are Cambodia, the Philippines, Myanmar, Thailand, Singapore, Laos, Brunei, Malaysia, Vietnam, and Indonesia.
3. Tiongson asserts the similarity of a Philippine epic, titled *Maharadia Lawana,* with the Ramayana and that modern performances have been based on it. See Tiongson 2000a 11–12.
4. Koreans did not understand it and the Chinese audiences ate and talked throughout the performance. See De, 2002.

REFERENCES

Bharucha, R. (2004), "Foreign Asia/Foreign Shakespeare: Dissenting Notes on New Asian Interculturality, Postcoloniality, and Recolonization," *Theatre Journal,* 56 (1): 1–28.

Bharucha, R. (2000), "Consumed in Singapore: The Intercultural Spectacle of *Lear,*" in *Centre for Advanced Studies Research Paper* Series, 21, Singapore: Centre for Advanced Studies.

Chan S. and Shapiro-Phim, T. "Chey Chankethya," *Tanzconnexions.* http://www.goethe.de/ins/id/lp/prj/tac/zgt/kam/cho/en5647208.htm. Accessed December 3, 2011.

Dasgupta, G. (1991), "The Mahabharata: Peter Brook's *Orientalism,*" in M. Marranca and G. Dasgupta (eds.) *Interculturalism & Performance,* New York: PAJ Publications.

De, A. (2002), "Rendezvous with Rama," *The Hindu* [online], November 18. http://www.thehindu.com/thehindu/mp/2002/11/18/stories//20021118005502.htm. Accessed November 9, 2009.

de Reuck, J. (2000), "'The Mirror Shattered into Tiny Pieces': Reading Gender and Culture in the Japan Foundation Asia Centre's *LEAR,*" *Intersections: Gender, History and Culture in the Asian Context,* 3. http://intersections.anu.edu.au/issue3/jenny3.html. Accessed November 12, 2009.

Diamond, C. (2010), "The Mekong Goes Global: International Festivals/Regional Gatherings," *SPAFA Journal,* 20 (1): 5–17.

Doctor, G. (2002), "Reinterpreting an Epic," *The Hindu* [online], November 24. http://www.hindunnet.com/mag/2002/11/24/stories/2002112400530200.htm. Accessed December 5, 2008.

Fischer-Lichte, E. (2009), "Interweaving Cultures in Performance: Different States of Being In-Between," *New Theatre Quarterly,* 25 (4): 397–398.

Holden, J. (1995), "Big Wind Blows in Asia," *American Theatre,* 12.

Kawashima, R. (1999), "Exploring New Horizons in Asian Theater Experimental Play 'Lear,'" *Fukuoka City Foundation for Arts and Cultural Promotion: Magazine,* March. http://222.ffac.or.jp/magazine/01/lear_e.html. Accessed November 11, 2009.

Lindsay, J. (2009), "Staging Globalism and Realizing Asia in the ASEAN Ramayana," Unpublished conference paper delivered at International Convention of Asia Scholars (ICAS), Korea.

Mandal, S. (2007), "Staging Asia," *Kyoto Review of Southeast Asia,* 8/9. http://kyotoreviewsea.org/Issue_8–9/Mandal.html. Accessed June 30, 2008.

Mandal, S. (2008), "Collaboration and Community-making! A Case Study of an Asian Theatre Collaboration," in S. Y. Tham, P. P. Lee, and N. Othman (eds), *Community in ASEAN: Ideas and Practices,* Bangi: Universiti Kebangsaan Malaysia.

Mok, C.Y.A. (n.d.), *The Big Wind Project: A Collaboration of Popular Theatre Workers East & West,* Unpublished Director's Report.

Pavis, P. (1992), *Theatre at the Crossroads of Culture,* London: Routledge.

Rustia [Santos], A. (2002), "On the Road to Multiculturalism; the Cry of Asia Experience," *Our Own Voice,* July. http://www.oovrag.com/essays/essay2002b-2.shtml. Accessed January 25, 2009.

Tanaka, N. (2005), "'Hotel Grand Asia': The Melting Pot of Theatrical Asia Served up for Japan," *The Japan Times,* March 9. http://search.japantimes.co.jp/cgi-bin/ft200550309al. html. Accessed November 21, 2009.

Tiongson, N. (2000a), "The Rule of Rama from the Bay of Bengal to the Pacific Ocean," *SPAAFA Journal,* 10 (2).

Tiongson, N. (2000b), "Realizing Rama, Realizing ASEAN," *SPAAFA Journal,* 10 (2).

Thammapruksa, N. (2006), "Hotel Grand Asia," *The Japan Letter* (Japan Foundation's newsletter), Bangkok, 49. http://www.oknation.net/blog/print.php?id = 248371. Accessed November 21, 2009.

Wee, C. J. W.-L. (2004), "Imagining 'New Asia' in the Theatre: Cosmopolitan East Asia and the Global West," in K. Iwaguchi, S. Mueke, and M. Thomas (eds.), *Rogue Flows: Trans-Asian Cultural Traffic,* Hong Kong: Hong Kong University Press.

Van Erven, E. (1992), *The Playful Revolution,* Bloomington: Indiana University Press.

INDEX

Chiayi county, 66

Chicago, 124–6, 132n1

China, 9, 13n11, 19–20, 27, 29, 35, 37–8, 42–4, 58, 74n4, 77–82, 84–90n8, 114, 117–18, 120, 134–40, 142–4, 146–7n6

China Academy of Art, 78, 84, 86, 88–9

China Literature Study Society, 134

Chinese Cultural University, 66

Chintamani shrine, 128

Chitor, 123

Cho, Yeou-jui, 64, 68, 74n7, 74n9

chromolithography, 126

Clark, John, 4–6, 12n3, 48, 64

Clifford, James, 3–4, 25, 144, 148n21

coding, 23, 30–31n3

Cold War, 153

colonial period, 47–8, 51–4, 58–9, 108

colonialism, 19, 48, 126–7

colonization, 10, 35, 185

colophon, 112

Columbus, Christopher, 139

Columbus, Ohio, 150

Commercial Press, Taiwan, 117

communication, 9, 34, 36, 83, 157–8, 189

conceptualism, 27, 30

Concrete House Art Centre, 95

Confucianism, 52, 65, 68, 70, 82

Consecration II, 99

consumption, 33, 36, 39, 44, 154

contextualization, 6

Coomaraswamy, Ananda, 50

coromandel technique, 53

crafts, 49, 88, 98

craftsmen, 95, 97, 100

Cry of Asia!, 180–1, 185–6, 188, 191

Cubism, 36

cultural

 forms, 2, 153, 176

 identity, 4, 6, 191

 practices, 2, 8–10

Cultural Revolution, 35, 38, 40, 81

culture

 dominant, 24–5

 gothic, 165–7, 172, 175–6n3

home 5, 22

literate, 10

material, 6, 12n7, 147n7

sub- 9, 85, 165, 174

visual, 6, 12n7–8, 21, 25, 65, 123

curators, 8, 20, 22, 33–5, 37, 40, 43, 65–6, 152–3, 157–8

Dai Nippon Printing Co. (DNP), 112, 114

Dakshineshvar Temple, 130

Dalai Lama, 38–9, 41, 44n5

Dal Lago, Francesca, 80

Danang, 107–8

dance, 3, 88, 96, 182–6, 188

Daniell, Thomas, 123

Daniell, William, 123

Danto, Arthur, 33

Daoism, 82

Dasgupta, Gautam, 180

Davis, Fred, 175

Dayal, Samir, 63, 74n5

Delhi, 123

democratization, 34

Deng, Xiaoping, 38

Derrida, Jacques, 151

design, 49, 53–4, 114–15, 117–19, 123–4, 147n7, 150, 168–70, 176n2, 188

designer, 115, 117–19, 169–70, 176n2, 184

developmentalism, 9, 153

Dharamsala, 41

Diamond, Catherine, 9

Diary of a Madman, 147n2

diaspora, 4, 37, 40, 42, 64, 74n5

Dickie, George, 33

Dien Bien Phu, 51

digital video (DV), 155–7, 160

Dijon, 150

Dimension Endowment of Art, 70

Đình Bảng communal house, 50

Đình, Văn Thành, 53

discourse

 art, 4, 20–2, 25–7, 29, 50–1, 84

 endogenous, 23, 29–30

 hegemonic, 23, 135

Suzuki, Mariko, 166
Sweet Tea Gallery, London, 44n4
Switzerland, 40–1, 137
Sydney, 99, 105
symbolism, 75n27, 182–3, 190
Synchronicity Space, 69
syncretism, 24
Szeto, Keung, 74n7

Tabaimo, 20
Tagore, Abanindranath, 50
Tagore, Rabindranath, 25, 56
Taipei, 67, 70, 75n11–12, 75n27, 120, 191
Taisho period, 167
Taiwan, 7, 62–75, 115, 117, 120, 187, 191
Taiwan Museum of Art, Taichung, 65
Taiwan Women's Art Association, 65, 75n10
Taj Mahal, 123, 127
Takeda, Taijun, 9, 134–44, 146–147n4–5, 147n9
Takemoto, Novala, 166
Takeuchi, Yoshimi, 147n6
Tan, Fiona, 25
Tang dynasty, 50, 58
Tanghalang Pilipino theater, Manila, 190
Tanizaki, Jun'ichirō, 144
Tardieu, Victor, 49–50, 52
Taylor, Nora, 48, 52, 59n4
Taylor, Phillip, 105
Teh, David 8–9
television, 155–6
Tenshō Embassy, 113
Tenzin Rigdol, 41
textiles, 7, 103, 147n7, 168
Thailand, 6, 12n1, 27, 29, 95–101, 105–6, 151, 153, 155–7, 159–62, 187–8, 191n2
Thaksin, Shinawatra, 160
thangka, 35, 40
theater, 153, 179–82, 185, 187–8, 190
30 Letters, 42
Thorn, Matt, 168
Thorp, Robert, 79
Three Worlds, 101
Tibet, 34–45
Time-Life, 143

Tiongson, Nicanor, 183, 191n3
Tiravanija, Rirkrit, 150–1, 158
Tô, Ngọc Vân, 47, 51–3, 57–9n5
Tokyo, 21, 30, 112, 114, 115–18, 134, 141, 174
Tokyo Imperial University, 134
Tonkin, 54, 59n1
tradition, artistic, 5, 8, 35, 186
tradition, visual, 11
traditionalism, 43
Trần, Quang Trần, 53
Trần, Văn Cẩn, 55–6
transcription, 23, 108
transcripts, 68
transculturalism, 62
translation, 2–4, 9–10, 22–6, 31n4, 35, 56, 89, 90n11, 100, 106–8, 117, 124, 135–6, 141, 154, 146–8, 184
translator, 2, 6, 8, 11, 22, 24–6, 158
transnationality, 22, 31, 37, 39, 63, 155, 159–60, 166, 170, 189–90
TseKal, 42
Tsering Sherpa, 41
Tsukijitai, 114
Two Young Girls and a Baby, 58
typeface, 3, 112, 114–15, 118–20
typography, 7, 112–13, 115–18, 120

Ua-areeworakul, Nitaya, 95
Uchimura, Kanzō, 147n13
Uehara, Kumiko, 176n2
Ujjain, 128, 130
Ujjain Darshan, 128–30
Uncle Boonmee who can recall his past lives, 162n7
United Kingdom, 35, 38, 41, 66, 114, 177n4
United States, 35, 41, 44n6, 64, 66–70, 74n1–2, 165, 177n4, 188
untranslatability, 24
Ushiroshoji, Masahiro, 48
Utrillo, Maurice, 57

Van Erven, Eugene, 186
Varanasi, 123
Varma, Ravi, 27, 29
Veblen, Thorstein, 175